Medici Family Tree

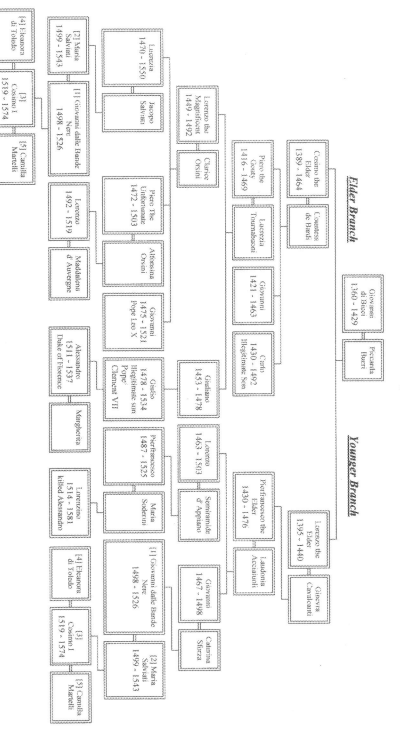

Botticelli's Primavera:
The Young Lorenzo's Transformation

Jean Gillies

iUniverse, Inc.
New York Bloomington

Botticelli's Primavera: The Young Lorenzo's Transformation

iUniverse books may be ordered through booksellers or by contacting:

iUniverse
1663 Liberty Drive
Bloomington, IN 47403
www.iuniverse.com
1-800-Authors (1-800-288-4677)

ISBN: 978-1-4502-2161-0 (sc)
ISBN: 978-1-4502-2162-7 (ebk)

Printed in the United States of America

iUniverse rev. date: 04/28/2010

Table of Contents

Acknowledgments

Throughout the many years that I have worked on this interpretation of Botticelli's *Primavera*, many people have offered suggestions or have given me advice on its content. Although, finally, I am solely responsible for the point of view and the research that led me to the conclusions presented below, there have been several people without whose support and knowledge I would not have been able to complete this project.

I could not have acquired the astrological information that was necessary to explain Marsilio Ficino's enigmatic words to his young student, Lorenzo di Pierfrancesco de'Medici, without the expertise of Linda Fish. Her understanding of the "stars," their influences, how they interact with one another, and how they were understood during the fifteenth century has been invaluable. I am truly indebted to her for her generous assistance.

My three daughters have been especially helpful, each in her own way. When I was exploring the possibility of an arithmetical component in the painting's iconography, my daughter Laurie Pitner's knowledge of mathematics was indispensable. Despite the fact that I decided not to continue in that direction, the possibility that a numerical element is implicit in the work cannot be completely dismissed, and, if needed, I have the relevant data on file. Several years ago, my daughter, Kendra

Simpson, transcribed the entire manuscript from its typed copy to computer disks that have enabled me to easily revise or otherwise edit the manuscript. I can't thank her enough for using this modern technology.

It has been Janice Mueller, my eldest daughter, who had the time and special abilities to make contributions to this project without which I could not have completed it. She undertook the difficult tasks of compiling both the bibliography and index. Further, she designed the cover, using the Mercury figure from the *Primavera* as he explores the heavenly realm with his caduceus.

My son-in-law, Keith Pitner, constructed the Medici family tree that is included herein, which was culled from several sources but based on his extensive knowledge of geneology. The tree concentrates on the relevant lines and those persons who were of importance in this work. I am most grateful for his help.

Finally, I cannot fail to acknowledge and thank my copy editor, Karen Telser, for her careful reading of the manuscript. I am also deeply grateful to Claudia Grosz, whose beautiful calligraphy enhances the book's cover and spine.

Jean Gillies, Ph.D.

Illustrations

Frontispiece: The *Primavera.*
 Photo courtesy of Galleria degli Uffizi, il Polo Museale Fiorentino

Overleaf: Medici Family Tree

1. Isis with Jar and Sistrum, 2nd Century C.E.
 Photo courtesy of Musei Capitolini, Rome

2. Isis, Athanasius Kircher, Oedipus Aegypticus, Rome, 1652
 Photo courtesy of The Newberry Library, Chicago

3. *Primavera,* detail of medallion on central figure
 Photo courtesy of Galleria degli Uffizi, il Polo Museale Fioentino

4. Alchemical illustration: *Sapientia veterum philosophorum sive doctrina eorundum de summa et universal medicina.* Ms. 974, fig. 14
 Photo courtesy of the Bibliothèque nationale de France, Paris

5. *Minerva,* Drawing by Botticelli or member of his workshop. Date uncertain.
 Photo courtesy of Galleria degli Uffizi, il Polo Museale Fiorentino

6. Central figure superimposed over drawing of Minerva

7. *The Soul of the World,* Robert Fludd, Utriusque Cosmi Historia, Oppenheim, 1617
 Photo courtesy of the Rare Books and Special Collections Division of the Library of Congress

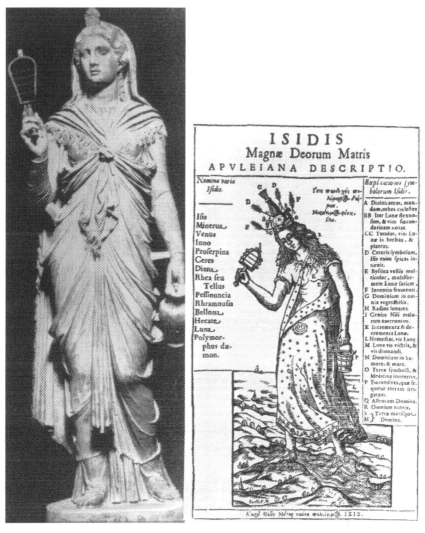

Figure 1 Figure 2

Figure 3

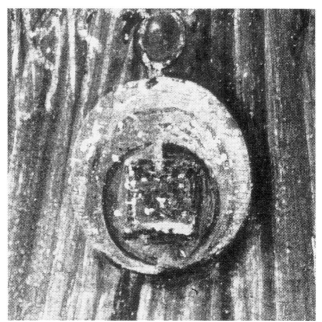

Figure 4

Figure 5

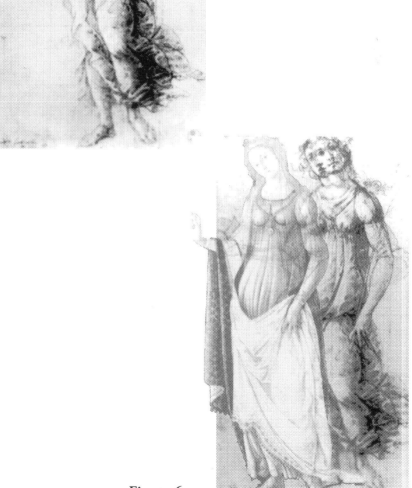

Figure 6

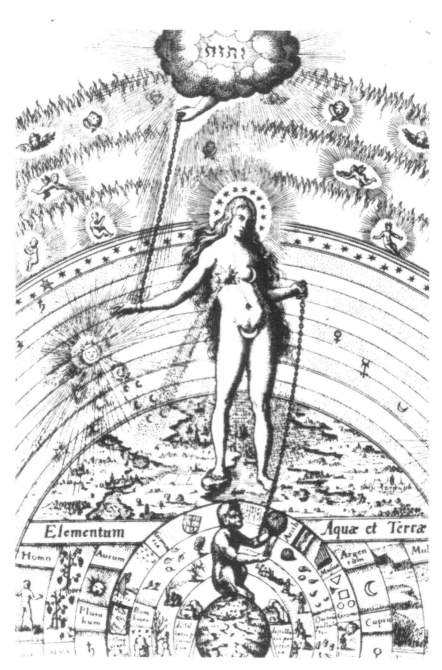

Figure 7

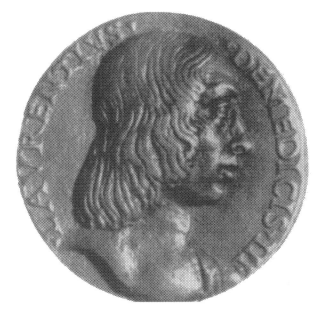

Figure 8

Figure 9

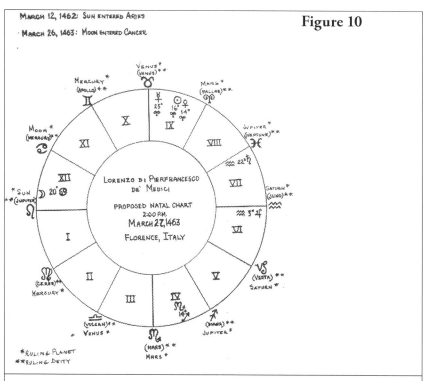

Figure 10

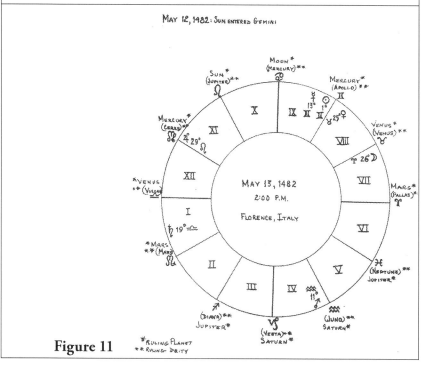

Figure 11

Figure 12

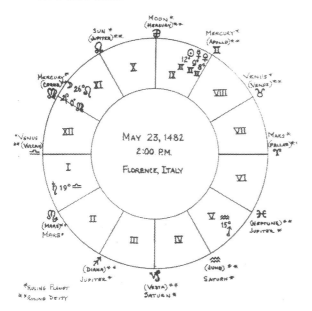

MAY 12, 1482: SUN ENTERED GEMINI

MAY 13: DAY OF MERCURY

MAY 23, 1482
2:00 P.M.
FLORENCE, ITALY

*RULING PLANET
**RULING DEITY

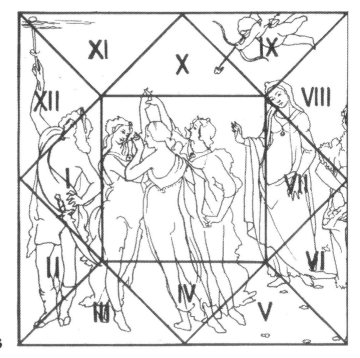

Figure 13

Figure 14

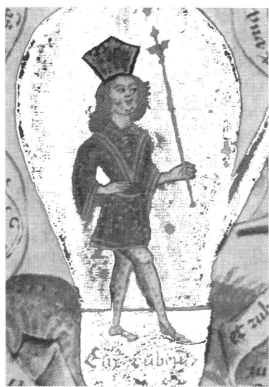

Figure 15

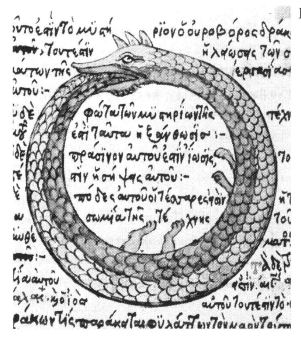

Figure 16

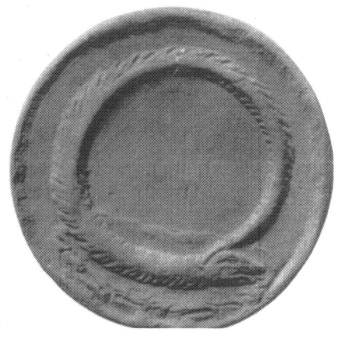

Figure 17

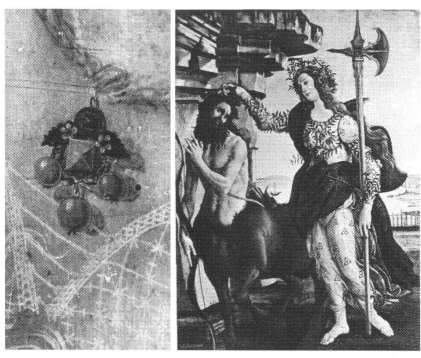

Figure 18 **Figure 19**

Introduction

The meaning of Botticelli's *Primavera*[1] has intrigued art historians since the late nineteenth century. Probably no other single painting has provoked more scholarly attention with less agreement regarding the possible sources of its program or its message. Scholars have not even concurred that there is a message to be found behind the solemn faces of its images or within its composition. Yet, it can be said that the very fact that numerous sources and stories have been offered to explain the painting's meaning strongly argues in favor of its containing a program that is both sophisticated and concealed. One has to ask why this particular work has proved to be so difficult to decipher and, apparently, so enigmatic. There does not seem to be one clear and simple answer to this question; on the contrary, several contributory factors need to be examined. Perhaps a clarification of them will suggest that a different approach to the analysis of Botticelli's famous painting must be found – one that can lead to a better understanding of its message.

One of the problems faced by art historians in their efforts to unravel the puzzle of the *Primavera* has been the lack of historical data about the work. Alessandro Filipepi, known as Sandro Botticelli, was practically forgotten after his death in 1510. He had no major commissions during his last ten years and his style apparently became unfashionable in the *Cinquecento*. Not until his rediscovery by mid-nineteenth century men associated with the Pre-Raphaelite Brotherhood–D. C. Rossetti,

A. C. Swinburne, John Ruskin and Walter Pater–did Botticelli's work again find an appreciative audience. By the end of the century, when his life and work were being considered seriously, the primary source to which scholars turned for information about him and his works was Giorgio Vasari's *Lives of Seventy of the most eminent Painters, Sculptors and Architects* (first published in 1550), which unfortunately is not completely reliable.

Vasari's often quoted passage on the *Primavera* merely comments on the existence of two paintings of female nudes, which he identified as Venuses and briefly described, that were then hanging at Duke Cosimo de' Medici's (1511-1574) rural villa at Castello. An excerpt from Mrs. Johnathon Foster's translation follows.

> For different houses in various parts of the city Sandro painted many pictures of a round form, with numerous figures of women undraped. Of these there are still two examples at Castello, a villa of Duke, one representing the birth of Venus, who is borne to earth by the Loves and Zephyrs; the second also presenting the figure of Venus crowned with flowers by the Graces; she is here intended to denote the Spring, and the allegory is expressed by the painter with extraordinary grace.[2]

Since Vasari provided no other salient facts to help historians, the patron of the *Primavera* and its original location were in dispute. Some scholars thought that Lorenzo il Magnifico was the patron of this painting, but in 1908 Herbert Horne hypothesized that the *Primavera* was commissioned by or for Lorenzo di Pierfrancesco de' Medici, the second cousin of il Magnifico, because Castello had been purchased in 1477 for this young man and his brother, Giovanni. Based on this evidence, Horne dated the painting to c.1478 when Lorenzo (1463–1503) was an adolescent of fifteen and Giovanni (1467–1498) was only eleven.[3]

In recent years, inventories have come to light that support Horne's view that the *Primavera* was done for this Lorenzo. Medici records

of 1498, 1503, and 1516 show that the painting was in Lorenzo di Pierfrancesco's house on the Via Larga in Florence during those years.[4] Perhaps this large and obviously important work could have changed hands and locations in the twenty years or so between the approximate date of its execution and the date of the earliest of these inventories, but such a notion seems unlikely. Therefore, until other evidence proves otherwise, it may be assumed that the *Primavera*'s original site was the Via Larga townhouse and that it was painted by Botticelli for Lorenzo di Pierfrancesco de' Medici.

These same inventories indicate that the painting was hung in an antechamber to Lorenzo's bedroom together with a painting that probably is Botticelli's painting known as *Minerva and the Centaur* and a large, costly, but unidentified and now lost tondo of a Madonna and Child.

These inventories may be taken as evidence of the *Primavera*'s original location and also as support for Horne's theory that the young Lorenzo was at least its recipient if not its commissioner. As such, they should provide clues to the interpretation of its purpose and meaning. Important though they may be, however, there is still no historical evidence or information regarding the painting's program or author–if, indeed, there was an author.

Another obstacle to determining the meaning of the *Primavera* has proceeded from the implications of art historical methodology. The iconological approach associated with Aby Warburg and Erwin Panofsky has been followed by most scholars who have investigated Renaissance paintings. The iconologist presumes a literary or philosophical basis for meaning in a work of art; therefore, he or she looks for textual passages that describe or correspond to the visual evidence and infers meaning from those passages.

However, because Renaissance humanists fostered a cultural and educational program that emphasized a thorough knowledge of the works of ancient Latin and to some extent Greek writers and philosophers and also promoted the writing of poems, commentaries, and rhetorical

works based on those authorities, there is an extensive body of literature that can be examined for source material.

In the case of the *Primavera*, some historians have looked to ancient works for passages that have seemed appropriate to its imagery; others have turned to the contemporary writings of members of the Neoplatonic circle that surrounded the Medici family, and still others have been eclectic in their choices of literary works.

The extent and variety of sources cited for the program of Botticelli's *Primavera* make it clear that no one has been or will be able to prove irrefutably that he has found the "right" passages. Unfortunately, even when the literary and visual correspondences are striking, they do not necessarily confirm that a correct interpretation of the content of the work of art has been determined.

Other possible textual sources for the *Primavera*'s program have been those that include *Quattrocento* aesthetic theories and artistic traditions. Certain concepts and instructions of Leon Battista Alberti (1404–1472) have been compared to Botticelli's stylistic characteristics in order to establish a direct influence from the one to the other. The publication of Alberti's treatise, *Della Pittura* (1435–36), which evidently followed his Latin version, *De Pictura*, was very popular and profoundly influential. That his theories affected Botticelli may be important for several reasons. Not the least of these is that they are appropriate to the iconological approach, for Alberti's treatises on the visual arts can be seen as compatible with and as contributions to the humanist movement of that time. One of his translators, John R. Spencer, has written, "By 1434 Alberti's literary and philosophical knowledge probably compared well with that of any young humanist."[5]

This emphasis upon "text as context" has had an interesting consequence for those who have offered interpretations of the *Primavera*. In their efforts to establish and support literary sources for the painting's program, some scholars have tended to ignore stylistic factors that may be important. Very little emphasis has been given to Botticelli's application of the formal elements and principles to the *Primavera*'s

composition, despite the fact that some critics have remarked on the painting's peculiarities.

Writing in 1938, Jacques Mesnil called attention to the mysterious qualities of this work, noting that the meaning of the composition has remained obscure over time. He asked, "What do these personages mean? Isolated or joined in little groups, each of them seems to live for itself, lost in a far-away dream from which it will never awaken. What means the vague gesture of that female whose head is so languidly inclined?"[6]

Similarly, in 1945 Ernst H. Gombrich referred to the "haunting character of Botticelli's physiognomies [that] not only permits but demands interpretations. These puzzling and wistful faces give us no rest until we have built around them a story which seems enigmatic expression."[7] Clearly, these writers were responding to some compelling quality that might account for the numerous and varied interpretations this painting has received. But Mesnil did not answer his own questions, and Gombrich did not explain the "haunting character" he perceived in the images. The viewer who also recognizes a peculiar "mood" in this work is left to ponder its nature and to wonder why no one has examined its cause.

The reactions of these two scholars suggest that something about this work interferes with or disrupts the viewer's aesthetic satisfaction and implies, in turn, that the mysterious quality of Botticelli's painting might be caused by an admixture of formal ingredients that have not been identified. This implies that a more careful formal analysis of the *Primavera* is in order.

Stylistically, this painting stands apart from other Renaissance works. Not only does it deviate from *Quattrocento* canons, it also does not fit comfortably into a developmental analysis of Botticelli's o*Beuvre*. Finally, it stands apart because it is strangely unsettling despite its grace and elegance. These observations are warning signs to the viewer: They suggest that the *Primavera* was meant to be different.

The following examination will explore the thesis that this famous fifteenth century painting is a unique expression of a specific message

intended for a particular occasion. Before this examination can be undertaken, it is critical that at least some of the important essays from the literature on the *Primavera* be reviewed. By doing so, one may determine which contributions still seem valid and which continue to pique interest. Such a review also may help explain why this work has been so difficult to understand yet remains so challenging. Finally, it should provide a foundation for looking at Botticelli's puzzling work anew.

1. The Literature on the Primavera

The earliest significant interpretation of Botticelli's *Primavera* was Aby Warburg's[8] "Sandro Botticelli's 'Geburt der Venus' und 'Frühling,'" originally published in 1893. This is a seminal work, since both its iconological methodology and its content have exerted a remarkably strong influence on later scholars' interpretations of the *Primavera*. Whether they have argued against Warburg's conclusions or have accepted his sources for the painting's imagery, no major contributors to the literature on this work have ignored Warburg's article. For this reason his study still warrants consideration.

Warburg sought sources for the imagery of both the *Birth of Venus* and the *Primavera* in contemporary as well as classical literature. In the case of the *Primavera*, two sources cited by Warburg generally have been accepted. The first is the description of the three Graces in Leon Battista Alberti's *Della Pittura*, which Warburg showed to be based on Seneca's *De beneficiis*, iii, 2-7.

> What shall we say too about those three young sisters, whom Hesiod called Egle, Euphronesis and Thalia? The ancients represented them dressed in loose transparent robes, with smiling faces and hands intertwined; they thereby wished to signify liberality, for one of the sisters gives, another receives

and the third returns the favor, all of which degrees should be present in every act of perfect liberality.[9]

Botticelli's Graces are not smiling, but it seems reasonable to accept the possibility that the artist took Alberti's advice, using the motif of the Graces in his painting for his own purposes. Also convincing is Warburg's contention that Botticelli used a passage from Ovid's *Fasti* in which the goddess Flora identifies and describes herself.

Come, Mother of Flowers, that we may honour thee with merry games; last month I put off giving thee thy due. Thou dost begin in April and passest into the time of May; the one month claims thee as it flies, the other as it comes. Since the borders of the months are thine and appertain to thee, either of the two is a fitting time to sing thy praises. The games of the circus and the victor's palm, acclaimed by the spectators, fall in this month; let my song run side by side with the shows in the circus. Tell me thyself who thou art; the opinion of men is fallacious; thou wilt be the best voucher of thine own name. So I spoke, and the goddess answered my question thus, and while she spoke, her lips breathed vernal roses: "I who now am called Flora was formerly Chloris: a Greek letter of my name is corrupted in the Latin speech. Chloris was, a nymph of the happy fields where, as you have heard, dwelt fortunate men of old. Modesty shrinks from describing my figure; but it procured the hand of a god for my mother's daughter. Twas spring, and I was roaming; Zephyr caught sight of me, I retired; he pursued and I fled; but he was the stronger, and Boreas had given his brother full right of rape by daring to carry off the prize from the house of Erectheus. However, he made amends for his violence by giving me the name of bride, and in my marriage-bed I have naught to complain of. I enjoy perpetual spring; most buxom is the year ever; ever the tree is clothed with

leaves, the ground with pasture. In the fields that are my dower, I have a fruitful garden, fanned by the breeze and watered by a spring of running water. This garden my husband filled with noble flowers and said, 'Goddess, be queen of flowers.' "[10]

It should be pointed out that Warburg did not apply the imagery of this passage to the other two figures included in the triad with the tall figure in the flowered costume, but cited the myth of Apollo and Daphne as more descriptive of them.[11]

For the primary source of the theme of the *Primavera* and the identification of its central figure, Warburg turned to the *Quattrocento* poet Angelo Poliziano, or Politian, a young intimate of the Medici circle who had written a poem to commemorate the 1475 tournament of Guiliano de' Medici, Lorenzo il Magnifico's younger brother. This poem, the *Stanze per la Giostra*, includes a reference to Venus and her followers, one of whom is a cupid with a flaming arrow. Believing that the painting had been commissioned by Lorenzo, Warburg concluded that this passage provided the inspiration for Botticelli's painting. However, no passages from the *Stanze* describe the *Primavera* in a literal fashion; therefore, Warburg's acceptance of Politian's poem as the source of the painting's theme has been very controversial. At the same time, many scholars have acknowledged some degree of influence from the Florentine poet's *Stanze*.

For example, Wilhelm Bode accepted Politian as the source of the painting's program and called the work an "anthem of the new faith of the joy of life and earthly existence; it depicts . . . the triumph of love that Spring awakens in all nature and quickens to redoubled vigor in men's hearts."[12] Jacques Mesnil was less certain of a direct reference to Politian's poem but conceded that if this is not the exact program, at least it can be reconstructed approximately with the help of antique texts and contemporary poems such as those of Politian.[13] Herbert Horne quarreled only with the use of the *Stanze per la Giostra* as the source of the central figure. "Although so large a portion of the

imagery of this picture of the 'Spring' has its counterpart in the imagery of the *Stanze* of Poliziano the conception of Venus, which forms the central idea of the painting, is not to be found in, nor explained by, the verses of Poliziano."[14] Lionello Venturi tried to solve the problem of reconciling the literary with the visual imagery. "The *'Primavera'* is a homage to Venus . . . who is surrounded by the Graces, Mercury, Cupid, Flora and the figure of Spring wafted by Zephyrus. Lucretius and Politian provided Botticelli with the motive not for an allegory but for a 'presentation of figures.'"[15]

Finally, in 1960, Erwin Panofsky wrote, "After Warburg's fundamental study . . . it can hardly be doubted that Venus is the heroine not only of the canvas which depicts her emergence from the sea, but also of the somewhat larger panel . . . which represents her gentle rule on earth; . . . and that what may be called the scenario of both compositions is largely determined by the ecphrases found in Politian's *Giostra*."[16]

No major departure from Warburg's thesis was made until Ernst H. Gombrich presented his study, "Botticelli's Mythologies," in 1945.[17] Gombrich accepted Horne's view that the *Primavera* had been commissioned not by il Magnifico but by or for his young second cousin, Lorenzo di Pierfrancesco de' Medici. In addition, he argued that the fifteenth century Neoplatonic philosopher Marsilio Ficino (1433-1499) had been involved in the commission of the work and was primarily responsible for its program, possibly with the assistance of two associates, Giorgio Antonio Vespucci and Naldo Naldi.

Ficino's connections with the Medici are well known. As the son of Cosimo de' Medici's physician, he had been brought into the family circle in 1459 by Cosimo, who commissioned the young philosopher to translate all and comment on some of the writings of Plato, in addition to translating the writings of other Greek authors. As the leader of the humanists associated with the Medici-sponsored Neoplatonic Academy, Ficino also served as a mentor to the young members of the Medici family during the second half of the *Quattrocento.* Ficino's mentoring of Lorenzo di Pierfrancesco would have developed after the

death of the boy's father, Pierfrancesco de' Medici, in July, 1476. His will, the first will written by a member of the Medici family, gave joint guardianship of his two sons, Lorenzo and Giovanni di Pierfrancesco, to their paternal grandmother, Ginevra Cavalcanti, and their two second cousins, Lorenzo il Magnifico and Guiliano de' Medici.

In her article, "Pierfrancesco de' Medici, 1430-1476: A Radical Alternative to Elder Medician Supremacy?" Alison Brown cites this stipulation in Pierfrancesco's will and then makes the following observation.

> At first their relationship seemed friendly enough Shortly after Pierfrancesco's death his young sons accepted Lorenzo's suggestion that they should buy Angelo della Stufa's farm at Castello because (they wrote to him): "we are certain you would not advise us in any manner contrary to our interests and that you would have no reason to harm us."[18]

These words of trust on the part of those two young boys give no indication of the bitterness they would feel toward their cousin in later years. In fact, it is this change in attitude that Brown uses to support her argument that it was their father's resentment over the way his uncle, Cosimo de' Medici, handled his finances that set the stage for the ultimate breach between the two branches of the family at the end of the century. Pierfrancesco's father had died when the boy was just ten years old; his uncle, as his guardian, controlled his inheritance in a manner that, as an adult, he would see as unfair. Brown further contends that the final disruption between the elder and younger Medici branches was due to the boys's conviction that il Magnifico also had handled their inheritance unfairly.

Nevertheless, during his adolescence, Lorenzo di Pierfrancesco was a part of his cousin's humanistic circle. As such, he not only would have been exposed to Marsilio Ficino's Neoplatonic teachings, but most certainly he would have been subjected to his counsel and advice.

Among the letters written by Ficino to friends and acquaintances, which have been preserved in the section of his *Opera Omnia* known as the *Epistolarium*, there are six directed to this Lorenzo. The earliest of these is undated, but Gombrich estimated that it was written during the winter of 1477-1478, when Lorenzo di Pierfrancesco was an adolescent of fifteen years of age. Its cautionary and advisory tone marks it as one written by a person of authority and responsibility. Gombrich hypothesized that this letter was a direct reference to the *Primavera*. Part of his translation follows.

> My immense love for you, excellent Lorenzo, has long prompted me to make you an immense present. For anyone who contemplates the heavens, nothing he sets eyes upon seems immense, but the heavens themselves. If, therefore, I make you a present of the heavens themselves, what would be its price?

Further on, the letter continues:

> The astrologers have it that he is the happiest man for whom Fate has so disposed the heavenly signs that Luna is in no bad aspect to Mars and Saturn, that furthermore she is in favourable aspect to Sol and Jupiter, Mercury and Venus. And just as the astrologers call happy the man for whom Fate has thus arranged the heavenly bodies, so the theologians deem him happy who has disposed his own self in a similar way. . . . My gifted Lorenzo, go forward to the task with good cheer, for he who made you is greater than the heavens, and you too will be greater than the heavens as soon as you resolve to face them.[19]

Ficino goes on to direct Lorenzo to "dispose" his own heavens according to instructions that include his attention to Luna, the Sun, Jupiter, Mercury, and Venus, who is called *Humanitas*. Gombrich's assessment of this letter is crucial to his interpretation of the *Primavera's*

content and theme, for it is apparent that his understanding of Ficino's intent influenced his exegetical direction. First, he evaluated the references to the planets as a rhetorical conceit. "The conception of the classical deities that we find in this letter from a humanist to Botticelli's young patron could hardly be more bizarre."

To explain Ficino's "bizarre" conception, Gombrich proposed that the philosopher had fused the two medieval traditions of moral allegory and astrological "lore," drawing up "a horoscope which is really a moral injunction."[20] As a result of this viewpoint, Gombrich finally concluded that the letter establishes the painting as a moral allegory directing Lorenzo di Pierfrancesco to follow the beauty of Venus toward love, virtues (such as refinement) and the divine. He dismissed the letter as a description of the work itself, stating that the *Primavera* "is certainly not an illustration of the philosopher's letter, nor would a moralized horoscope of this kind easily have lent itself to pictorial illustration."[21]

Satisfied that he had to look elsewhere for the source of the painting's program, Gombrich found it in *The Golden Ass*, or *The Metamorphoses of Lucius*, written in the second century C. E. by Lucius Apuleius Madaurensis.[22] This Latin romance probably was meant to be an allegorical autobiography of Apuleius's spiritual awakening and initiation into the cult of the Romanized Egyptian goddess, Isis, since Apuleius's protagonist, Lucius, undergoes such an initiation himself at the end of the story. Gombrich, however, disregarded the references to Isis and her cult and instead chose an episode from the novel that features the goddess Venus. Although he recognized certain difficulties with this episode, which recounts the Judgment of Paris, he may have been drawn to it because he accepted the central figure in the painting as Venus, whom Paris chose as the most beautiful goddess.[23]

Regardless, Gombrich justified his choice on the grounds that Apuleius's description of Venus and her train was simplified by Botticelli in accordance with Leon Battista Alberti's pictorial rule against the use of more than nine or ten figures in a painting. He also argued that the moral and mystical inferences that can be made from the

Roman author's account of Lucius's experiences would have appealed to *Quattrocento* humanists.[24]

The difficulties acknowledged by Gombrich cannot be ignored. If the Judgment of Paris as related in *The Golden Ass* were the source of the painting's program, one has to insist that Botticelli's lack of regard for Apuleius's text is baffling. It becomes incomprehensible when one considers Gombrich's demonstration of Ficino's involvement in the project and his own assessment of Ficino's attitude toward the visual representation of deities.

> To Ficino . . . it was an established fact that the attributes and appearance of the Gods revealed their real essence. It was as important to establish the authentic image of a god or a planet as to find its "true name." In both was hidden, for those who could read the esoteric language of ancient wisdom, the secret of their being.[25]

Clearly, this contradicts the depiction of the central figure whose appearance in no way conforms to Apuleius's description of Venus and in addition differs markedly from that goddess's traditional representation.

These problems do not minimize the importance of Gombrich's contributions to the literature on the *Primavera*. His essay reminds the modern reader that *Quattrocento* tastes included a fascination with witchcraft and magic, since both of these motivate the story and moral of the popular novel *The Golden Ass*. In addition, his research introduced letters from Ficino to Lorenzo di Pierfrancesco that indicate the philosopher's genuine concern for boy's emotional wellbeing and intellectual growth. This concern would have been the motivation for his developing a program for a painting that could affect the boy's future development through its detailed iconography and specific message. This is especially significant because it has persuaded scholars to pursue a line of inquiry that includes Ficino's influence on and/

or involvement in the commission and execution of the *Primavera*. Nearly all have acknowledged that Ficino's Neoplatonism is implicit in the painting's program. At the same time, many have been unwilling to completely dismiss Politian as a contributor to the content of the *Primavera* (Appendix I).

For example, Charles Dempsey, like Warburg, is an advocate of Politian's authorship of the *Primavera's* program. In the introduction to his monograph on the painting, *The Portrayal of Love*, he identifies the two dominant hypotheses that have been used to explain its meaning.[26] The first asserts that the painting's images derive from ancient poetry that influenced and was even imitated by the humanist poets of Lorenzo il Magnifico's circle, especially Politian; or, in other words, the model initiated by Aby Warburg. The second hypothesis is the Neoplatonic Model used by Gombrich, and here Dempsey includes Panofsky.[27]

Dempsey argues extensively against the second model, which is based on the Neoplatonic theories of Marsilio Ficino and his followers. He indicates that it may incorporate the poetic model, but, "[r]ather than growing naturally out of the poetry, Neoplatonic readings instead have been artificially superimposed on it . . . with the result that conjecture quickly parts company from the phenomena in the *Primavera*."[28]

Dempsey's own view is that the figure of Mercury is the key to the meaning of the *Primavera* because his designation as the god of spring is affirmed in the ancient Roman Agrarian calendar.[29] This, he believes, suggests that the painting belongs to a specific poetic genre, the *Carmen rusticum*, i.e., it is "a species of rustic song." With this in mind, Dempsey dismisses the Neoplatonic model. "To assume the Neoplatonic hypothesis is in effect to deny the poetic conception on which [the *Primavera*] actually depends as a hypothesis"[30]

But Dempsey's interpretation of Botticelli's famous work is not without its own flaws. In his original 1968 article on the *Primavera*, he identified Mercury as "a god of spring and the month of May." This, he wrote, defines "his relationship to the other principal springtime deities, namely Venus, Flora, Chloris, and the wind god, Zephyr or Favonius."

Dempsey based his interpretation on his belief that the *Primavera* had been commissioned for the rural villa at Castello, and therefore he accepted its subject as spring in accordance with Vasari's account. Thus, when he compared the painting's imagery to a sixteenth century engraving of *Spring*, which was one of a set of four illustrations of the seasons whose imagery followed the rustic Roman calendar, giving April to Venus and May to Mercury, he concluded, "The *Primavera*, destined for the rural villa of a Medici prince, is also based on the rustic farmer's calendar."[31]

Although Dempsey thoroughly revised and omitted much of his 1968 proposal in his 1992 monograph, he retained his original thesis that the ancient Roman rustic farmer's calendar establishes the theme of the *Primavera*, i.e., the rustic song of love. Why such a theme should be seen as appropriate for a painting apparently intended for a townhouse is puzzling, but there are more serious problems with Dempsey's astrological argument, and, since these have not been identified elsewhere, they may be examined here.

Dempsey implies that only the rustic farmer's calendar connected the month of May with Mercury and that Botticelli scholars have not understood this circumstance, leading them to seek other rationales for his presence in a painting of springtime. But this is misleading. In addition to the rustic or agrarian calendar, there was another ancient source that assigned "rulers" to the months of the year. That source, which Dempsey differentiated from the rustic calendar, is the treatise on "astronomy" written by the first century Roman astrologer, Manilius, whose influence during the Renaissance was established by Warburg.[32] However, in 1968 Dempsey implied that Manilius's assignments contradict those of the rustic calendar when he stated, "The Manilian calendar . . . gives May to Apollo and June to Mercury."[33]

In fact, Manilius did not give May to Apollo and June to Mercury; he gave the *zodiacal signs* of Gemini and Cancer to Apollo and Mercury, which is very different. More important, Manilius's list does not assign planets but *deities* as guardians over the signs of the zodiac. For example,

he gave Aries to the goddess Minerva, while, at the same time the ruling *planet* was (and is) understood to be Mars. To Taurus he gave Venus (coincidentally the ruling planet of that sign) and, as already noted, to Gemini he assigned the deity Apollo but the planet Mercury; Cancer was given to the god Mercury.[34] To say that the Manilian assignment of Mercury contradicts that of the rustic calendar represents a confusion of two different categories or kinds of rulers; the fact that Manilius give the guardianship of Gemini to the *god* in no way conflicts with the rulership of that sign by the *planet* Mercury.

Both the planetary rulers and Manilius's guardians were known to and accepted by Renaissance humanists. Of particular interest is the fact that the two lists appear in the writings of Marsilio Ficino.[35] Since his connection with the Medici circle is well documented, there could have been no misunderstanding among the members of that circle regarding these guardianships.

The distinction between sign and month is important because the calendar in use at the time of Manilius, as well as during the fifteenth century, was the Julian calendar. This differs from the modern Gregorian calendar because, in the Julian calendar, the sun enters each sign of the zodiac about ten days earlier than it does in the case of the Gregorian. For example, the sign of Aries, which today "starts" about March 21 or 22, used to begin around March 12.

Similarly, the sign of Taurus began in the second week of April, whereas today the sun does not enter that sign until the third week of April. In the Julian calendar, then, the signs of the zodiac fell almost one month "earlier" than they do today. This is important because it was to the zodiacal signs and not to the months that planetary rulerships were given.

It now becomes clear that references to rulers of *months* rather than rulers of *signs* can be misleading, for the associations between signs and months have changed with the change from the Julian to the Gregorian calendar. Indeed, Mercury the *planet* traditionally has been the ruler of the sign of Gemini; but a problem arises if one does not recognize that

today the sign of Gemini is associated with the month of June, whereas during the Renaissance that sign was virtually synonymous with the month of May. [36]

Therefore, the rustic farmer's calendar is not the only one that gives the planet Mercury to May. Nor is it necessary to turn to an ancient source to justify a connection between the *Primavera* and the month of May on account of the Mercury figure. If such a connection were intended by Botticelli, it would have been readily understood during the Renaissance without recourse to an esoteric, ancient authority.

One other problem emerges from Dempsey's interpretation of the *Primavera*. He used Flora's speech from Ovid's *Fasti* not only to account for the Zephyr-Chloris-Flora triad but also to support his belief that the subject of the painting is spring.

> Spring is shown in two phases; from its beginning with the blowing of the west wind (Favonius, or Zephyr) to its fullness in the month of April, represented by Venus; and from April to its end in May, presided over by Mercury[37].

Ovid clearly states that Flora is claimed by April as that month flees and by May as that month arrives. Indeed, the festival dedicated to Flora was celebrated from April 28 to May 3.

According to Ovid, spring began in March, reached its midpoint on April 25, and ended on May 13, when the sun entered the sign of Gemini and introduced summer. [38] Thus, the triad in the painting cannot be introducing spring, leading "to its fullness in the month of April, represented by Venus" (if the painting is read from right to left), for Flora already will have introduced the month of May by the time we reach the image of April's Venus. On the other hand, the notion that this strange group on the right side of the panel may have an iconographical significance in relation to the figure of Mercury, and that, together, they give the painting a temporal or astrological framework, should not be dismissed.

In his two-volume work, *Sandro Botticelli*,[39] Ronald A. Lightbown argued that the *Primavera* is a reference to the wedding of Lorenzo di Pierfrancesco to Semiramide d'Appiano in May, 1482 (Appendix I). Following his lead, Mirella Levi-D'Ancona accepted this thesis in her 1983 book, *Botticelli's Primavera: A Botanical Interpretation Including Astrology, Alchemy and the Medici.*[40] She also included an astrological interpretation along with the wedding throry. However, there are two essential problems with Levi-D'Ancona's astrological argument.

The first issue concerns her astrological interpretation, which is predicated on a misreading of the second of the six letters sent from Ficino to Lorenzo di Pierfrancesco.[41] The letter in question, dated October 18, 1481, was cited and translated in part by Gombrich in his study on the *Primavera* because of its reference to the three Graces. Levi-D'Ancona uses it because that reference transforms the Graces into personifications of three planets–Mercury (under the influence of Jupiter), Sol, or the Sun, and Venus–and she believes that Ficino intended this metaphorical use of the Graces to refer to the spring months that include May, when Lorenzo was scheduled to marry Semiramide.[42]

However, she has misunderstood the astrological meaning of Ficino's metaphor. First, she has assumed that the Florentine was referring to the planetary rulers of the months that constitute the season of spring. In fact, Ficino made it very clear that he was speaking of the wandering or transiting planets rather than the fixed constellations, for he goes on to say in this letter that both he and the adolescent Lorenzo found those planets in their ninth houses on the days of their respective births, a circumstance that gave them similar if not identical natures.

The second problem with Levi-D'Ancona's astrological reading lies in the fact that only two of the three planets cited by Ficino rule spring constellations; Venus rules Taurus and Mercury rules Gemini, but the sun rules the sign of Leo, which begins in the month of July. Still, the notion that the three Graces have an astrological significance need not be dismissed, especially when one recalls that Ficino's letter of c.1477–1478, like that of October 18, 1481, also includes astrological references.

In spite of these problems, the author has made some important contributions. She has pointed out that the marriage between Lorenzo and Semiramide evidently was postponed from May to July 18, 1482, presumably because of the death of il Magnifico's mother, Lucrezia, in March of that year.[43] She also has suggested that the Mercury figure should be identified as the groom in a marriage between him and the central Grace. This implies that he may be an allegorical reference to Lorenzo di Pierfrancesco de' Medici, an implication that is supported by the laurel trees, which can be a symbol of Lorenzo or "Laurence," and the representation of laurel leaves on the pommel of Mercury's sword, and by the sword itself, which Levi-D'Ancona has identified as an emblem of this Lorenzo.

In addition to her own text, Levi-D'Ancona included in her book three essays written by seminar students at Hunter College of the City University of New York: Barbara Gallati, John J. Petrizzo and Cheryl Wacher. These essays are well researched and contain valuable information on their respective subjects, but their methodologies have not allowed them to make direct or totally convincing applications of their conclusions to the *Primavera*. Gallati's article, "An Alchemical Interpretation of the Marriage between Mercury and Venus," is the most pertinent; and therefore deserves comment. [44]

Gallati has endeavored to give the painting an alchemical reading by equating the alchemical "marriage" between Sol and Luna to a relationship that she considers implicit between the images of Mercury and the central figure, Venus. She has extended the meaning of that union to the philosophical reading of alchemy, which sees the process (whereby a base metal is converted to gold) as an analogical or metaphorical allusion to the purification of the human soul following rites of initiation. This is consistent with alchemical writings, but she equates the alchemical "marriage" between Sol and Luna to a union between the painting's images of Mercury and Venus and then extends this equation to a metaphor for the wedding between Lorenzo di Pierfrancesco and Semiramide d'Appiano[45].

This interpretation is troubling, since it means that the mature central figure must be taken for a representation of–or at least an allusion to–the very young Semiramide d'Appiano. It is even more confusing when one turns back to Levi-D'Ancona's main text, wherein she proposes, like Lightbown, that the central Grace in the triad of nymphs is a reference to Semiramide. But, she also proposes that the Flora figure was originally a portrait of a certain Fioretta (who had been a secret paramour of Guiliano de' Medici) but was altered by Botticelli to resemble Lorenzo di Pierfrancesco's bride. Levi-D'Ancona offers this second Semiramide–the head of Flora as her portrait–without any explanation for the fact that it was not conventional for *Quattrocento* artists to paint three-quarter or full-face portraits of women (Leonardo excepted) Regardless, it seems that there is a surplus of Semiramides in the *Primavera* if Gallati's interpretation is accepted along with Levi-D'Ancona's theories.

The purpose of this brief discussion of some of the interpretations of the *Primavera* has been to identify those contributions that remain significant in light of current knowledge about the painting's first owner and its original site. The significant contributions that still stand may be summarized as follows.

First, Alberti's passage regarding the three Graces offers no real problems as the immediate source of Botticelli's triad, since, after all, it is descriptive and not iconographical in function. At the same time, it does not contribute to the meaning of the painting nor offer any information that might explain the role of the Graces or their purpose in relation to the painting's other images.

Next, the description of Zephyr, Chloris and Flora from the fifth book of Ovid's *Fasti* accords exceptionally well with Botticelli's images. Generally, it has been accepted as their source. Nevertheless, here there is a problem, because Ovid's passage is not only descriptive but also has iconographical implications. In the context of the painting, the simplest and perhaps most convincing view of this triad would see it as a time signifier, indicating the beginning of the month of May. Should this be

the function of the three figures on the right side of the panel, one must conclude that the *Primavera* was given a specific temporal denotation that argues against an abstract, timeless program.

Despite the problems cited in Gombrich's interpretation of the painting, the close connections among Marsilio Ficino, Botticelli, and Lorenzo di Pierfrancesco, which are implicit in Gombrich's reading of the *Primavera*, argue in favor of the philosopher's involvement in its program. Ficino's letters to Lorenzo and his role in relation to the members of the Medici family are solid evidence of his authority and influence, which, in turn, make his participation in the commission of this work likely. It is well known that the young Lorenzo became one of Botticelli's most important patrons; thus, it is entirely possible that their association began with the *Primavera*. If one accepts the notion that the function of the Zephyr-Chloris-Flora triad was to establish a temporal context for the message of the painting, then Ficino's astrological allusions in his early (c.1477-1478) letter to the young Lorenzo may not be so bizarre after all.

Lightbown's suggestion that the painting was done to commemorate Lorenzo's 1482 marriage to Semiramide d'Appiano cannot be dismissed. While this reading of the painting's purpose seems to contradict the notion that Ficino's letter is a reference to the work, or that Ficino had a significant role in its program, it tends to confirm the temporal role of the Zephyr-Chloris-Flora triad.

Finally, the author of the botanical interpretation of the *Primavera*, Mirella Levi-D'Ancona, has introduced a serious consideration of astrological and alchemical elements.

In spite of the breadth of research and the depth of analysis that have been devoted to Botticelli's famous *Primavera*, there remain unanswered questions. Why, for example, does the central figure wear a costume that is unorthodox for a Venus figure? Why does Mercury turn his back to the other figures? Do the Graces play an astrological role and, if so, how does that affect or involve the other images in the painting? And, why is the cupid figure blindfolded?

Despite these provocative questions, perhaps the most compelling one concerns the "haunting" quality that several scholars have perceived in this work, unlike other paintings by Botticelli. If one assumes an artistic intention behind this characteristic, what can be its cause and what is its significance?

II. Compositional Analysis

A few scholars have noted a mysterious quality that seems to pervade the *Primavera*. Some have even remarked on the painting's composition. For example, almost ninety years ago, Bode wrote the following: "The deeper we penetrate into the artistic qualities of the picture … the keener grows our need to fathom the significance of the scene, the coherence of the strange composition, and the occasion of its origin."[46]

Jacques Mesnil was more poetic about the painting's setting.

> This is a vision of a higher world that Botticelli tried to render, a world where Beauty would be queen. It is a dream where memories of the most beautiful impressions of life mingle with images suspended in a wonderful time now past, and evocation of splendors that are no more, made by a soul filled with the desire to create novel things.[47]

Bode and Mesnil were not the only ones to notice the strange world depicted in the *Primavera*. The editors of Mrs. Foster's translation of Vasari's *Lives* attributed the painting's confusion to Botticelli's use of color.

> The composition of lines is admirable, but like so many Florentine works of the fifteenth century, the *Primavera* can hardly be said to have any color composition at all, the carmine

drapery (with whitish lights) upon the central figure and upon the Mercury at the extreme left being much the strongest points of color, and confusing and breaking up the composition. The Graces are all in a golden ochre tone, the shadows little darker than the lights. All of the right-handed part of the picture is grayer than the rest, and the figures there are more "enveloped."[48]

Although this seems harsh after the recent cleaning of the work, these critics have correctly observed that Botticelli's color composition tends to separate the images on the left section of the panel from the Flora-Chloris-Zephyr triad on the right.

Other writers have discussed the illusion of depth in the *Primavera*. In 1908, Horne recognized the painting's unusual composition and likened its space to that seen in medieval tapestries. "For the composition of the picture there is no precedent. The figures move over the background like the figures in a tapestry."[49]

Fifty years later, Roberto Salvini stated that the painting exhibits a "relaxed" three-dimensional perspective plot.[50] These two comments acknowledge that the *Primavera* is conspicuous for its flat linearity and decorative quality and for its overt denial of space-distance.

Despite these observations, no recognized scholar has made an effort to analyze the pictorial oddities of the *Primavera* on the basis of its formal components. Perhaps the reason for this lies in the assumption made by some art historians that, in general, all Botticelli's art deviates from *Quattrocento* pictorial conventions and rules, in which case the *Primavera* is not really an exceptional painting with stylistic anomalies that set it apart from his other works or otherwise warrant special attention.

Lionello Venturi concluded that Botticelli had his own peculiar style that stood apart from the contemporary mainstream. "Neither the draftsmanship nor the modelling nor the colouring nor the composition of Botticelli can be said to conform to the so-called laws of art which are nothing else but conventions derived from so-called classical art…"

Seeing this artist as a "primitive," Venturi suggested that one "should not try to discover the merits and defects of Botticelli but to understand his personality."[51]

In the first edition of his text, the *History of Italian Renaissance Art*, Frederick Hartt described Botticelli's style as "anti-atmospheric, anti-scientific…[and] strongly colored by his own neurotic personality… Unlike that of Piero [della Francesca], Botticelli's perspective space is fragmentary, dreamlike, and even when it seems real, its very reality is only the surreality which torments us in dreams."[52]

Both these writers predicated their assessments on the presumption that Botticelli was emotionally disturbed and that, as a result, his art presents an illogical world that is antithetical to the rationality of fifteenth century art. It is true that Vasari described Botticelli as "restless," and there are anecdotes about Botticelli that make his behavior seem eccentric; but the extent to which Botticelli's personality informed his art is difficult to determine because of the paucity of reliable data. More important, whether or not it did affect his style has no bearing on his mastery of the "rules" of Renaissance art. In fact, the visual evidence of his art argues that Botticelli had learned his craft and the contemporary conventions well; several historians have demonstrated that this was so.

Aby Warburg cited Alberti's description of the three Graces in his treatise, *Della Pittura*, as the source for Botticelli's rendition of them in the *Primavera*. Recently, Lightbown expanded on Alberti's influence on the artist, quoting the entire passage that refers to the Graces and stressing the way Botticelli followed it by showing even the effects of wind and motion in the painting.[53] Elsewhere, Lightbown commented on Botticelli's knowledge of contemporary concerns in art. "We know from the internal evidence of his pictures that he… read and carefully digested Alberti's treatise on painting, the *Della Pittura*, a manual recommending all the most progressive notions of the early Renaissance."[54] In reference to the Berlin *St. Sebastian* (1474), he observed, "The structure of bone and muscle that underlies the flesh is emphasized to display Botticelli's knowledge of anatomy."[55]

One can verify Lightbown's observations by examining Botticelli's paintings. Linear perspective, consistent lighting, detailed and accurate observations of nature–all are hallmarks of his style. His obvious taste for a strongly designed art based on contour and shape does not allow for sculpturally modeled forms or tonal mutations; but Botticelli may have avoided that style in response to his patron's preference for a decorative art of courtly elegance and refinement. Or, he may have considered that kind of art out of fashion. Botticelli's master, Filippo Lippi, had himself abandoned such a style, which he had learned from Masaccio, for one based on clarity of line and color. This clarity marked his mature style, before Botticelli joined his workshop.

Clearly, then, Botticelli was very much aware of the theories and practices of his time; and, just as clearly, he was an accomplished, knowledgeable, and popular artist who enjoyed an enviable reputation. The evidence does not support the notion that his art was thought to be outside the mainstream, peculiar, or "surreal."

The *Primavera* does have the linear quality for which Botticelli is famous, and it features certain personal mannerisms, such as the drooping right eye on the three-quarter view of the central figure's head and her inordinately long arms. However, these characteristics do not differentiate this painting from his other works.

What makes this painting unique is its space-distance. Even a cursory examination reveals that Botticelli completely ignored–or chose not to employ–the *Quattrocento* systems for depicting the third dimension: specifically, linear and/or aerial perspective.

In the *Primavera*, the absence of linear perspective is obvious, since there is no horizon line in the painting, nor are there any right-angled objects from which orthogonals might be projected in order to establish one. Furthermore, Botticelli did not employ aerial or atmospheric perspective. Behind the trees are patches of a light-blue plane that have only the slightest tonal variations; consequently, these patches are parts of an essentially flat, two-dimensional area, rather than indicators of an atmospherically gradated sky. The painting hints at the existence

of a landmass between the trees on either side of the Mercury figure, but these vague references are not large enough to effect a convincing space-distance.

Botticelli's rejection of both linear and aerial perspective could be understood as whimsical, were it not for the fact that he substituted spatial devices that must have been considered old-fashioned during the fifteenth century. For example, the ground plane, which appears to be enclosed by a copse, is strewn with flowers, all of which are clearly described as though in sharp focus. Further, the flowers show no diminution in size, which might imply recession in space. Since the ground itself lacks the tonal gradations that would be consistent with aerial perspective, this presumably horizontal plane seems to rise vertically. Were it not for the assumption that eight of the painting's figures are standing on solid ground, this area could be seen as a vertical drop. It is not surprising that Horne likened the *Primavera*'s background to a tapestry, for the spatial treatment of this painting is like that used by medieval designers of that art form.

Botticelli used another archaic device. The central figure is elevated above the other seven standing figures, suggesting that her position is behind the other images. This interpretation is in keeping with the ancient spatial convention that intends higher figures to be seen as more distant than those in a lower position on a vertical plane. However, Renaissance artists knew that the heads of figures in the distance appear to be level with the heads of figures nearest to the viewer or, in other words, on the viewer's own line of sight. The farther away from the viewer (or the closer to the horizon line) figures stand, the shorter will they appear, but since it is the ground plane that seems to incline upward toward the horizon line, the figures' feet appear higher; the eye level of all the figures will remain relatively constant.[56]

Thus, the tapestry effect of the ground area is enhanced by the use of this obsolete convention, which describes space-distance as rising on a vertical plane. In contrast to the Renaissance view of space-distance, which is dependent on a horizontal ground that implies an extension of

the viewer's real space, vertically-based conventions actually assert the two-dimensional surface of the painting and cannot suggest a logical extension of the viewer's space into the third dimension.

The use of these conventions must have been intentional. Therefore, the fact that Botticelli pointedly chose to use them mandates this conclusion: The realm depicted in the *Primavera* is not supposed to be an extension of the viewer's own earthly realm; the viewer is expected to see or experience another, almost completely two-dimensional environment.

This conclusion is supported by other observations. First, the eye follows a lateral movement across the painting from right to left in a way that contradicts a sense of recession into the distance. With seven figures on the frontal plane linked by the curvilinear shapes and directional lines of their poses and gestures in a rhythmically descending, turning and rising movement, one never is invited to see beyond this surface or to imagine any landscape that might stretch into the distance behind the copse that defines the painting's shallow space.

Botticelli controlled the lateral movement in the painting by means of strategically placed and decisively articulated verticals. The composition is not really symmetrical, but there is a central axis formed by the cupid and the central figure that controls the balance of the painting so that it seems symmetrical. This axis and the strong vertical of the Mercury figure stabilize the composition and punctuate the almost palpable rhythm that otherwise would sweep across the panel.

Here Botticelli's choice of color is critical. He gave emphasis to these two verticals, i. e., the central figure and Mercury, by dressing both figures in red garments. Nor should it go unnoticed that the mantle of the central figure, which she holds across the lower part of her body, falls in folds that repeat the lines of Mercury's chlamys-like robe.

Other oddities contribute to the strangeness of this composition. Some of the figures exhibit anatomical distortions that go beyond the artist's personal idiosyncrasies. The sharp, disjointed angle of Zephyr's left shoulder, his awkwardly short left arm and abruptly bent head are difficult

to accept as stylistic mannerisms. The figure of Flora is noticeably taller than any of the other figures in the painting. Her extremely attenuated legs give her a height that looks Amazonian next to that of the central figure. That these two images are side by side accentuates their very different proportions, and, next to Flora, the central figure's unusually long torso and arms take on a simian-like character. As inexplicable as these distortions seem, they are essential to the painting's lateral rhythm and to the viewer's experience of a flat, unapproachable world.

Another observation that supports the conclusion that the *Primavera* was intended to be seen as a two-dimensional realm rather than as an extension of the viewer's space lies in the fact that all the standing female figures seem to float. The figures convey a lack of solidity, partly because Botticelli minimized corporeal modeling and did not depict cast shadows. In addition, he did not permit these ethereal ladies to plant their feet firmly enough on the flower-strewn area of dark green to carry the weight of their bodies. In fact, the law of gravity suggests that the Chloris figure is falling forward and that the weight of both Flora and the left Grace must be carried on the balls of their feet; yet these appear to skim the surface of the leafy plants and do not seem to support any weight at all.

In comparison, the position and placement of Mercury on the far left of the panel are curious. His back is to the other figures in a way that makes him seem unaware of them; he is separate and self-contained. He, alone of all the standing figures, is situated firmly and solidly with his body's weight carried by his left leg. The only suggestion of a landmass in the painting consists of provocatively meager glimpses beyond the copse, on either side of his figure. Finally, one has to wonder why Botticelli permitted this image to destroy the symmetry of the axially balanced composition.

The two-dimensional space with its lateral movement, the anatomical distortions, and the imbalance of the painting's composition are all deviations from *Quattrocento* principles of pictorial art. Taken singly, any of these might not seem remarkable; together they constitute a

concurrence of aberrations that is incomprehensible in a major work by a proven and popular master.

At the same time, only the creative skill of a Botticelli could have made this strange composition acceptable and even believable. The recent cleaning of the painting reveals beautifully juxtaposed areas of light and dark and a very carefully chosen color scheme that plays soft reds, golds, and flesh tones against shimmering mother-of-pearl whites. The sweetness of these ice cream colors is tempered by the grayed greens of foliage and ground cover, and over all are sprinkled crisp blue, pink, and yellow flowers and spiky-shaped leaves of green myrtle and laurel. This decorative texture heightens a viewer's awareness of the undulation of wavy hair, fluttering drapery, and precious poses.

Shape, value, color, line and texture have been used to create a concoction of such visual delight that one may not notice the absence of the illusion of mass and deep space. One wants to ignore the anatomical distortions, which threaten to make monsters of these ethereal beings, and to forget that the painting's balance is precarious.

The unusual space of the *Primavera* would seem to be a deliberately designed environment for images meant to be seen as unearthly and without corporeal substance, images that would not and could not exist in the Renaissance world of linear and aerial perspectives, which Botticelli ordinarily depicted. These are creatures who belong in a heavenly realm of the stars, like Mesnil's higher world, "where Beauty would be queen."

III. The Central Figure

All scholars of the *Primavera* have made assumptions about it that were fundamental to their interpretations of its content. As noted above, one of these seems to be that this work is stylistically consistent with Botticelli's *oeuvre,* for, until now, no one has argued seriously that the flattened space or the anatomical distortions of the figures are deviations from his other works or from *Quattrocento* ideals.

Another assumption is more critical, because it has determined the *Primavera*'s basic theme. Regardless of variations resulting from the selection of different source materials, all major interpretations of the painting have identified its theme as love, in one or another of its forms. Whether it has been the unrequited love of Guiliano de' Medici, a Neoplatonic concept of ideal love, the choice of Venus by a smitten Paris, or the marital bond between Lorenzo di Pierfrancesco and Semiramide d'Appiano, love has been seen as the *raison d'être* of the *Primavera*.

This is not surprising, of course, since the central figure of the painting always has been accepted as Venus, the goddess of love. Yet, this acceptance has not been based on firm substantiation. Indeed, there are several reasons why this image may *not* be Venus. For example, her costume, her Madonna-like demeanor, and her apparent pregnant condition are inconsistent with the traditional representations of the goddess of love.[57] There is no recognized scholarship citing a single

written description of such a Venus figure, or any literary source that might support the notion that the main figure in the *Primavera* is Venus. Finally, no documentation exists that firmly establishes either the title of the work or its subject matter. The only source that can be cited in defense of identifying the central figure as Venus is Vasari's reference to the two paintings by Botticelli that, in the middle of the sixteenth century, were hanging at the Duke's country villa at Castello. One of these he describes as "the birth of Venus, who is borne to earth by the Loves and Zephyrs." Having indicated that both paintings were among those in which Botticelli showed nude female figures, he described the second one, presumably the *Primavera*, as a painting of "Venus crowned with flowers by the Graces; she is here intended to denote the Spring."[58]

While no one has missed the obvious discrepancies between Vasari's descriptions of a nude Venus in the second of the two paintings that were then at Castello and the actual appearance of a clothed figure in the *Primavera*, at the same time no one has considered the possibility that Vasari (who probably never saw the painting) miscalled the identity of its main figure. The presence over her head of a baby with an arrow–a cupid figure–undoubtedly has been sufficient to allow Vasari his identification of the figure.

Since the paintings were not hung together originally; and since now it is generally accepted that the subjects and/or the patronage of the two works probably are not related; and, further, that Vasari's description of the main subject in a painting presumed to have been the *Primavera* is clearly erroneous, surely it is possible to question his identification of that figure. Despite the winged babe, then, perhaps the central figure in the *Primavera* was never intended to be Venus.

The importance of this figure's identity cannot be overestimated. Not only has her name controlled the scholarship on this painting for over a century, but also the identities of the other figures are seen in relation to her, and, as such, are dependent upon her identity. It is for this reason that her image and identity must be analyzed first; only

then will there be a context against which to further examine the compositional and stylistic peculiarities of the work and determine the nature of its program.

It is apparent that the main figure in the *Primavera* does not bring to mind any of the goddesses well known in the *Quattrocento*. She carries no attributes and wears nothing that immediately strikes the viewer as iconographically significant. Nor does this seem to be a portrait; her costume is not of the Fifteenth Century, and she is not seen in the conventional profile pose that is associated with *Quattrocento* portraiture. The fact that she cannot easily be identified suggests that this was intentional. In other words, if it is assumed that this figure *is* a goddess because of her authoritative position and control of the composition, then she must be a female deity whose powers and functions are not intended to be specific to any one goddess. Such is the role of the supreme goddess in Apuleius's novel.

Gombrich's selection of the episode of the Judgment of Paris from Apuleius's *The Golden Ass* or *The Metamorphoses of Lucius* as the source of the *Primavera*'s program has already been cited (see above, p. 13). In the next part of the novel, Book XI, Apuleius tells of Lucius's encounter with the goddess Isis, who would be responsible for his transformation back to human form from that of an ass, and his subsequent conversion to the worship of that goddess.

This is not a section that would have alerted Gombrich, because he was under the impression that the *Primavera* was commissioned for the villa at Castello and was intended to be a companion to the *Birth of Venus*. Thus, he did not question the central figure's identity as Venus. Indeed, Gombrich clearly exaggerated the role of Venus in Apuleius's novel and undervalued that of Isis, for he wrote that Lucius's story "is the tale of human degradation and salvation. The Goddess through whom Lucius's salvation is wrought, and who finally restores him to his 'humanities,' is not Venus but is, rather, Isis. As she appears to Lucius in a vision, slowly rising from the sea with the attributes of Isis, she proclaims herself the mother of nature, the mistress of the elements"[59]

During the Renaissance, Isis, the ancient Egyptian moon goddess, may have been less popular than the more familiar divinities from the Greco-Roman pantheon. However, among educated Florentines, she was indeed known and thus could have been the deity that governs Botticelli's painting. In fact, she is a likely candidate for this role, partly because Apuleius's written description of her bears a remarkable similarity to the image in the *Primavera*, but also because he attributes to her the overriding and all-consuming identity of a moon goddess under whom all other moon goddesses were subsumed.

The section in which this goddess is described is introduced with Lucius's complete demoralization, for, as an ass, he had been chosen to fornicate publicly with a convicted murderess. While this act was intended to be her punishment before she would be devoured by a hungry lion, Lucius, who retained his human feelings and sense of propriety, considered his role in this punishment to be personally humiliating, and he was determined to escape before he was forced to participate.

Since he was not being carefully watched, Lucius was able to elude his guards and gallop six miles to Cenchreae, a safe harbor near Corinth. Exhausted, he fell asleep in a cove by a secluded beach, only to be awakened by a dazzling full moon that was rising over the water. After purifying himself by dipping his head in the sea seven times, he prayed to the goddess of the moon, addressing her as *regina coeli*, or "queen of heaven," and beseeching her to to restore him to human shape or else permit him to die. He returned to his cove and fell asleep but was awakened almost immediately by a vision of a lovely woman, described by Apuleius as follows:

> First, her abundant, long hair, gently curled over her divine neck or loosely spread, streamed down softly. A crown of many designs with all kinds of flowers had girt her lofty head; in its centre a flat disk above the forehead shone with a clear light in the manner of a mirror or indeed like the moon, while on its

right and left it was embraced by coils of uprising snakes; from above it was adorned also with outstretched ears of corn. Her tunic too was of many colours, woven entirely of fine linen, now bright with a white gleam, now yellow with saffron hue, now fiery with roseate ruddiness. But what most of all overwhelmed my sight further was the cloak of deepest black, resplendent with dark sheen; it went round her, returning under the right side to the left shoulder, a part of the garment being draped in the manner of a knot; and hanging down with many folds, the whole robe undulated gracefully with tasseled fringes to its lowest edges.

Along the embroidered border and in the very body of the material there gleamed stars here and there, and in their midst a half-moon breathed a flame of fire. But wherever the sweet of that magnificent mantle moved, a wreath garlanded of all manner of flowers and fruits was indivisibly joined to it. The things she carried were of quite varied kind. For in her right hand she bore a bronze rattle in which a few rods in the middle, thrust across a thin sheet of metal that was curved like a belt, emitted a tingling sound when the arm made three quivering jolts. From the left hand then there hung a golden vessel on whose handle, where it was conspicuous, there rose a serpent which reared its head high and puffed its neck thickly. Her ambrosian feet were covered by sandals woven with leaves of victorious palm.[60]

She addressed Lucius, identifying herself:

"Lo, I am with you, Lucius, moved by your prayers, I who am the mother of the universe, the mistress of all the elements, the first offspring of time, the highest of deities, the queen of the sea, foremost of heavenly beings, the single form that fuses all gods and goddesses; I who order by my will the starry heights

of heaven, the health-giving breezes of the sea, and the awful silences of those in the underworld; my single godhead is adored by the whole world in varied forms, in differing rites and with many diverse names.

"Thus, the Phrygians, earliest of races, call me Pessinuntia, Mother of the Gods; thus the Athenians, sprung from their own soil, call me Cecropeian Minerva; and the sea-tossed Cyprians call me Paphian Venus, the archer Cretans Diana Dictynna, and the trilingual Sicilians Ortygian Proserpine; to the Eleusinians I am Ceres, the ancient goddess, to others Juno, to others Bellona and Hecate and Rhamnusia. But the Ethiopians, who are illumined by the first rays of the sun-god as he is born every day, together with the Africans and Egyptians who excel through having the original doctrine honour me with my distinctive rites and give me my true name of Queen Isis."[61]

Lucius's queen of heaven and goddess of the moon who was known by many names, here identifies herself as Isis, a deity who enjoyed widespread popularity in Apuleius's day with even more power and prestige than her consort, the Egyptian god, Osiris.[62] Yet, it is significant that, even as Apuleius signified that she is Isis, he did not reject the other manifestations by which she was known. The description of Isis is comparable to Botticelli's painted image. Botticelli omitted the specific attributes that are included in the Roman's account–perhaps purposely– for his central figure does not carry a bronze rattle in her right hand or hold a vessel with a serpent in her left. However, other variations are minor, especially when Botticelli's figure is compared to visual images of the Egyptian goddess. Two examples may be cited: a Roman cult statue and an illustration from a seventeenth century alchemical treatise. These two examples span the centuries–at least 1500 years–demonstrating that the image of Isis had a long pictorial tradition. In both, the costume, stance and arm positions are almost identical. These are echoed in the *Primavera* (Figs. 1 and 2).

It is true that Botticelli did not depict the elaborate headdress seen in the seventeenth century illustration and described by Apuleius, but the sculptor who was responsible for the Roman cult statue omitted it as well. On the other hand, the painter gave his figure a golden veil adorned with a round disc that is in accordance with Apuleius's description. The golden serpentine ornamentations that dangle from the yoke of her dress could have been the artist's way of showing Isis's attribute of the snake.[63] The colors of her clothing are close to Apuleius's account, for the painter used the "white gleam," the "saffron hue" and the "roseate ruddiness" mentioned by the writer. Further, the color of her mantle corresponds to the lustrous, deep black that caught Lucius's eye. Even the border of the mantle has the decorative detail and tasseled fringe described in Apuleius's text: the hem carries a motif that seems to be a compromise between the writer's glittering stars and the flowers seen on the mantle's border in the illustrations.

Finally, support for the notion that the main figure in the *Primavera* was intended to be an image of a universal moon goddess or queen of heaven lies within the painting itself. Botticelli carefully adorned her with the primary attribute and symbol of the goddess's essential nature, the crescent moon (Fig. 3).[64]

Until now, no one has carefully investigated the medallion that lies between the figure's breasts. It consists of a lunar crescent surrounding an earth-red stone that has a rough, undefined surface. It is an unusual ornament, but its very peculiarities are associated with Isis. First, the crescent is not silver, the traditional metal of the moon, but instead, it is gold. Careful consideration of the painting's light source may explain the reason: the medallion lies along a path of light whose source, presumably the sun, is outside the painting on the left. Since the medallion is in a position to reflect the light of the sun, it appears golden. Iconographically this indicates that the feminine moon reflects or incorporates the sun's masculine light. By extension, the central figure, as a goddess of the moon, is imbued with the light of the "masculine" sun. This agrees with R. E. Witt's comment on the goddess Isis: "From her springs the

light of the sun."[65] The *Primavera*'s central figure, therefore, represents the essence of creativity; she is Nature, universal mother and goddess of the moon.

The golden color of the crescent-shaped medallion may be a reference to the apparent pregnancy of the *Primavera*'s main figure. A pregnant Venus is incomprehensible; but a pregnant moon goddess is wholly consistent with her universal maternalism. Imbued with the sun's light, she, figuratively speaking, has been impregnated by the male principle. This may be understood as the meaning behind Witt's words, which suggest that the moon must continuously reflect, or regenerate, the light that informs her.

This same notion is implied in the seventeenth century illustration of Isis, which shows her with the same type of moon on the lower part of her abdomen. Here the crescent encloses the letter H. According to the key accompanying this picture, that letter denotes "lunar rays." It is tempting to see this as an allusion to Horus, the son of Isis and the personification of the rising sun in Egyptian mythology, because lunar rays are, indeed, reflections of the sun's light from the moon's surface. In fact, during the Greco-Roman period, Horus's identity was conflated with that of Apollo, the Greek god of light and the sun's charioteer, so that he came to be known as Horapollo.[66] Thus, Isis's reflection of the sun's light could refer to the son to whom she gave birth, the personification of the solar body.

Most important, the unusual shape of Botticelli's medallion is identical to that of the crescent shown in the alchemical illustration. Not only does this particular kind of moon specifically identify the Egyptian moon mother, Isis, but Botticelli's version encloses a rectangular stone that is similar in outline to the letter H in the illustration. Since it is red in color, it could carry a meaning that corresponds to that of the letter, "lunar rays." In that case, both the stone and the letter could be understood as consistent with Apuleius's written description of the half-moon worn by Isis, his goddess, which "breathes a flame of fire." It is also striking that this crescent moon is shown in an another alchemical

illustration in which the moon encloses a "flame of fire" that, although in black and white, may be interpreted as being red like the stone of the central figure's medallion (Fig. 4).

Therefore, while it may have been sufficient to present Apuleius's written description along with the visual evidence of the cult statue and the alchemical illustration in support of the notion that Botticelli's central figure is a universal moon goddess, one need not rely on the similarities of costume, stance, and arm positions alone. The crescent medallion is a specific clue to the identification of the central figure in the *Primavera*: This interpretation clearly denotes this image as a goddess of the moon who is more closely allied with a benevolent, maternal Isis than with a conventional Venus of the garden.

It is apparent that the foregoing discussion of Botticelli's main figure, which likens her clothing to that described by Apuleius and that depicted in visual images of the goddess Isis, intends to challenge the traditional acceptance of this image as Venus. This, in turn, implies that the program of the *Primavera* was not based on a "poetic/love" hypothesis, to borrow Dempsey's terminology. In fact, there are other reasons for questioning a theme of love as the program for Botticelli's famous painting.

First, it should be recalled that the poetic/love model dates back to Aby Warburg, who believed that this painting, along with the *Birth of Venus*, was commissioned by Lorenzo de' Medici for his country villa. Since it is now known that the painting was commissioned by or for his young cousin, Lorenzo di Pierfrancesco, for his town house in Florence, the theme of love in a garden makes little sense. And, considering the worsening relationship between il Magnifico and his cousins during those years, the elder Lorenzo's participation in or support of the commission of the *Primavera* seems unlikely.

Next, if Gombrich's contention that Marsilio Ficino authored the program of the painting is indeed correct, his very role as the young Lorenzo's mentor would argue against his choice of a somewhat frivolous theme of poetic/love for a major painting intended for a teen-age boy. On

the contrary, Ficino's extant letters to Lorenzo underscore the authoritative but caring tone of his c. 1477–1478 letter as he continued to admonish him to better himself morally and ethically (see below, chapter X).

These observations make the "poetic/love" theme implausible, and, together with all the facts now known about this painting, oblige one to conclude that the *Primavera* was authored by Marsilio Ficino with its iconography deriving from his Neoplatonic tenets and writings.

Identifying the main figure as a universal moon goddess rather than as Venus has far-reaching implications for the meaning of the *Primavera*'s program. First and foremost, it means that the program must explicate the moon's essence and whatever practices or beliefs were associated with its veneration. More precisely, it means that the letters written by Ficino to Lorenzo di Pierfrancesco undoubtedly relate in some way to the program of the *Primavera* and should be read against the function and attributes of a universal moon goddess. Only in this context can the letters be understood properly and will the painting's purpose in the life of the young Lorenzo become accessible.

But perhaps the most interesting ramifications of this identification emerge from the moon goddess's powerful presence in Apuleius's story. It was she who inspired, directed, and implemented the metamorphosis of Lucius from a beast to a dedicated, pious priest, ascetic, and devout. This transformational power is implicit in her image, and thus she can be seen as an extension or even an elaboration of the metamorphosis of the plain and colorless Chloris into the flowering beauty of Flora. This first transformation, denoting spring, is physiological; the second raises the physicality of the animal to the spirituality of the initiated soul. This, then, may be the real theme of the *Primavera*, and only Ficino could have conjured such a program. Before developing this theme, however, it is necessary to demonstrate the significance of a spiritualized moon goddess to Ficino and establish her importance as a symbol of an essential component of his Neoplatonism.

There can be no question that Ficino read Apuleius's novel, since its popularity would have made it familiar to any lettered person during the

second half of the fifteenth century. In addition, he would have known Plutarch's essay, *On Isis and Osiris*.[67] Furthermore, he was especially familiar with the *Corpus Hermeticum*, a collection of fourteen treatises attributed to a certain Hermes Trismegistus. In fact, these were the first works translated from Greek into Latin by Ficino for Cosimo de' Medici (c.1463).[68] Ficino called the collection the "Pimander," which was the title of the first treatise and means "the Shepherd" (*Poimandres*). In it, "Pimander" is the Divine Mind who appears to Hermes Trismegistus, instructing him about the creation of the universe and the power and wisdom of God. In general, the treatises are mystical revelations regarding the soul and its redemption.

As long ago as 1967, Frances A. Yates, in her article, "The Hermetic Tradition and Renaissance Science," wrote, "[H]istorians of philosophy may have somewhat misled us as to the nature of [Neoplatonism]. The new work done in recent years on Marsilio Ficino and his sources has demonstrated that the core of the [Neoplatonic] movement was Hermetic, involving a view of the cosmos as a network of magical forces with which man can operate."[69]

In this same essay, Yates reminds the reader, "Ficino and his contemporaries believed that 'Hermes Trismegistus' was a real person, an Egyptian priest…a Gentile prophet of Christianity, and…the source–or one of the sources–with other *prisci theolog*–of the stream of ancient wisdom which had eventually reached Plato and the Platonists. It was mainly…in the Hermetic texts that the Renaissance found its new, or new-old conception of man's relation to the cosmos."[70]

Therefore, since Ficino believed that the tenets of Trismegistus had helped formulate Plato's precepts and then were fed into Christianity, he must have granted pre-eminent authority to Plato's Egyptian predecessor.

Ficino and others attributed another divine book, the *Asclepius*, to Hermes Trismegistus.[71] This work, which instructs the adept in ways to attract the benevolent influences of celestial bodies, had been known to the West through a late antique translation attributed to none other than Lucius Apuleius, the author of *The Golden Ass*. This fortuitous

circumstance could have had special significance for Ficino, who might have extrapolated a philosophical kinship with the Roman from the belief that Apuleius had translated one of the two ancient sources of Hermetic wisdom while he himself translated the other. At the same time, such a kinship could have enhanced any authority that Ficino would have ascribed to the message, events, or personalities included in *The Golden Ass*.

Finally, there is other evidence that *Quattrocento* thinkers and/or artists esteemed Isis. The pavement in the central aisle of the Siena Duomo, attributed to Giovanni de Stefano and dated 1488, includes an image of Hermes Trismegistus. Pintoricchio's frescoes (1492–1503) in the Borgia apartments (Room of the Saints) in the Vatican, Rome, show Moses, Hermes Trismegistus, and Isis together. These same frescoes include the sacrificial bull that was sacred to Isis and was, as well, the symbol of the Borgia pope, Alexander VI, who commissioned the frescoes.[72]

These few examples indicate the *Quattrocento* interest in the Hermetic tradition. Recent research by Yates and others has established that this tradition underlay Ficino's belief in cosmological forces that act on the souls of men.[73]

As his patron, the aged Cosimo (d. 1464) must have influenced the young Marsilio's belief system. But it was Ficino who directed the Florentine Neoplatonic Academy and instructed its members. It was he, then, who inculcated the members of the intellectual circle around the Medici family with a Hermetically imbued Neoplatonism. It was this philosophical system that recognized the importance of a universal moon goddess whose most benevolent manifestation was the Egyptian Isis, at the same time that her most famous accomplishment in literature was the transformation of Lucius.

IV. The Goddess of Many Names

If Ficino chose the image of a universal moon goddess, signified by the costume and symbol of Isis, for a major work executed by a prominent painter for a member of Florence's most powerful family, why has that fact escaped the notice of scholars who have researched and written on the painting? Several reasons may account for this.

The most obvious is that no one has questioned Vasari's identification of the *Primavera's* subject as Venus. Next, as Yates indicated, some historians of Renaissance philosophy have not recognized the extent to which Ficino's Neoplatonism was informed by Hermeticism, which implies that scholars would not have looked for allusions to Isis, her mysteries, or Isis-like counterparts in the philosopher's writings. Finally, Ficino did not make many references to Isis; however, two passages may be cited that include her name, thereby providing some insight into the Florentine's regard for her.

The first of these, a mere mention, occurs in his treatise, *De vita coelitus comparanda*, where Ficino remarks on the ancient Egyptians' belief in the efficacy of graven images. He tells us that the Egyptians believed that genii descended from heaven into the statues of such deities as Phoebus, Isis and Osiris, informing them with supernatural powers. This accounted for the veneration of statues as idols on the part of those ancient people.[74]

A second reference to Isis is found in the *Asclepius*, the Hermetic treatise whose translation Ficino attributed to Lucius Apuleius. Ficino

calls him a "Platonic philosopher" in his subtitle to this treatise.[75] In chapter XII, Hermes speaks to Asclepius about Isis, the wife of Osiris, who "is propitious and responsible for many good things." But, says Hermes, she flies into a rage at the many gods and beings that men have invented and then named as the sacred spirits of their city-states. These beings have survived because men made them divine, wrote them into their laws and proclaimed them publicly by naming their cities after them. However, since those beings that are venerated in one place are not held sacred in other communities, they can provoke wars among the Egyptians.[76]

This reference to Isis does little more than confirm her claim to a preeminence over the other deities, which Apuleius made clear in *The Golden Ass*. Furthermore, Ficino did not elaborate on–or even repeat– the name of Isis in his gloss on this passage. Along with his failure to refer to this goddess more frequently in his writings, this omission could support the notion that Ficino disregarded Isis. However, that may not have been the case.

Apuleius made it clear that the identity of the true goddess, Isis, had been conflated with those of many other female deities worshiped throughout the Mediterranean area. Of all the goddesses with whom she had become interchangeable, the most important seems to have been Minerva (Pallas, Athena). In *On Isis and Osiris*, Plutarch refers to a temple at Sais in Egypt, which was dedicated to Minerva. Minerva, he says, was held to be the same as Isis. At this temple there was a seated statue of the goddess that bore an inscription which Plutarch gives as, "I am all that has been and is and will be; and no mortal has ever lifted my mantle."[77]

Ficino repeated a variation of this inscription at least twice in his writings. The first occurs in his commentary on Plato's *Timaeus*. In that dialogue, Plato has one of his speakers, Critias, refer to Sais as a city that was under the protection of Athenaor Neith.[78] In his gloss on this passage, Ficino included a rather lengthy "description of Minerva," which he concluded with a different version of the inscription quoted above:

You will remember that Neptune is indeed divine foresight and that Pallas truly signifies intellectual foresight; that this same Pallas was described by the Platonists as the divinity who, through her wisdom and power, first provided what belongs to the heavens and then established those things that are under the heavens. Further, she is the principle leader of the stars of Aries and the leader of the equinoctial cycle, where, it is believed, she flourishes most powerfully as the motivating force of the universe. You have memorized the golden inscription which, in the stories of the Egyptians that Proclus retold, had been written in the temples of Minerva: I am those things that are, that have been and will be. No one has lifted my veil. Sol is my son, the fruit that I have brought forth.[79]

Ficino credits Proclus (410–c.485 C.E.) for this version of the inscription, which differs from Plutarch's by the addition of the last sentence, "Sol is my son, the fruit that I have brought forth." Proclus did indeed give this rendition in his own gloss on the *Timaeus*.[80] According to Thomas Taylor, the English translator of Proclus's commentary on that dialogue, this is the only source in which the extra sentence is found, which means that Ficino deliberately and intentionally chose the Fifth Century philosopher's version of the inscription in preference to Plutarch's second century rendition.

The additional sentence is significant; no myth about either the Greek Athena or the Roman Minerva bestows motherhood upon her. On the contrary, virginity is essential to Athena's personification of an inviolable city-state. Isis alone fits the description of Proclus's passage, in part because it was her maternity that qualified her as a benevolent, loving goddess, but also because her son, Horus, was recognized as a sun god, or Sol. Therefore, by including this sentence in his own comment on Critias's remark, Ficino reveals that he was well acquainted with the mythology of Egypt and accepted the conflation of Isis and Minerva, but chose to call this syncretized goddess by her Roman, rather than her Egyptian, name.

The same thing occurs in Ficino's second use of Proclus's version of the Saitic inscription, which is found in his treatise *Liber de Sole*.[81] Before quoting the inscription, the Florentine compares the light of the sun to the "good God" and discusses the sun as the "illuminator and lord of the heavens." Then, in chapter VI, entitled "The praises of the ancients about the sun and in what way celestial men and all things are in the sun and from the sun," Ficino restates the inscription in the context of remarks attributed to Orpheus. He says that Orpheus (1) called Apollo the living eye of heaven; (2) said the sun is the eternal eye that sees everything; and, (3) claimed that the moon (Luna) is filled by the planets and is the queen of the planets. Ficino continues:

> Among the Egyptians this golden inscription was written in the temples of Minerva: "I am those things that are, that have been and will be. No one has lifted my veil. Sol is my son, the fruit that I have brought forth." So it seems that the sun is Minerva's; that is, that he was born of divine intelligence; he was the flower that was brought forth. The ancient theologians by the testimony of Proclus himself said that the queen of all, Justice, came from the middle throne of the sun through all things, disposing everything in a straight line, as if the sun itself were the moderator of all.

Ficino then attributes to Iamblichus the thought that whatever good things we have, we have from the sun; to Moses he credits the notion that the sun is the lord during the day while the moon rules at night, as if she were a nocturnal sun. He also says that the sun is in the middle of the world; it is the mean between the five planets above and the moon and the four elements below.[82]

In this chapter of his book on the sun, Ficino has made the moon, which is Luna, identical with Minerva. Since Isis rather than Minerva was recognized as the pre-eminent personification of the moon, it is clear that Ficino once again chose to overlook Isis or, at least, to conflate

the identities of the two goddesses under Minerva's name. When he goes on to equate the sun with Apollo, he again shows a preference for the Greco-Roman name of the deity.

It already has been observed that the Greek god Apollo had been merged with the Egyptian Horus under the name Horapollo (see above, p. 39). Therefore, Ficino's use of Apollo's name in this section of his book on the sun is significant. He states that the sun was born of Minerva. In truth, the only way Ficino could maintain that Minerva was the mother of Apollo would be under circumstances wherein Minerva would be Isis and Apollo would be Horus.

The importance of the Saitic inscription and Ficino's renditions of it lies in the fact that Hellenized Egypt had equated Isis with Minerva and both Plutarch and Proclus accepted this equation. Ficino merely took the next step and gave the Latin Minerva preeminence over the Egyptian Isis.

Minerva, of course, was not the only name by which the "goddess of many names" could be known, and she was not the only deity cited by Ficino instead of, or in place of, Isis. In fact, he pursued the essence of the moon goddess under several other identities.

In the same chapter of the *Liber de Sole*, Ficino writes that the moon can be addressed as "Justice." It may seem strange that he permitted the moon to be denoted by the abstract principle of justice, but this is verified by a passage in *De Amore*, his commentary on Plato's *Symposium*.

Cristoforo Landino was assigned the task of explaining Aristophanes's version of the origin of human beings to the Florentines who were present at Ficino's re-enactment of Plato's famous discussion of the nature of love. First, Cristoforo quotes from Aristophanes: "They had three sexes: Males born from the sun; Females from the earth; and Bi-sexuals from the moon." Then he comments on these three sexes.

> The first type received the glow of God as Bravery, which
> is masculine; others as Temperance, which is feminine; others
> as Justice, which is Bi-sexual. These three virtues in us are the

offspring of another three which God possesses. In God these three are called Sun, Moon, and Earth, but in us, Male, Bi-sexual, and Female.[83]

While this supports the notion that Ficino accepted the moon as a symbol of justice, it introduces another complication. Now the moon is neither a maternal deity nor a virgin goddess but is a bi-sexual being. To further confuse the reader, Ficino elsewhere refers to justice by yet another name.

In a letter to Lorenzo il Magnifico, written about 1474 and entitled "De lege et iustitia," Ficino says that Justice is the "salvation of mankind" and the "Queen of the world," and he asks her to guide him in the writing of this letter. Finally, he invokes her. "Justice that is blissful life! Justice that is heavenly life! Mother and Queen of the Golden Age, sublime Astrea seated among the starry thrones!"[84]

Here Ficino gives Justice the name "Astrea." According to tradition, this deity lived on earth during the Golden Age, but when mankind became intolerably evil she ascended to the heavens to become the constellation Virgo. It is clear that Ficino was familiar with that myth, for he refers to Astrea as "Queen of the Golden Age, sublime Astrea seated among the starry thrones." This implies that he saw Astrea as the personification of the constellation and as signifying justice. But he already has noted that justice is symbolized by the moon, and it has been established that Isis was the pre-eminent moon goddess and that Ficino equated Isis with Minerva.

This apparent confusion is clarified by Ficino's description of Virgo, the personification of that constellation, which is found in *De vita coelitus comparanda*. In this treatise he describes Virgo as "the beautiful virgin of Virgo who is seated, having twin ears of corn in her hands and nursing a boy."[85] Like the inscription on the seated statue at Sais, this description can be applied to only one goddess. That, of course, is Isis, for Isis was the only goddess who could signify corn and, at the same time, be shown nursing a baby boy.

This description of the virgin of Virgo is very unusual. In fact, to assign motherhood to a personification of this zodiacal sign may seem as strange as it was to grant maternity to Minerva. However, a source for the Florentine's view of this astrological sign can be cited.

The famous and influential Persian astrologer, Abu Ma'shar, (787–886 C.E.) was known to the West through translations of his chief work, the "Great Introduction to the Science of Astrology," which dates from as early as the first half of the twelfth century. This treatise contains descriptions of the personifications of the zodiacal signs. Abu Ma'shar subdivided each of the twelve 30° signs into three equal parts, a common astrological practice that allows for three different personifications for each sign. It is the Persian's first image of the sign of Virgo that is relevant. According to Abu Ma'shar, this virgin is a beautiful young woman with long hair and a shining countenance. She sits on a cushioned throne, holding two ears of corn in one hand and an infant boy in the other, whom she nurses.[86] And she is called Isis.

This treatise probably was the source of Ficino's description of the virgin of Virgo, since the Muslim's imagery is repeated almost verbatim in *De vita*. However, once again Ficino refuses to use the name of the Egyptian goddess in his version.

Another goddess also was associated with the sign of Virgo. The Roman astrologer, Manilius, who assigned to each of the twelve zodiacal signs a ruling deity in addition to a ruling planet, assigned Demeter (Ceres) to Virgo. Ceres, the Greek goddess of agriculture, was similar to Isis in that both were associated with the annual cycle of nature and the rebirth of plant life in the spring. Thus, she as well as Isis claimed ears of corn as an attribute, but never was Ceres described or shown as a nursing mother. Ficino was fully aware of the Manilian assignments, so it is noteworthy that he chose to describe Virgo's virgin in a way that would be appropriate for Isis alone.

Proclus and Abu Ma'shar have been cited as two sources of passages that Ficino evidently borrowed, passages that originally included Isis's name. Plutarch's *On Isis and Osiris* also has been mentioned in connection

with Ficino's comments on the temple at Sais (see above, p. 45). Of these three sources, Plutarch's must have been the most important to Ficino, for his writings include other versions of the moon goddess's aspects or counterparts that apparently were borrowed from it. In fact, with the exception of Astrea as Virgo, each of the identities of the moon goddess cited in Ficino's works can be found in *On Isis and Osiris*.

Further on in his account of the temple of Sais, Plutarch reiterates that the two goddesses are one and the same. "[The Egyptians] often give Isis the name Athena, which has some such meaning as this: I came from myself, which indicates self-impelled movement."[87]

Plutarch also saw Isis as a personification of justice. He tells his reader that at Hermopolis, Isis was thought to be the daughter of Hermes and, as such, was known as both Isis and "Justice." She was called Justice, explains Plutarch, because she is wise. Since Minerva is generally recognized as the goddess of wisdom, Plutarch seems to be acknowledging the conjoining of Isis and Minerva through the notion of justice.[88]

In chapter 43 of this essay, Plutarch calls the moon bi-sexual. "[The Egyptians] locate the power of Osiris in the moon and say that Isis, as the creative principle, has intercourse with him. For this reason they also call the moon the mother of the world and they believe her nature to be both male and female since she is filled and made pregnant by the sun, while she herself in turn projects and disseminates procreative elements in the air."[89]

Although Plutarch did not make a direct equation between Demeter (or Ceres) and Isis, he did say that Isis is none other than Persephone, Demeter's daughter.[90] In this connection, he must have recognized that Isis and Demeter often were indistinguishable, for the conflation of these two goddesses was common in the ancient world. R.E. Witt has elaborated on this.

We meet this identification constantly in Greek writers, and the resemblances spring to the modern mind at once. We find Herodotus writing "Demeter" for "Isis." At the end of the fourth

century B.C., Leo of Pella, author of the work *On the Gods of Egypt*, stresses the identification and still later Diodorus remarks that of all the Greek goddesses he mentions the one who comes nearest to Isis is Demeter.[91]

Witt is also helpful in explaining how Isis, Demeter, and Justice came to be seen as identical.

> In her homeland Isis could assume the role of Māʾet, who, through the personification of Truth, Righteousness and Justice, was a shadowy abstraction. Far more graphic was the Hellenistic portrayal of Isis under the title, which was peculiarly Demeter's: Thesmophorus, the 'lawgiver.' When viewed in this guise she was known as "the Rhamnusian goddess" in the Latin of Apuleius and in the Greek as Themis or Nemesis, both champions of justice at Rhamnus, a coastal town not far from Athens.[92]

Witt's reference to the Greek writers advises the reader that Ficino would have had many authorities besides Plutarch and Apuleius to support his own use of the goddess's other names, choosing one or another in keeping with his context or to emphasize a specific role or aspect of the "mother of all."

Although Ficino was willing to call this universal goddess by whatever name seemed appropriate at the time, he invoked the name of Minerva (Pallas, Athena) more often than that of any other goddess. Ficino's devotion to her can be explained in part by the fact that the Florentines placed their city under her protection.[93] Nowhere is this adulation more apparent than in a letter Ficino wrote about 1476 to Pietro Placentino, entitled "*Veritas sua potentia potius quam aliena defenditur*" ("Truth needs no defense other than its own strength").

> The Pope has sent you, as a vigorous general, to take up arms against the enemies of divine wisdom. But it is the priest of Pallas

rather than the soldiers of Mars who muster in wisdom's defense. God forbade me to serve under treacherous Mars; He ordered me to follow the standard of invincible Minerva. May I be as successful in reaching her as I have long so willingly followed her! I am therefore sending you these arms with which I fight unceasingly and with all my strength against the enemies of truth. As a dutiful son of Pallas and patron of the muses, you will take care to see that I am able to forge still more weapons of this kind. The man who assails the enemies of reason is in truth always victorious.[94]

Ficino not only assures Pietro Placentino that he himself is a follower of Minerva, but he calls Pietro a "dutiful son of Pallas." The entire letter seems to encode allusions to Florence, wisdom, and truth in the name of Minerva. This letter not only reveals Ficino's devotion to Minerva, but it also recalls the words of Plutarch, who referred to Isis as "Justice" because she is wise, and then called her the leader of the Muses.[95] Further, Isis shared Athena's military function through her identification with the Egyptian military deity, Neith.[96]

This letter confirms that Ficino's veneration of Athena/Minerva was not a personal one, for he assumes that Pietro Placentino shares his enthusiasm for her. Another reference also indicates that she was especially respected by the Florentines.

According to Ficino's account of the Academy's re-enactment of Plato's *Symposium*, Tommaso Benci rose and addressed the participants as devotees of Minerva and Diana. "You, most innocent guests, and all others consecrated to Diana and Minerva who exult in the freedom of a pure soul and in perpetual joy of mind, come and be welcome."[97]

One additional source demonstrates Ficino's devotion to the goddess of wisdom. Near the end of a letter written c.1475 to Bernardo Bembo in praise of philosophy, he stated the following:

Oh most wonderful intelligence of the heavenly architect! Oh eternal wisdom, born only from the head of highest Jove!

Oh infinite truth and goodness of creation, sole queen of the universe! Oh true and bountiful light of intelligence! Oh healing warmth of the will! Oh generous flame of our heart! Illumine us, we beg, shed your light on us and fire us, so that we inwardly blaze with the love of your light, that is, of truth and wisdom.[98]

Whether references such as these were meant to refer to Minerva alone or were arcane references to the universal goddess of many names may be irrelevant; for it seems clear that Ficino sought correspondences among and between the ancient female deities that permitted their interchangeability. All, and each in turn, were personifications of the moon and its benevolent aspects.

One final piece of visual evidence supports the notion that the central figure in Botticelli's *Primavera* is the universal moon goddess referred to as Minerva. In the collection of the Uffizi Gallery (Florence), there is a drawing by Botticelli or a member of his workshop, executed in pen and bistre over black chalk with white highlights (Fig. 5). This drawing is identifiable as Minerva from her attributes–the helmet in her right hand and the olive branch in her left.[99] It is been argued that this was a preliminary sketch for a tapestry that could not have been made before 1491; however, comparisons also have been made between it and the female figure in Botticelli's *Minerva and the Centaur* (Fig.19), which usually is dated c.1482–1483. In other words, the date of the drawing is uncertain.

Although there are similarities between the figure in this drawing and the image in *Minerva and the Centaur*, its kinship with the central figure in the *Primavera* is much more striking. Both right arms are raised to an angle of 90°. The heads are tilted, the bodies are turned almost to the same degree, and the fingers of the left hands are in identical positions. Furthermore, the style of the left sleeve and the fall of the drapery from the bodice of the dress worn by the figure in the drawing echo the sleeve and the drapery in the painting. But most

compelling is the fact that, if a same-scale rendition of the central figure in the *Primavera* is superimposed over this drawing, an astonishing coincidence of the two images becomes apparent (Fig.6).

These correspondences insist upon a connection between the figures. One must believe that the drawing was a preliminary sketch for the painting's image. In that case, its date would have to be moved back to approximately 1479-1480. More importantly, if, indeed, it is a preliminary sketch of the central figure, must one ask if Ficino intended the painting's image to be Minerva, since, after all, in the drawing she does carry the attributes of that goddess. On the other hand, the pose, costume and, especially, the Isaic medallian identify the figure as Isis. This suggests that a conflation of the two goddesses was intended and that they were meant to co-exist in the one image. Therefore, Ficino's original intention must have been to have two levels of meaning in the painting, each associated with a different aspect of this dual image.

Of course, the modern reader balks at the notion that a figure's name may fluctuate or change or that one image can have two identities. But it must be remembered that the modern reader has been educated in a culture steeped in a scientific methodology that insists on neat categories of inclusion and exclusion, scoffs at magical incantations, and discounts whatever cannot be proven syllogistically or through direct observation. This was not the world of Marsilio Ficino, who lived in a pre-Copernican, static, and stratified universe that required superhuman beings in order to penetrate those strata, and that accepted the ability of those beings to transform themselves whenever necessary.

Ficino's fifteenth century worldview is almost incomprehensible today. Even Ernst Gombrich deemed his conception of the "classical" deities, in the letter of c.1477–1478, bizarre, and he insisted that Ficino believed that the secret of a god's being lay in establishing its "authentic" image (see above, p. 13).

A completely different point of view has been offered by Leonard Barkan in his thorough and impressive study of the phenomenon of metamorphosis from Ovid through Shakespeare.[100] His initial chapter

considers, not surprisingly, Ovid's *Metamorphoses*, and here he supplies a basic definition of the subject in connection with an analysis of Ovid's account of the transformation of the mortal Arachne into a spider. "The universe is structured in layers . . . and metamorphosis is the vehicle whereby individuals are transported among the layers."[101]

Of particular interest, however, is Barkan's discussion of Ficino's Neoplatonism in his chapter on the Renaissance. He observes that a true "Ovidian Renaissance," which he defines as the "revival and transformation of metamorphosis and paganism," began in the early sixteenth century; but he notes that evidences of this had already begun in the fifteenth century. Here Barkan is referring to an aesthetic revival. He writes:

> Three modes dominate in the artistic portrayal of the pagan world during this Ovidian pre-Renaissance. Most important is the strong continuity of medieval cosmology and cosmography. The fourteenth and fifteenth centuries witness a massive interest in the systems of correspondence–microcosm and macrocosm variously interpreted–that link the earth to the heavens. Among the most important of the systems is astrology. . . .[102]

This, he notes, led to "vast diagrams."

The second mode continues the "traditions of medieval romance," which he sees as a meeting between "Platonic love and Christianized allegory, as in the Romance of the Rose." Barkan explains the third mode.

> Compared to cosmology and romance, our third mode, at least in its pre-1500 form, is the most specialized and arcane. The Florentine Neoplatonic circle surrounding Lorenzo de' Medici stretched the fabric of orthodox Christianity almost to the breaking point. Marsilio Ficino and Pico della Mirandola not

only attempted to reconcile pagan and Christian theology, they also treated the mythic figures of both religions as *exchangeable* (emphasis added). The result is a composite mythology that must be read as a sequence of mysteries, with the frivolous elements of pagan lore overturned and transformed into the deepest truths.[103]

Here Barkan refers to Botticelli's *Primavera*, which, he says, "is certainly cosmological in the sense that it is concerned with the great motions of time in the universe" Further on, Barkan returns to the ideas of the Florentine Neoplatonists that had a direct bearing on their attitude toward metamorphosis. He sees metamorphosis as a "central image" in their system of reconciling opposites and describes their philosophy as one "that looks through and beyond the surfaces of this world to a realm of essences."[104] This is a world of mysteries, the occult, emblems, symbols, and secrets. Barkan states: "Metamorphoses are in themselves mystery images" since they are naturalistically and theologically impossible and since they combine opposites in a single act.

> In fact, a new pantheon of multiple gods like Venus, Diana or Hermeros is invented in the Renaissance in order to contain and enshrine the oppositions among the pagan gods and also between pagan and Christian values.[105]

Barkan's explanations of metamorphosis and pagan mythology, as these informed and were in turn transformed by the Neoplatonic mysticism of Ficino and his circle, underscores the proposal that the theme of the *Primavera* is transformation. So, to the metamorphosis of Chloris into the springtime of Flora and the transformative power of the moon goddess, who changed the outward, physical form of Lucius, transforming his inner spiritual life, may be added the metamorphosis of that goddess as she mutates into another deity, incorporating this new identity into a multiple goddess, in keeping with the new Neoplatonic pantheon.

More than this, Barkan's understanding of Ficinian syncretism helps put to rest any arguments against a Neoplatonic interpretation of the *Primavera* that sees astrology as the means by which a very special transformation was being sought—the change, the spiritual transformation of Lorenzo di Pierfrancesco de' Medici. Thus, metamorphosis was the goal and astrology was the means by which Ficino hoped to mentor his young charge. Explaining how these elements have been visually expressed in Botticelli's painting is the real challenge. This can be met only by further analysis of both the painting and Ficino's complicated and abstruse philosophical system that includes his astrological beliefs.

V. Ficino's Astrology and the Hermetic Tradition

Even though Ernst Gombrich found the astrological allusions in Ficino's c.1477–1478 letter to Lorenzo di Pierfrancesco bizarre, they comprised the documentation that led him to Ficino as the primary author of the program of the *Primavera*. Now that it has been shown that the painting's images probably were meant to function in an unearthly realm, Ficino's astrological references seem less fantastic. Now it is possible to think of the painting as a depiction of the heavens where the stars and planets reign. But it is the central figure's identity as the universal moon goddess, which must include the mystical associations of the Egyptian moon goddess, Isis, that is critical to an astrological interpretation of the painting's program. Isis's intimate connection with the *Hermeticum*–treatises filled with astrological explanations and references–provides the rationale for taking the letter's astrology seriously.

As Yates has written, "The cosmological framework which [the *Hermeticum*] takes for granted is always astrological, even where this is not expressly stated. The material world is under the rule of the stars, and of the seven planets"[106]

Today it is known that the Hermetic treatises probably were written in the late first or early second century C.E. by more than one mystic

living in Hellenized Alexandria. However, as late as the Renaisance they were accepted as authentic documents containing the revelations of ancient Egyptian wisdom.

The theme that runs through most of the fourteen chapters attributed to Hermes, the "Thrice-greatest," is the redemption of the soul. The first treatise consists of a dialogue between Hermes and "Pimander," during which the Divine Mind recounts a creation story. Hermes is told that the Almighty Creator made man in his own image, immortal and pure soul. Then man revealed himself to Nature below who loved him, and loving her in return, he descended to dwell with her. Hence, man would become mortal as well as immortal.

The descent of man proceeded from the eighth realm of the Divine Mind, which is beyond the universe, through the angelic realm that consists of three spheres. Next man descended through the celestial realm, which holds the sphere of the fixed stars and the constellations of the zodiac as well as the seven spheres of the planets. Finally, he went through the physical realm of the elements to the center of the universe, which was thought to be the earth. In the process, man took on some of the attributes associated with each of the spheres. At his death, the mortal self of man would be shed as he returns to the eighth circle of the Divine Mind, becoming once again purely immortal.

Further on in the *Hermeticum*, Hermes instructs his son, Tat, about divine things, telling him that he must purify himself of irrational urges in order to be regenerated and come face to face with the One.

The *Asclepius*, allegedly translated by Lucius Apuleius and also attributed to the mythical Hermes Trismegistus, is closely allied with the *Hermeticum* because it, too, concerns divine things. Again the reader is told about the supreme God and that Man has a two-fold nature, mortal and immortal. But the *Asclepius* gives more emphasis to astrological phenomena, explaining the constellations, or the fixed stars of the zodiac, and citing the planetary spheres. In addition, it says that the god Jupiter gives life to all things as an intercessor between heaven and earth and that the divine sun disseminates its light to that which is below.

Since Ficino included his own translation of the *Corpus Hermeticum* followed by Apuleius's version of the *Asclepius* among his collected works, his knowledge of these treatises is not an issue.[107] The connection between the two works becomes clear if the nature of Ficino's belief in planetary influences is understood.

Ficino's relevant letters and treatises show that he was an adherent of the practice of astrology, modified, perhaps, by his Christian beliefs. He believed that the positions of the planets at the moment of birth predispose one toward certain traits and talents, but that no one is ordained to a specific fate or destiny. Each person is responsible for his own life's course and outcome and should make every effort to counter any malevolent predispositions.[108]

Ficino was very concerned about his own natal horoscope and the domination of the planet Saturn over his life. His remarks about this matter shed light on the way in which he reconciled astrology with his Christian beliefs. In a letter of c.1476 to his "unique" friend, Giovanni Cavalcanti, Ficino responded to Cavalcanti's admonition that he, Ficino, should not blame Saturn for his melancholy because that planet also bestows benefits. In this same letter, the philosopher revealed his rationale for accepting the practice of astrology: "Indeed, in your letter you seem to have sung a hymn of recantation for me to Saturn and the other stars; or rather, to God, the cause of their movements."[109]

In other words, Ficino believed that God determines the influences of the planets when He decides their placements in one's horoscope. They are His instruments, by and through which one is conditioned astrologically.

Nine years earlier, in 1467, this same "unique" friend had urged Ficino to write the first version of his commentary on Plato's *Symposium*. Cavalcanti apparently made the suggestion with the hope that the activity would alleviate Ficino's depression, which must have been unusually severe at that time. Ficino struggled with periods of depression or melancholy, which included a protracted period of despair from 1469–1474.[110] Undoubtedly, this underscored his concern with Saturn, which

in turn must have strengthened his strong identification with Plato, since both shared Saturn's influence. Having cast Plato's horoscope, Ficino knew that Plato's natal Saturn was in the ninth house at the top of his astrological chart, a placement that the Florentine considered powerful.[111]

Based on his reading of Plato's works, particularly the *Apologia* of Socrates, Ficino found a strong influence from Saturn on Socrates, the teacher of Plato. In his commentary on the *Apologia,* Ficino noted that Plato began the entire defense of Socrates under the good auspices of oracular prophecies, and that at one time, Socrates's life had been controlled by the prophecies of his own special daemons.

> If you want to know what kind of daemon was Socrates's, the answer is that it was a fiery daemon because it elevated him to the contemplation of the sublime. Also, one of Saturn's daemons acted upon him, since every day, to an extraordinary extent, his mind was diverted away from his body. This trait was innate—not acquired—for he said that he aspired to this from boyhood. He was never provocative because he was not under the daemon of Mars, but often he called a thing into question by his actions because of Saturn's daemon.[112]

Here Ficino is arguing for an inclination toward "higher" things as a result of Saturn's power, an inclination that he might have claimed for himself. At the same time, he could extend his identification with Plato to Socrates, for all three shared personality traits attributable to Saturn.

This passage from Ficino's commentary on the *Apologia* is important for several reasons. Not only does it confirm his identification with Plato as well as Socrates, but it uses Plato as an authority for a belief in astrological influences. It also introduces the notion of daemons, the agents who, Ficino believed, transmit heavenly effusions to mortals on earth.

Since Ficino's belief in astrology is certain; it only remains to relate it to the Hermetic writings associated with the cult of the moon goddess or Isis.

This is not difficult to do. The link lies with the list of the *prisci theologi*, the pre-eminent philosopher-theologians who were supposed to have transmitted ancient truths down through Plato to the Christian era. The list always began with Hermes Trismegistus, Isis's priest. Ordinarily it consisted of six names, among which that of Pythagoras always appeared.

Ficino's acceptance of the *prisci theologi* is well documented by his own writings. He gave one version of the list of six in the preface to his translation of the *Corpus Hermeticam*, and this alone testifies to the importance of the chain that linked Hermes to Pythagoras and Plato. Paul Oskar Kristeller's translation of that passage follows in part.

> Mercurius Trismegistus was the first philosopher to raise himself above physics and mathematics to the contemplation of the divine. . . . Therefore, he was considered the original founder of theology. Orpheus followed him and held second place in ancient theology. Aglaophemus was initiated into the Orphic mysteries. Aglaophemus's successor in theology was Pythagoras, and his pupil was Philolaus, the master of our divine Plato.[113]

Ficino modified his list more than once in later writings, but in each series, Pythagoras's name is between those of Trismegistus and Plato. The appearance of Pythagoras's name on all these lists attests to the importance of the tradition associated with his life and teachings. According to that tradition, Pythagoras, a sixth century B.C.E. metaphysician, introduced the ancient wisdom of Egypt to Greek colonists in Italy.

Pythagoras's dates are uncertain, but most scholars agree that he was born between c.580 and 550 B.C.E. on the island of Samos and died about 500 B.C.E. Pythagoras achieved fame as the leader of a religious-

scientific cult that was founded in southern Italy at Croton, where his disciples–both male and female–led ascetic existences with little sleep or food in emulation of and devotion to their leader. They practiced a strict regimen of exercise and meditation in an effort to understand the mysteries and tenets of Pythagoras, who was accepted by these followers as the son of the god Apollo and was therefore semi-divine.[114]

Tradition traces the source of Pythagoras's knowledge and beliefs back to ancient Egypt. His biographer, Iamblichus, relates that Pythagoras, who had been initiated into several different mystery cults in his home territory of Greece, went to Egypt with the intention of being "a partaker of more beautiful, divine, and genuine monuments of erudition in Egypt," He remained there for twenty-two years, "learning the wisdom possessed by all the priests in the land."[115]

The list of the *prisci theologi* makes it clear that the divine wisdom learned by Pythagoras was taught to him by Hermetic or Orphic priests. He learned, and then taught, the secrets that originally had been revealed to Trismegistus. To Ficino, therefore, Pythagoras's cult was an extension of the ancient cult of Isis, and his teachings about a divinely ordered and hierarchically ranked universe undoubtedly reflected a cosmography that was fundamental to the sacred knowledge guarded by Isis's priests.

Although there are no written records of Pythagoras's teachings, tradition says that a disciple, Philolaus, who was one of the six *prisci theologi*, compiled the master's beliefs in a work that went to Philolaus's student, Archytas of Tarentum.[116] In turn, Archytas shared his knowledge and the work of Philolaus with his friend, Plato. Of these three followers of Pythagoras, only Plato left manuscripts that Ficino would translate.[117]

The late Hellenistic period provided the context for a renewed interest in Plato's Pythagorism, colored by the mysticism that characterized that time, especially among the Alexandrian Greeks. By the first few centuries C.E., these Neoplatonists had produced the treatises that Ficino would accept as the authentic and ancient written sources of

Pythagoras's knowledge. Thus, Pythagoras became the link between the "original" Hermetic treatises and Plato's Pythagorean dialogues. Each body of writing reinforced the other, and the later Neoplatonists of the third and fourth centuries accepted them both.

Plato's debt to Pythagoras is evident in several of his dialogues, but nowhere is it more explicit than in the *Timaeus*, with its numerology that was held to be the true explanation of the cosmos and all of nature. This mystical worldview persisted for over two thousand years, undergoing transmutations or refinements in keeping with different historical contexts, but retaining its essential identity up to and throughout the Renaissance. It was not to be challenged until new knowledge of natural phenomena was acquired, beginning with the seventeenth century.

The ideas expressed in the *Timaeus* are profoundly important. They explain the universe as Ficino understood it and provide the foundation for his Christianized astrology. As a background for understanding the astrology of the *Primavera*, it needs to be examined.

VI. Ficino's Cosmology

Ficino translated all of Plato's dialogues. Except for three of them, these dialogues were new to the humanists of the fifteenth century. One of those already known to them was the *Timaeus*; It had been available to Westerners throughout the Middle Ages in Chalcidius's Latin translation.[118] This work had kept Plato's Pythagorean numerology alive and accessible so that it was both known and accepted as an authoritative account of the creation. As such, it was not seen as a contradiction to the Judaeo-Christian account but instead as an augmentation of theGenesis story. Therefore, until Ficino translated the rest of Plato's works from Greek into Latin for Cosimo de' Medici, in large measure the *Timaeus* represented the Greek philosopher to the West.

The durability and accessibility of the *Timaeus* are reasons enough to insist on its importance up to and throughout the Renaissance, but it was influential and significant for at least two other reasons. The first of these stems from the Pythagorean tenet, "Everything accords with number," which referred not only to arithmetical and geometrical proportions but also to the proportions Pythagoras found between and among the intervals of musical tones. Additionally, these were the same proportions that he believed determined the distances among the wandering planets. Thus, arithmetic, geometry, music, and astrology shared a common numerical basis. These four disciplines, known

as the quadrivium ("a place where four roads meet") are implicit in the numerology of the *Timaeus* and were the heart of an educational system that was practiced from the time of Plato down through the Renaissance.[119]

In the *Quattrocento* the renewed interest in Plato that culminated in the Florentine Platonic Academy brought with it an excitement about the mathematical sciences of the quadrivium. According to Paul Laurence Rose, "the starting point for this renaissance of mathematics was the correction of Greek mathematical texts, to be undertaken by those who were expert in both the Greek language and astronomy."[120] In the words of Kristeller, "mathematics and astronomy made remarkable progress during the fifteenth century and assumed increasing importance in their practical application, both in the literature of the time, and in the curriculum of the schools and universities."[121]

Ficino was one of the *Quattrocento* scholars who were expert in both Greek and astronomy (astrology). His translations were responsible for introducing classical texts to the West and for stimulating its interest in Plato. Simultaneously, these same sources shaped his own religious beliefs into a remarkable, syncretic theology. These two effects shared one cause: the numerology of Pythagoras, which is the foundation of the system espoused in the *Timaeus* and underlies both.

A second circumstance also gave the *Timaeus* special significance in the Renaissance. Parts of the dialogue are not easy to understand, and, as a result, early commentators–both Greek and Latin–elaborated upon it in an effort to explain the more abstruse or perplexing passages. In this connection, Benjamin Jowett wrote, "In the supposed depths of this dialogue the [late antique] Neoplatonists found hidden meanings and connections with Jewish and Christian scriptures. . . . They were absorbed in [Plato's] theology and were under the dominion of his name."[122]

Therefore, the fifteenth century–and Marsilio Ficino–inherited not only Plato's Pythagorism but the accretions and extrapolations that embellished it. From his commentary on the *Timaeus*, it is apparent

that Ficino accepted these elaborations as the interpretations of respected and learned authorities. Throughout this treatise, he credits either those writers or Plato, as though he saw little difference between them or believed that the words of the former supported those of the latter. Indeed, he seems to have introduced the views not only of every Neoplatonic and/or Christian writer whose works were known to him, but those of Moses as well. At least a dozen names are mentioned throughout his commentary; in effect, his work comments on their interpretations of the *Timaeus* as much as it does on Plato's original dialogue.[123]

Ficino's willingness to be completely syncretic suggests that he may have been determined to reconcile even the most disparate views or interpretations of Plato's dialogues. In fact, his own treatise amplifies Plato's ideas in ways that are sometimes startling because he had to allow himself considerable latitude in content and style. For example, he begins his commentary on the *Timaeus* with a comparison of this dialogue with Plato's *Parmenides*, since both contain much that is Pythagorean. In the *Timaeus* Plato allows Pythagoras's follower, Timaeus of Locris—who, says Ficino, wrote a book on the nature of the universe—to present everything he knows about divine and natural things. These phenomena are discussed in both dialogues, the *Parmenides* and the *Timaeus*; but nature is emphasized in the former. Therefore, says Ficino, Plato rises to divine things more often in the *Timaeus*.[124] After summarizing briefly the setting and persons involved in this dialogue, Ficino offers a few remarks on their initial discussion. From that point on he permits himself to extrapolate on the nature of the world body and soul according to his own Neoplatonic and/or Neopythagorean inclinations.

Of the ideas presented in the *Timaeus*, three are especially pertinent. The first of these concerns the creation of the visible universe, which Timaeus, the Pythagorean authority on these matters and a philosopher of natural phenomena, explains to Critias, Hermocrates and Socrates. Timaeus says that this visible world, being also tangible and sensible and having a body, was created by a cause (or supreme deity) who followed

an uncreated and eternal archetype and who made the world out of goodness.[125] Timaeus maintains that there is only one created world; it is made of fire, which is visible, and of earth, which is tangible.[126] It is at this point that Pythagorean numerology is introduced, for Timaeus observes that any two terms must be united by a third; that is, there must be a mean between any two extremities. However, in the case of the world, which is composed of fire and earth, there must be two means because the world is solid and not planar, and solid figures, according to geometric principles, require two means.

Therefore, the creator interposed the two elements air and water between fire and earth so that there is a proportional relationship among them: fire:air::air:water; and, air:water::water:earth.[127] From the harmonious union of these four elements was made the universe (or world) in the form of a sphere. The sphere is the one perfect body and therefore the creator deemed it the appropriate form for the universe.

The second important concept pertains to the world soul, which, having already been created, was diffused throughout the world.[128]

The creator divided the mixture of which the world soul is composed into two lengths; he joined them at their midpoints in the shape of an X, and each bar of this X was then brought around to meet at its endpoints, forming two circles. One of these is an outer circle–the circle of the same–that was made to revolve horizontally to the right. The second, or inner, circle is called the circle of the other, and it revolves diagonally to the left. The circle of the same was left undivided. It is the celestial sphere wherein reside the fixed stars or constellations. The inner circle was divided into seven unequal circles, each becoming a moving orbit for a planet.

> Now when the Creator had framed the soul according to his
> will, he formed within her the corporeal universe, and brought
> the two together, and united them centre to centre. The soul,
> interfused everywhere from the centre to the circumference of
> heaven, of which also she is the external development, herself

turning in herself, began a divine beginning of never-ceasing and rational life enduring throughout all time. The body of heaven is visible, but the soul is invisible, and partakes of reason and harmony, and being made by the best of intellectual and everlasting natures, is the best of things created.[129] Time came into being at the same instant that heaven was created; then the creator brought the planets into being and placed them in their orbits in the circle of the other.[130]

Plato's account of the creation of the universe was held to be "scientifically" valid for centuries. Robert Fludd's 1617 illustration is one of the most frequently reproduced visualizations of this concept of the universe (Fig.7). It shows the earth at the center, spherical but static; above and around it are the elements of water and air. Here fire is considered a heavenly element.[131]

In the celestial realm are found the wandering stars or planets. The lowest of these is the moon. Above the moon and restricted to and moved by their own zones are, in ascending order: Mercury, Venus, sun, Mars, Jupiter and Saturn.[132] The circle of the same is the celestial sphere of the fixed stars and the constellations of the zodiac. Above this transitional sphere, in the angelic realm, are the three graded angelic spheres that, in turn, ascend to the cloud-like realm of the Divine Mind, whose hand moves the lower realms by means of the Soul of the World. It is this structured and hieratic concept of the cosmos that was the basis of Ficino's theology. In this cosmos everything has its place, and each body or unit influences those that lie beneath it. Thus, the earth receives influences from all heavenly bodies, but the influence of the highest or most remote body is transmitted through intermediaries that lie between it and the earth. It is apparent that the predetermined and immutable status of each body or realm or zone in this cosmos has great significance, for all positions and the character of each heavenly body were decreed at the time of creation by divine ordinance (Appendix II).

Timaeus continues with the explanations of the classifications of birds, fishes, animals, and gods, and the creation of human souls from the diluted remains of the compound from which the world soul has been created. Then, he states that human souls were entrusted to the gods in order that they might be sown in the planets, whence they would descend to human bodies.[133] A discussion of the relationship between soul and body follows.[134] Then Timaeus points out that all the works he has considered were brought into being by the creative mind. However, creation also follows from necessity, which fact returns the discussion to the nature and identities of the four elements.[135] It is at this point that Plato's protagonist introduces the third of the three concepts that are especially pertinent to the meaning of the *Primavera*.

Reiterating that the elements are visible and therefore changeable, which means that they can take on new shapes, Timaeus contends that they are bodies and therefore are solids, composed of several planes. The planes of these solids are reducible to one of two kinds of triangles, either the right-angled isosceles triangle or the right-angled scalene triangle. Therefore, these solids must be closely related to each other, but they are not identical.

Timaeus then discusses the solids. One is composed of isosceles triangles while the other three are made up of scalene triangles, which have sides of unequal length. These three, he states, can be resolved into one another. On the other hand, the first one (of isosceles triangles) cannot fit into any of the others nor they into it. Nevertheless, each of these solid figures is perfect and regular; that is, each has an equal number of faces, which have identical edges and angles, and the faces are arranged so that they come together at their angles or vertices.

On this basis Timaeus posits their beauty, noting that each element is composed of particles in the shape of the solid assigned to it. Accordingly, the simplest solid is the tetrahedron. Its four faces are comprised of equilateral triangles (composed of scalene triangles), which are combined in a pyramid-like polyhedron. This solid is assigned to the element fire. The octahedron, with eight equilateral triangles and six

angles, is given to air. The third perfect solid is the icosahedron. With twenty sides and twelve angles, it is given to water. Finally, Timaeus says that earthy particles are in the shape of the cube, the solid figure whose six square faces can be segmented into isosceles triangles.[136]

Following this description of these four regular solids, Timaeus almost casually adds that there remains a fifth regular polyhedron, the dodecahedron, which God used as model for the heavens, assigning the twelve signs of the zodiac to its twelve faces.[137]

As the model for the heavens, the dodecahedron is set apart from the other four polyhedrons and immediately given special significance. Unlike the other four solids, it does not represent tangible elements but instead must be associated with the circle of the same, which contains the fixed stars and the constellations of the zodiac.

This solid figure is composed of twelve faces, each of which is a pentagon. It is clear that the mystical connotations of the pentagon are multiplied in the polyhedral form of that plane figure. For this reason alone, the dodecahedron would have been the logical choice for the model of the universe; but two other factors add to the logic of that choice. Of the five regular solids, it is the most difficult to construct, consisting as it does of pentagonal faces. This fact, and the wonderful coincidence that the number of its faces is twelve, corresponding to the number of signs in the zodiac, must have impressed Plato as nothing less than marvelous and, of course, divinely planned.[138]

The *Timaeus* provides all the information necessary for understanding Ficino's concept of the universe with its static zones based on numbers and geometric solids. And it is clear that he believed that the heavenly bodies within those zones could irradiate influences to the earth. For Ficino, the heavens teemed with vital and powerful beings that acted in accordance with a divine will. However, because of their remoteness and rank, and because of their confinements within orbiting circles, their influences could not touch mortals under their dominion without help. Thus, for the astral influences to be operational, Ficino had to develop a system of agents that could transmit irradiations from heavenly sources

down through the zones of the world to humans.[139] He found this system in an elaborate daemonological construct.

Ficino conceived of daemonic beings, which fill the heavenly spheres, that are sent from (1) the zodiacal signs (or constellations of the zodiac), (2) each of the seven "wandering stars" (or planets), and (3) the four elements, which were ranked from the highest, fire, down through air and water to the lowest element, earth.[140] The most powerful daemons are those that originate in the highest sphere of the universe, and the power of daemons from each of the lower spheres decreases in accordance with the descending rank of the zones.

One reference to the nature of these daemons in relation to their sites of origin is found in Ficino's commentary on the *Timaeus*, where he states that each of the seven planets has a leader that resides within the planetary orbit. "Moreover, under each planetary leader there are many beings, almost exactly like the leader, and howsoever they may be called [by others], I now generally call them daemons. . . [because] they imitate the planetary leader in their performance and motion."[141]

Thus, each of the deities of the zodiacal signs, along with each of the ruling planets of these signs and each of the deities who govern the wandering planets, has a host of beings around itself. These beings partake of the character or personality of the leader to which they are attached, and they are the emissaries that descend to the earthly, human children who are born under the dominion of the various leaders.[142] In addition, there must be fiery, airy and watery daemons that transmit the inclinations of the celestial elements informing their natures.[143]

In a letter to Braccio Marcelli (c.1485) Ficino made several important points about daemons, based on ideas that he credited to the writings of Plotinus, Porphyry, Origen, and other "Platonists."[144] The fourth section of this letter has a lengthy title in which Ficino tells his correspondent that all daemons are souls that are produced out of the total soul; that is, from the very idea of soul. And each one has a spirit. He then distinguishes between beneficent and maleficent daemons, explaining that the good ones are more powerful than those with malevolent intentions.

In the same part of this letter, Ficino provides his reader with a description of the physical appearance of beneficent daemons. They are invisible and cannot be perceived by human senses, because they do not have a solid body. "Further, they do not all have the same form but take many forms; some of these are remarkable, which attests to the nature of their spirits, while others are in no way remarkable." Ficino concludes this section by observing that the bodies of good daemons are harmonious, which is reflected in us, while the bodies of maleficent daemons are "inelegant" or awkward.[145]

The manner by and in which Ficino's daemons affect human beings is critical. The clearest explanation of this process is found in his commentary on the views of the late Byzantine Neoplatonist and theologian Michael Psellus (1018–1078 C. E.), regarding the nature of daemons. Ficino responds to the question of whether daemons dominate humans. Ever mindful of the importance of the Christian belief in free will, he says that Psellus limited the control of these beings by insisting that they do not dominate us but, instead, communicate with the spirit within us in a secret manner, approaching us as though in the imagination, since daemons themselves are of spirit.[146]

Altogether, then, Ficino apparently conceived of good daemons that have (1) souls, which are bestowed upon them out of and by the world soul, (2) bodies that are invisible to humans, and (3) spirits, which are the communicating vehicles between them and humans and correspond to, or are compatible with, the human spirits upon which they act.

Finally, one of the most interesting remarks that Ficino made about daemons is the following from his commentary on Plato's *Apologia*. "If it does not much please you to call the friendly leader of a man his daemon, at least (and this appeals to me) call it a good angel."[147] The implication is clear: These astral intermediaries are essentially the same as "guardian angels," which are not to be confused with the angels placed in a realm beyond the universe, above the zone of the fixed stars.

Ficino's daemonology was essential to his astrology. By including these beings, he made a highly structured system functional and

established a tight chain of command through his hierarchy. More than that, his daemons lent an air of respectability to the science of reading the stars. By endowing daemons with soul and spirit and by comparing them to angels, he granted them a status that is semi-divine. Yet, by making them agents of the celestial bodies, he avoided the implication that the planets and stars, which are physical phenomena, possess a divine spirituality that can act directly on humans. Lastly, by having a daemonic spirit act only on the human spirit, Ficino reserved the human soul for Christian salvation.

In addition to his daemonology, Ficino developed another concept that is fundamental to his universal structure and astrological hierarchy. In several different contexts, the Florentine described an entity that he called the world spirit. Since his daemons communicate with humans by means of and through their respective spirits, one might think that the world spirit is also a means of communication between two bodies, but Ficino's explanations of this being make it clear that the concept is more complex than that (Appendix II, B).

Ficino saw this spirit in connection with the human spirit, the vehicle by and through which the human soul governs the body. He elaborated on this connection in the first few chapters of *De vita coelitus comparanda*. First, Ficino reminds his reader that the world soul creates lower forms with the support of the stars and celestial figures (that is, the constellations) and notes that individual gifts are bestowed upon mortals through planetary influences. Then, he says that the world soul thrives everywhere by means of the sun, just as our soul sends the vigor of life throughout our bodies by means of the heart. "Truly, always remember that, as the vigor of our soul is transmitted to the limbs by the spirit, so the goodness of the world soul is diffused through everything under it by means of the fifth essence, which is active everywhere, like the spirit within the human body. . . ."[148] Moreover, he continues, it is possible to take more and more of this fifth essence into ourselves if we know how to separate it from other substances with which it has been, in effect, contaminated.

Here the Florentine offers advice on how to attract more of this quintessence (which radiates from the soul through the special agency of the sun, thereby permeating all lower beings and substances) by first attracting the influence of the sun. The influences of Jupiter, Mercury, and Venus, all of which are benevolent planets, also should be attracted.

Ficino then makes an important distinction between the world spirit and the human spirit. The human spirit, he says, is composed of the four elements: fire, air, water and earth. The world spirit, which is not quite body and not quite soul, must have affinities with both. Therefore, it is composed of the natures of the elements but in disproportionate amounts. This spirit has very little of the nature of earth, somewhat more of water, a greater amount of air; but, mostly, its nature is fiery and stellar. Ficino adds that, since everything is generated by means of the spirit, "at one time we call it the heavens; at another time we can call it the fifth essence."[149]

Ficino did see a correspondence between the world spirit and the human spirit, despite their differences, and he envisioned the world spirit influencing human beings by acting on their spirits. But the most striking thing about these passages is Ficino's insistence that the world spirit is synonymous with the fifth essence, which also constitutes the heavens. Although Ficino does not define this quintessence further, his use of the term compares to Plutarch's reference to the heavens as the fifth essence. Therefore, it may be that, once again, the Florentine borrowed from the Greek, based on the latter's interpretation of Timaeus's description of the creation of the world in his essay, "Of the Word EI Engraven over the Gate of Apollo's Temple at Delphi."

> For, indeed, though there is but this one world, as Aristotle is also of the opinion, yet this world is in some sort composed and assembled of five, of which one indeed is of earth, another of water, the third of fire, the fourth of air, and the fifth, being heaven, some call light and others the sky; and some also name

this same the fifth essence, which alone of all bodies is naturally carried about in a circle...

Plutarch's discussion continues with a most interesting remark.

> Plato, knowing that, of the figures which are in Nature, there are five most excellent and perfect—to wit, the pyramid, the cube, the octahedron, the icosahedron, and the dodecahedron—has fitly accommodated each of them to each of these worlds or bodies.[150]

Plutarch is saying that the dodecahedron, which is the model of the heavens (or the sphere of the zodiacal signs), is the fifth essence, and this, according to Ficino, is the same as the world spirit.

Another reference to the dodecahedron by Plutarch extends its meaning and is even closer to Ficino's equation of the world spirit with the fifth essence, implying that Ficino borrowed both concepts from the Greek. In his dialogue, "Why the Oracles Cease to Give Answers," Plutarch permits one of the discussants, Heracleon, to interpret Plato's attribution of the dodecahedron to the zodiac as evidence of its pre-eminence over the other four solid figures and their corresponding elements.

> Plato, assigning unto the principal parts of the universe the first forms and most excellent figures of the bodies, calls them five worlds—those of the earth, water, air and fire, and finally, of that which comprehended all the others, which he calls dodecahedron . . . [which] is of easy motion and capacity, its form and figure being very fit and proper for the revolutions and motions of the souls.[151]

The key phrase here is, "that which comprehended all others, which he calls dodecahedron," for this implies the subsumption of the four elements by the fifth essence, just as Ficino suggested in his analysis of the world spirit.

From the foregoing discussion, one may conclude that Ficino conceptualized the world spirit as the circle of the same, for Plato made it clear in the *Timaeus* that the circle of the same was modeled after the dodecahedron, because the twelve faces of that solid figure would accommodate the twelve signs of the zodiac. Plato also said that both the circle of the same and the circle of the other were made from the compound of the world soul. And since the four elements were made from the circle of the other, these same four elements must comprise the essential material of not only the circle of the other but the circle of the same as well. This composition is identical with that of Ficino's world spirit.

Finally, the notions that the world spirit, the fifth essence, the dodecahedron, and the circle of the same are identical with one another, and that these, alone or together, constituted Ficino's conceptualization of a mean between the world soul and the world body (the circle of the other), are given further support from the fact that Ficino credited the world spirit with a nature that is predominantly fiery–for he equated fiery with stellar–which must characterize the circle of the same. Surely Ficino had the fiery nature of the world spirit in mind when he identified one of Socrates's daemons as fiery; because such a daemon would be able to lift him to a contemplation of the sublime.

Ficino leaves the reader with the task of making one other inference. Since he does not identify the means by which the world spirit communicates with or acts on human spirits, one must deduce the method from what is known of the hierarchical structure of his system.

Basing his ontology on the *Timaeus*, Ficino conceived of the circle of the same as revolving in a direction that is different from that of the circle of the other, which carries the zones of the planets in their orbits. Thus, it is difficult to imagine how the world spirit, as the circle of the same, could penetrate the spheres of the circle of the other, for these seem to have their own spatial positions, directions, and identities. Indeed, the functions of these two circles distinguish them from each

other and from the world soul; and the fact that they are composed of the same mixture as the world soul does not guarantee a direct channel from the celestial sphere down through the zones of the planets and elements to the earth.

When Ficino says that it is possible to absorb more of the desirable, beneficial influence from the world spirit by attracting the influences of the sun, Jupiter, Mercury, and Venus, he not only is drawing attention to the intermedial bodies that are sympathetic with the quintessence; he also is providing the means whereby the world spirit can reach earthly beings. Since planets and elements use their own special daemons when they act on the spirits of those humans who are born under their influence, the world spirit must also approach humans–if and when they have sought its affections properly–by means of and through daemonic media.

These media may originate from the spirit's own zodiacal stars, which undoubtedly communicate with the sympathetic planets (the sun, Jupiter, Mercury and Venus) when these fall under compatible signs. Certainly, spiritual daemons arise from the elements, for these are the essential materials of the composition of the quintessence. Finally, the natures of the planets are identified with one or another of the four elements; therefore there must be a direct intercession between the fifth essence and the planets by daemonic beings that are elemental in nature.

Ficino, then, gave his daemonic beings or guardian angels a central role in his belief system. Without them, the zones of his world would have been locked in a rigid and impenetrable hierarchy. Without them, his conviction that humans can receive benefits from the heavens would be untenable, for such a reception would have to depend on some kind of communication between and among the zones. Ficino's daemons, some of which are with the person at birth while others can be induced or enticed to act on him or her in special circumstances, provide that communication.

The nature of Ficino's daemonology is such that any benefits he wished Lorenzo di Pierfrancesco to receive from the spiritual harmony

of the world spirit and/or from a particular horoscope could not be bestowed directly but would descend to him through the agency of cooperative daemonic beings. In that case, at least some of Botticelli's images must be personifications of intermedial daemons that have been made visible for the sake of Lorenzo.

Therefore, Ficino's letter of c.1477–1478 to the boy should be reread, keeping in mind his worldview with its hierarchical structure of zones and benevolent intercessors who would help Lorenzo attract the harmonious benefits of the quintessence.

VII. Astrological Interpretations of Ficino's Letters and the Primavera

My immense love for you, excellent Lorenzo, has long prompted me to make you an immense present. If, therefore, I make you a present of the heavens themselves, what would be its price?[152]

It seems that Gombrich was correct in his contention that Ficino's letter of c.1477–1478 referred to the *Primavera*, for the formal analysis of the painting has shown that the "heavens themselves" are implicit in its composition. If that truly is the case, then the astrological content of this letter should be explored for referential data to a particular condition, circumstance or time. That cannot be done convincingly without first clarifying some astrological fundamentals and then examining Ficino's metaphorical style of writing about astrology.

Astrology, which many define as "the science of the stars," is the study and interpretation of the planets and their positions as they appear in the firmament, in relation to each other and the sun and the moon, at a given time and geographical location. For centuries people have believed that the planets and the sun and the moon possess characteristics and powers that they may radiate to mortals. But their transmission of qualities is conditioned by their positions in the heavens, and these vary considerably because the heavenly bodies do not move at the same rate or follow the same path.

Although the interpretations of an adept may, and in the Renaissance often did, depend on complex or subtle extrapolations of the conventional meanings of planetary positions, a knowledge of the basic principles of astrology should be sufficient to enable the reader to understand Ficino's message to the young Lorenzo di Pierfrancesco.

Modern astrologers use a circular chart on which to diagram the positions of the planets. Ficino probably used a square chart like the one he drew of Plato's natal placements and which he included in a letter to Francesco Bandino about the philosopher's life.[153] Nonetheless, both the circular and square charts were known during the Renaissance, and any explanation of one applies to the other.

Interestingly, the circular chart (see Fig. 11) more closely depicts the Renaissance concept of the universe. At that time, the belief in an earth-centered universe still prevailed and only five planets were known. People thought that these planets, as well as the sun and the moon, revolved around the earth. Therefore, on a circular map, a larger, outer circle represents the heavens through which those bodies appear to move, while the smaller, inner circle represents the earth, the individual's frame of reference.

In everyday experience, one sees the sun "rise" over the horizon in the east and "set" below the horizon in the west. Similarly, the other heavenly bodies seem to rise and set in a counter-clockwise manner according to their orbits. A horizontal line that bisects the astrological map designates the horizon of one's experience. The meridian is perpendicular to the horizon line and bisects it to create four equal quadrants. These are further divided into three sections of 30° each and are numbered 1 through 12, starting below the horizon line on the left side of the chart. These twelve sections, through which the heavenly bodies seem to move, are called "houses." They represent and govern different facets of one's life experiences, relationships and personality. The houses are stationary.

The two main axes of the map, the horizon and meridian, also designate the four cardinal directions. However, since this is a map of the

heavens, it is a mirror image of the earth, and the directions are reversed from those on a map of the earth. In other words, the first house, on the left side of the chart, is in the east; north is at the bottom of the chart with south at the top and west on the right. It is for this reason that the numbering of the houses is done in a counter-clockwise fashion.

As the planets and the sun and moon traverse the heavens, they seem to pass through twelve constellations of stars. These were identified by the ancients as the twelve signs of the zodiac.[154] Like the houses, the constellations are influential; they contribute to the formation of one's personality and character. The first sign of the zodiac, Aries, designates the constellation that is seen in the first house at the time of the vernal equinox. Like the heavenly bodies, the constellations appear to move. For example, Aries seems to "rise" in the spring, marking the vernal equinox, while its opposite sign, Libra, disappears from the heavens in the spring, passes clockwise through the northern houses and rises at the time of the autumnal equinox in the fall. Thus, a different configuration of the planets can appear in the twelve houses, along with a different arrangement of the signs, at any given time. An interpretation of any such configuration is based on traditional understandings of the relative powers of the planets, their interactions with each other, the characteristics of the signs in which they are found, and their relationships to the houses.

The placements of the planets and constellations in the houses at the time of one's birth are determined by the position of the sun. It is assumed that the sun rises in the first house at that moment. Thus, the constellation that then occupies the first house is one's birth sign. The placements of the other signs follow accordingly, and those of the planets are determined by their relative orbital positions. Such a configuration is called a horoscope.

> The astrologers have it that he is the happiest man for whom
> Fate has so disposed the heavenly signs that Luna is in no bad
> aspect to Mars and Saturn and furthermore she is in favourable

aspect to Sol and Jupiter, Mercury and Venus. And just as the astrologers call happy the man for whom fate has thus arranged the heavenly bodies, so the theologians deem him happy who has disposed his own self in a similar way.

In this passage from his letter to the young Lorenzo, Ficino refers to "aspects" between and among the planets. An aspect signifies the angle that can be measured between any two bodies on an astrological chart. It will be deemed favorable or unfavorable according to traditional interpretations.[155]

Therefore, when Ficino advised Lorenzo that the aspects between the moon and other bodies should be favorable–or at least "in no bad aspect"–he meant that the planets ought to be arranged in propitious angular relationships. Unfortunately, he did not give sufficient data about the formation of these planets in this letter to enable one to draw up an exact chart. It is for this reason that some scholars have dismissed the notion that Ficino was really transmitting astrological advice to his young friend. However, there are other remarks in this letter that seem to refer to a specific horoscope; and these, along with other evidence from Ficino's writings, bear careful consideration.

After suggesting that men should dispose of their heavens in ways that compare to his favorable disposition of the planets, Ficino tells Lorenzo, "You, too will be greater than the heavens as soon as you resolve to face them. We must not look to these matters outside ourselves, for all the heavens are within us and the fiery vigour in us testifies to our own heavenly origin." This passage recalls Ficino's description of the fiery daemon that, as an innate influence, raised Socrates to a contemplation of the sublime. In fact, with Ficino's concept of daemons in mind, one can interpret his claim that "all the heavens are within us" to be a figurative reference to the influence of those spiritual beings. Since they themselves are composed of heavenly properties, which they transmit to humans, in effect they bring the "heavens" to mortals, acting on their spirits even before birth.

Ficino then admonishes Lorenzo to dispose of his own heavens, and he explains why the boy should do so.

> Onward, then, great-minded youth, gird yourself, and together with me, dispose your own heavens. Your Luna– the continuous motion of your soul and body–should leave everything to the right and opportune moment, and should not hasten unduly, nor tarry too long. Furthermore this Luna within you should continuously behold the sun, that is, God Himself, from whom she ever receives the life-giving rays, for you must honour Him above all things. Your Luna should also behold Jupiter, the laws of human and divine, which should never be transgressed–for a deviation from the laws by which all things are governed is tantamount to perdition. She should also direct her gaze on Mercury, that is, on good counsel, reason and knowledge, for nothing should be undertaken without consulting the wise, nor should anything be said or done for which no plausible reason can be adduced Finally, she should fix her eyes on Venus herself, that is to say on Humanity (*Humanitas*).

Ficino's description of Lorenzo's Luna as "the continuous motion of your soul and body" is especially suggestive. It reminds one that there must be a mean between the human soul and body, which is the "spirit." This is the entity that receives the influences of the spiritual daemons. In addition to its receptive nature, the spirit also seems to be the agent that produces corporeal movement, which finds its source in the human soul.[156] In other words, the spirit now may be thought of as the "motion" between soul and body.

Therefore, when Ficino designates Luna as the intermedial motion between Lorenzo's soul and body, he is marking the boy's spirit with an essentially and peculiarly lunar identity. In addition, the philosopher credits the moon with intermedial powers, for it is the Luna within

Lorenzo that Ficino calls upon to face the heavens, beholding the sun, Jupiter, Mercury and Venus.

This emphasis on Lorenzo's Luna coincides with and supports the identification of the central figure of the *Primavera* as a moon goddess for two reasons. First, the image makes direct eye contact with the viewer, who is assumed to be Lorenzo. She would be directing her gaze toward the daemonic Luna–her emissary and microscopic representative–within the boy.

Second, Ficino insists that Lorenzo's Luna must behold the sun, "from whom she ever received the life-giving rays." Surely Botticelli intended the gilded lunar crescent that adorns the central figure in his painting to be a visual expression of these words of advice. The medallion is not just a depiction of the reflection of the physical sun's light upon the moon; it is the sun, "God Himself," that Luna attracts and whose influence she ensures.

These points not only verify the notion that the universal goddess of the moon is the central figure of the *Primavera*; they testify to an astrological interpretation of the content of the painting. The fact that the c.1477–1478 letter from Marsilio Ficino to Lorenzo di Pierfrancesco does not provide enough information to determine the nature of that astrological message might seem to present a real difficulty. But this letter was just one of six that he wrote to the boy; so there are other sources that may be examined.

Among those letters, written between c.1477–1483, during which time the painting certainly was executed,[157] is the one dated October 18, 1481, the day before Ficino's forty-eighth birthday. This letter is replete with astrological allusions. Gombrich quoted one section of this very long letter, not because he thought it referred to the painting, but because in this section Ficino discussed the three Graces, whose images appear in the *Primavera*.

The letter, entitled, "About the Three Graces and Genius," begins with a paragraph that makes Ficino's close identification with the young Lorenzo very clear. He apologizes for not having written sooner but

claims that, when he tried to write, he was unable to produce anything, for his mind had gone completely blank. Then Minerva came to him on the very day he was trying to write to Lorenzo and explained that he should address the young man as, in effect, an alter ego. It is the next part of this letter, in which Ficino offers Minerva's explanation of his difficulty in writing to the boy, that Gombrich translated.

> Know first that those three Graces, whom our poet depicts as three maidens embracing each other, are among the heavenly beings essentially three planets: Mercurius Jovius, (that is, Mercury who receives the grace and benefit of Jupiter), Sol and Venus who are harmonious and propitious companions in the heavenly dance. Similarly these three names of the Graces, Verdure, Light and Gladness, conform excellently with these stars. These stars are, among the celestial bodies, those which most affect by their favour the human genius; and for this reason they are called the Graces of man, not of any other kind of animal. Nor are they really the followers of Venus but of Minerva, and if you ever hear the first Grace identified with Jupiter, understand that it is not so much Jupiter but Mercurius Jovius, that is, Mercury aided by the aspect of some other favour of Jupiter. For it is Mercury who, with that certain vital and prompt liveliness of his, exhorts us always to reach into the truth of matters. The sun with his light makes every kind of invention apparent to all ye who seek. Venus, finally, with her most amiable beauty, always adorns and embellishes what has been found.[158]

Minerva continues with an explanation of the natal daemon that is shared by Ficino and Lorenzo. She begins this long paragraph with the statement that the three planets named above (the sun, Mercury under Jupiter's influence, and Venus) consult with each other about the daemons or genii that will be sent to those people who are born when these three planets are "in conjunction"–that is, when they share the

same number of degrees, or the same angle. The daemons come from whichever house happens to hold these planets at the time of one's birth. Now, says Minerva, when these planets see that certain people are born when they themselves are in the same part of the heavens (the same house), they bestow upon these people the same or a similar daemon. And whenever there is a similar daemon, and therefore one "will" bestowed upon two people, even though there are two different bodies, the men will be the same "inside."

. . . For this reason, Marsilio, you ought to realize that you– yes, you!–have been defying the higher powers. You know that your horoscope and that of Lorenzo of the Medici family are the same. In other words, you know that, in both your natal charts, Jovial Mercury, the sun and Venus are indeed in the same part of the heavens–the ninth house, of course, which astrologers have designated as the house of faith, religion, genius and wisdom and therefore as the house that is favored by Phoebus–and that these bodies are aspected similarly in both your charts. It thus follows that not just a similar but the very same genius [daemon] has been sent from there to both of you. Without a doubt it is an Apollonian daemon since Apollo is happy in the ninth house of the heavens and influences human spirits from there. From his numerous daemons, Phoebus himself assigned one to both of you with the consent of Venus and Mercury. Hence, one mind has been bestowed upon you. And, in the same way, one will is common to both of you. If, then, these two daemons are actually one, the men receiving them are one. Do not, by some chance, continue to separate through words those things your daemon unites in you–the heavens themselves and your intellects. Remember, therefore, that very often it is appropriate to write, "Marsilio salutes Marsilio" in your letters to your Medici friend. When you do that, your natural inclination for invention at last will flow forth from you in great bursts.[159]

Ficino finished this letter with a few remarks on the similarities he shared with Lorenzo about which Minerva had counseled him; then he offered felicitations; and finally he extended greetings to Giorgio Antonio Vespucci, who, along with Naldo Naldi, had tutored Lorenzo. Ficino dated the letter and noted that he had written it while at the villa at Careggio.

As in the earlier letter, this one was introduced by Gombrich to show the close affiliation between Lorenzo and Ficino, and, in a like manner, Gombrich was not inclined to read a literal meaning into the astrological references. Of the several such allusions found in this letter of 1481–all of which bear investigation–the one to the Graces as three planets is perhaps the most arresting, for Ficino calls them by the very same names that he used in the c.1477–1478 letter.

Gombrich considered these planetary appellations irrelevant to the images in Botticelli's painting.

> Need we conclude from this letter that Ficino took the Graces to symbolize the three planets, Mercurius Jovius, Sol, and Venus? It is evident that such an interpretation is not applicable to the "Primavera." If one of the Graces is Venus and the other Mercury, what are the real Mercury and Venus doing in the painting?[160]

Gombrich, of course, was under the impression that the central figure in the painting is Venus. Once she is seen as a moon goddess, the possibility that there are two Venuses is eliminated. This suggests that there may not be a problem with an extra Mercury figure, either. In fact, if it can be shown that the image taken for the "real Mercury" is neither the deity Mercury nor the planet Mercury but, instead, was intended to be a very different "Mercury," one might be persuaded to accept Ficino's references to the planetary bodies in his 1481 letter as applicable to the three Graces in the *Primavera*.

There are several reasons why the male figure known as Mercury may not represent either a deity or a planetary genius, despite the fact that

he carries the deity's attribute of the caduceus. First, the dark hair, the contemporary sword and helmet, and the unusually youthful body of the figure are all deviations from traditional representations of the god.[161]

Next, in the context of the painting itself, this figure is distinctive for reasons that already have been noted. Unlike the other images, this one does not give the impression of weightlessness. His feet are planted firmly on the ground and support his body. In addition, it is this figure that destroys the perfect pyramidal composition of the painting. Finally, by turning away from the other images, he alienates himself, establishing an autonomy that differentiates him from the others. Indeed, he seems totally unaware of them, as though he is not a part of their company.

One can hardly avoid the conclusion that this "real Mercury" has a function in the *Primavera* that is completely different from that of the other figures. Whereas they seem to be abstracted, weightless personifications, conveying an otherworldly mood that is almost Byzantine, he could very well be a portrait. Or, if it is not a specific portrait, at least the visual evidence suggests that this may be an idealized stand-in for Lorenzo di Pierfrancesco de' Medici.

Others may have noticed certain connections between the Mercury of the *Primavera* and Lorenzo, but no one has suggested that it was intended to be a reference to his person. Frederick Hartt called attention to the flame motif on Mercury's cloak as an attribute of both Mercury the god and the patron saint of the Medici, Lawrence, for whom Lorenzo was named. Hartt also noted the patch of laurel, Lorenzo's plant, at the feet of the central figure but does not compare the image of Mercury to the extant profile portraits of Pierfrancesco.[162]

Yet, a comparison of the head of Botticelli's figure with the profile depicted on one of two medals that were struck during Lorenzo's life shows similar characteristics (Figs. 8 and 9). The length and curly texture of the hair, the prominent nose with its flaring nostrils, the slightly fleshy lower lip above a short, almost weak chin, and the protruding eyes are all comparable. In addition, the body of the painted image is obviously that of an adolescent. Botticelli even refined the figure's left leg, which

the *pentimenti* reveal, as though he had decided that a slimming of the leg's muscularity would make it look more boyish.

For all these reasons, the notion that the *Primavera*'s Mercury is an idealized version of Lorenzo di Pierfrancesco is plausible; it becomes probable because of the posture, position and gesture of the painted image. Only an intention to suggest a real person could justify the corporeality of this figure as well as his alienation next to, and in the realm of, daemons from the "heavens themselves." Finally, the fact that Botticelli's figure seems to be using his caduceus to stir the branches of the trees that surround him suggests that he wishes to see beyond them to those heavens. In turn, this implies that Ficino intended the *Primavera* to be the "immense present" by which his protégé would experience a new and more beneficent horoscope.

The only question that remains regarding Botticelli's Mercury image is why this deity was selected to personify the young Lorenzo. This is a question that must be addressed; but for now it is sufficient to recognize that there are no duplications of identities in the painting if the central figure is seen as the universal moon goddess and the Mercury is accepted as an idealized Lorenzo. These identifications permit the Graces to be personifications of the three planets mentioned in the letter of 1481. Furthermore, all the figures in the painting will have been identified.

However, there are still other problems with the images in the painting in relation to Ficino's c.1477–1478 letter that must be considered. The first concerns the proposition that Ficino was indeed identifying specific planetary positions in his discussion of the three Graces. Ficino's association of astral bodies with the Graces in this letter is not unique. Gombrich identified several other passages in which Ficino referred to planets as the three Graces. The following quotation indicates that Gombrich believed that these passages show that the Florentine was inconsistent and therefore could not have intended a literal reading of his astrological remarks.

There is ample evidence that Ficino himself never meant to establish a fixed meaning by his exegetic firework on the Graces

as planets. Even within the realm of astrological interpretation we find him shifting and changing the significance according to his requirements. In his book *De vita coelitus comparanda* he expounds the very theory he has been at pains to disprove in the letter: "That the three Graces are Jupiter, Sol and Venus, and that Jupiter is in the middle of the two other Graces and in greatest harmony with us."

In yet another passage, a letter about Pico [della Mirandola], the significance has shifted to Sol, Mercury, and Jupiter, now identified with wisdom, eloquence, and probity. When Pico was born, Ficino says, the Graces ceased to follow Venus and joined the "dux concordiae [i. e., Apollo].[163]

Gombrich's reluctance to accept Ficino's astrological allusions as specific citations is understandable if one insists that the Graces always signify the same three planets. However, Ficino saw four planets as benevolent–the sun, Jupiter, Venus, and Mercury–in keeping with ancient astrological lore; so he very well could have considered any combination of three of the four to be "Graces," an epithet that would express the accrued blessings when any three are in close proximity.

In Lorenzo's case, the philosopher evidently wanted the boy to partake of the benefits of all four planets, for he called Mercury "Mercurius Jovius" or Mercury "who receives the grace and benefit of Jupiter." While it is possible that this title implies a conjunction of those two bodies in the boy's natal horoscope, whereby the weaker planet would find its characteristics modified by the strengths of the larger body, there is a legendary relationship between Jupiter and Mercury in which the father of the gods, Jupiter, is assumed to exert power over the boy, Mercury. In mythology the latter is the messenger of the former; hence, Mercury could and would assume the traits of the superior and more powerful deity.

Ficino alluded to this dependent relationship on the part of Mercury in his commentary on Plato's *Phaedrus*, when he wrote that the divine

might of Mercury is most powerful when it pertains to those things that we associate with Jupiter, "who is the artificer of the world." Here he was referring to the essential identities of these two as abstract concepts. Further on he continued in the same vein. Having compared the Egyptian god Ammon to Jupiter, he wrote that invention is the capability of either Ammon or Jupiter, while the material form that invention must take refers to Mercury.[164]

This same close correlation between the identities of Jupiter and Mercury has persisted in astrological lore. A modern astrologer, Michael Meyer, has written about the respective roles of these two deities in their planetary manifestations.

> Jupiter and Mercury compose a polarity representing the interplay between preservation and participation of the individual with a social whole and the interchange and association of the contents of that social whole. In these terms Jupiter represents the basic social function, the preservation of any established form, and the general increase and expansion of the organic unit. Mercury is the "servant" of Jupiter: the symbol of the technique of gathering and associating knowledge and its efficient application.[165]

Whether or not Mercury is seen as a planet that is directly under the influence of Jupiter, the two have a long, traditional association that grants to the lesser identity the attributes and/or powers of the greater. This could account for Ficino's peculiar assignment of the name of Mercurius Jovius to the planet Mercury in his 1481 letter to Lorenzo. It is entirely possible that he wished to associate Mercury with the socially expansive and successful nature of Jupiter so the Mercurial Grace would be able to exercise authority and initiate activity. At the same time, such a conjecture does not rule out the possibility that Ficino was referring to an actual astrological position in which Jupiter's powers superintended those of Mercury.

Therefore, Ficino's lack of consistency regarding the planetary denominations of the Graces could have been motivated by astral formations or by traditional associations. Either way, it does not invalidate the metaphorical function of the triad.

A similar inconsistency seems to plague Ficino's identification of the leader of the Graces. In his letter about Pico, which Gombrich cited, the Florentine stated that the Graces had ceased to follow Venus and had joined the "leader of harmony," who is Apollo. Yet, in his letter of 1481 to Lorenzo, he made Minerva the leader of the Graces.

It is quite possible that Ficino changed the identity of the leader of the Graces in these cases because he was referring to actual planetary placements. On the other hand, as Leonard Barkan has explained, it was customary for the Florentine Neoplatonists to exchange mythic personages, allow one deity to metamorphose into another, or create a new, multiple identity. Thus, since these tendencies were characteristic of Ficino's system, any inconsistencies in his appellations of deities should not be surprising.

VIII. Lorenzo's Horoscopes

F icino's 1481 letter to Lorenzo di Pierfrancesco, in which he gave an astrological explanation for his inability to write to the boy, is important for several reasons. First, it reveals that he felt a genuine affection for and kinship with his young protégé. Next, it indicates the sincerity of Ficino's acceptance of astrological phenomena. The kinship he felt with Lorenzo was based on coincidences in their natal horoscopes that were remarkable enough for him to identify with the boy. Finally, it provides clues to the date of Lorenzo's birth and, in turn, to the configuration of his natal chart.

The most striking of these clues is Minerva's astrological authority. In his letter of 1481, Ficino makes Minerva the leader of the Graces, which in this case are the sun, Venus and Mercury under the influence of Jupiter; and he states that in both his and Lorenzo's horoscopes these three planets are in the ninth house, which, says Ficino, governs religion, faith, genius and wisdom. He does not indicate which sign filled the ninth house at the time of Lorenzo's birth. However, according to the Manilian rulerships, Minerva was the ruling deity of the sign of Aries. Therefore, it seems that Ficino must have meant that the three Graces were in the ninth house of Aries, under Minerva's command, when Lorenzo was born in 1463.

Whether or not this was indeed his meaning can be verified. An ephemeris, which is a day-by-day listing of the positions of the planets by

their latitudinal and longitudinal degrees, has this kind of information. The ephemeris for the year 1463 shows that the sun entered the sign of Aries on March 12, and on March 16 both Venus and Mercury were in that same sign along with the sun. Not until March 29 did Mercury move out of Aries to enter the sign of Taurus.[166]

Finding those three planets in the sign ruled by Minerva in the year of Lorenzo di Pierfrancesco's birth cannot be accidental. It must mean that Ficino was citing a specific astrological phenomenon in his letter. For, although the sun, Mercury, and Venus often "travel" together, they do not do so with such frequency that one can dismiss as a matter of coincidence the fact that they were exactly where Ficino said they would be.

Not only is Ficino's reference to Minerva's leadership of the Graces a valuable clue to Lorenzo's date of birth, now the identification of the central figure in the *Primavera* as a universal moon goddess who incorporates both Isis and Minerva is more understandable. Visually, as Minerva, this goddess governs the Graces who are, as Ficino wrote in the 1481 letter, "harmonious and propitious companions in the heavenly dance."

The ephemeris confirms that Lorenzo's Graces were in Aries from March 16 through March 28. During those same thirteen days, slow-moving Saturn and Jupiter were together in the sign of Aquarius and Mars was in Sagittarius. The position of the last of the seven astrological bodies, the moon, cannot be determined from the ephemeris, since she moves through one sign in only two and one-half days, more or less, and therefore would have traversed almost five signs during the days in which the Graces were together.

This information alone cannot determine Lorenzo's exact birth date, but it is possible to further narrow the time frame. One circumstance makes it possible to bring Lorenzo's birth date within four days. According to the Florentine calendar that was in use at the time, the new year began on March 26; thus, March 16-24 fell in 1462 and not 1463. This immediately restricts the natal day to sometime between the 25th and the 28th of March.

A second piece of information narrows his birth date by one more day, placing it between March 26 and March 28, and this introduces the astrological importance of the moon. In Ficino's 1481 letter, he states that the three planets in his and Lorenzo's charts are aspected similarly. Although many astrologers have used the word "aspect" to mean the angle between any two planets, Ficino's usage of the word in his writings indicates that he was referring to the angle between the moon and other heavenly bodies, which gives her "aspects" special significance. This is implied in his c. 1477–1478 letter, and it is unmistakable in the chapter on the three Graces in *De vita coelitus comparanda*, wherein he says that the benefits of Jupiter, Venus, and sun are best received when they are close together, in 30° or in 60° aspects to the moon He also reminds his reader that the moon has the power to transmit the benefits of these planets at all times.

Ficino's emphasis on the power of the moon is instructive but not unusual. In fact, astrologers have always considered the moon's position especially important, because it reveals much about a person's intuitive nature and disposition. Therefore, Ficino's remarks may be taken to mean that his "Graces" and Lorenzo's Graces have the same relation to the moon. In that case, it is possible to determine the house in which Lorenzo's moon fell when he was born, because Ficino left information regarding the location of the moon at the time of his own birth in 1433.

In the same letter to Giovanni Cavalcanti in which he discussed his natal Saturn, Ficino said that the moon was in the twelfth house of his birth chart. This means that it formed a 90° angle to the planets in the ninth house, which, astrologically, is called a "squared" aspect and is unfavorable. Like Ficino's, then, Lorenzo's moon would have been in twelfth house and, like Ficino, he would have been subjected to the unfavorable influences that befall one whose moon "squares" such important bodies as the sun, Mercury and Venus.

Of course, the natal charts of Lorenzo and Ficino were not identical, since different signs were rising in the eastern sky when they were born.

The one that was rising in the first house at the time of Ficino's birth was Aquarius; Lorenzo's rising (or ascending) sign had to be Leo, because his ninth house held the sign of Aries. Therefore, his twelfth house, just above the first house with the ascendant sign, would have been occupied by the sign of Cancer.

Now, according to Manilius, the sign of Cancer was given to the deity Mercury. In those days, as today, the ruling planet of Cancer was the moon. This means that, if Lorenzo's *natal* moon was in Cancer, its power would be especially strong by virtue of a reinforcement from the sign's own *ruling* moon. Furthermore, his natal moon would transmit an influence from the ruling deity Mercury to Lorenzo, since such a transmission was believed to be a function of the moon, and since, additionally, the ruling deity of a sign was thought to exert an even stronger influence on a native than the ruling planet. One may conclude from this that Lorenzo's moon, or Luna, was markedly Mercurial in character, with a very powerful influence over him.

Now the reason why he is idealized in the *Primavera* as Mercury becomes clear: Lorenzo's natal moon would have transmitted her own Mercurial nature to the boy's soul at the time of his birth. Consequently, his essential self would have been imbued with traits associated with Mercury's personality. In a painted image, such innate characteristics can be conveyed only through an outward appearance, specific attributes, or a costume. In this light, it is most appropriate that Lorenzo's astrological likeness—his essential being—be garbed in a variant of the traditional costume worn by the god Mercury, modified by the fifteenth century sword and helmet that would signify a contemporary personage.

Proposing that Lorenzo had a Cancer moon is consistent with the Florentine calendar, with Ficino's 1481 letter, and with the personified soul of Lorenzo in the *Primavera*. Since the date of his birth has been narrowed to within three days, one may propose a natal chart based on the planetary positions of March 27, 1463 at 2:00 p.m., Florentine time (Fig. 10).

This chart does not augur well for its native, especially with the Cancer moon opposing the Aries sun, Mercury and Venus. Additionally,

the planet Saturn implies competition and insinuates trouble with a benevolent planet Jupiter, his companion in the sign of Aquarius. Further, these two planets face the angry Mars, which increases the possibility of conflict with others—especially those who might be close to him—and tension within himself. To make matters worse, the position of Mars suggests duplicity and intrigue. There are two good features in this horoscope: The natal moon softens Mars because of their respective positions; and Saturn's melancholy is lessened by the friendly sun, Mercury, and Venus in Aries. Despite these features, the message of the planetary positions on March 27, 1463, points to a life of conflict, dissatisfaction and selfishness, and to a tendency to whine about misfortunes.

This woeful horoscope takes on importance when Ficino's strong identification with the young Lorenzo is considered. By claiming that he and the boy shared the same Apollonian daemon, which had been chosen by the sun with the consent of Venus and Mercury because the ninth house is pleasing to Apollo, and by stating that he was unable to complete his letter until he wrote "Marsilio salutes Marsilio," he implies that he saw Lorenzo as an extension of himself.

This kind of identification affords the best possible motive for Ficino's commission of the *Primavera*, and for his injunction to the boy to dispose his own heavens anew. Ficino must have feared that the boy would suffer the same kind of melancholy that had plagued him. If, however, he could convince Lorenzo that harmony and balance can overcome, and even transform, negative predispositions or adverse inclinations, he might save the boy from experiencing difficult and prolonged periods of depression.

Returning to the letter of c.1477–1478, with information about Lorenzo's horoscope that offers a motive for the letter's astrological content, one can understand why Ficino would instruct the boy to absorb beneficial influences radiated from favorably aspected planets. But that might not have been enough for Ficino. Since he evidently felt an uncommonly deep concern for the young Lorenzo, it would have

been in keeping with his personality and beliefs to look for a future date when the heavenly bodies would be in a remarkably propitious arrangement. Having found such a date, he would have lost little time in advising Lorenzo that the influences of that arrangement should be sought. Indeed, it is likely that he was referring to such a formation when he offered the boy a gift of the heavens.

These inferences have three implications. First, they indicate that the date of the propitious arrangement of the planets can be ascertained to within several days, by discovering whether there really was a time when the planets fell into a formation that corresponds to Ficino's description. Second, they suggest that the philosopher expected the beneficial aspects of the heavenly bodies to leave a lasting and positive impression on the boy, one that would create, in effect, an emotional or spiritual metamorphosis. Finally, they imply the presence of an astrological chart in the *Primavera*, or at least a specific astrological reference.

Once again, it is necessary to use the ephemeris. This time the purpose is to determine whether Ficino's reference to that most favorable disposition of the heavenly bodies was in fact an allusion to an actual chart. An appropriate date would be one when the planets are positioned so that the moon is in good aspect to the sun, Venus, Mercury, and Jupiter and in no bad aspect to Mars and Saturn. Further, it will be assumed that Ficino's 1481 letter identified a conjunction of the sun, Venus and Mercury–the three Graces that had been together in Lorenzo's natal horoscope–and that Jupiter must be in good aspect to the moon and the other three benevolent bodies. Since it is probable that the triad of Zephyr, Chloris and Flora is an indicator of the time of year, the month of May will command special attention. Finally, a date between 1478 and 1483 is indicated, the period of five years during which the *Primavera* undoubtedly was painted and which includes the dates of the two important letters from Ficino to Lorenzo.

The ephemeris does indeed show that the sun, Venus, and Mercury were together during late May and early June of 1482 with all the above

conditions fulfilled. This coincidence almost surely means that the *Primavera* includes a direct reference to, or a visualization of, an actual time when the planets were arranged according to Ficino's description. Moreover, it appears that Ronald Lightbown was correct in suggesting that this painting was executed later than 1478, most likely in the early years of the next decade. It may also be noted that, if Gombrich was correct when he dated the earlier of the two letters that seem to pertain to the *Primavera* to the winter of c.1477–1478, Botticelli's efforts must have extended over a period of several years.

Despite the fact that the three Graces were together during a period that conforms to a believable date for the execution of the painting and the dates of the letters from the philosopher to the boy, the arrangement of the planets during late May and early June must be examined more carefully in terms of the favorable aspects required by Ficino's first letter to Lorenzo. Only then will the necessary evidence of an astrological reading in the *Primavera* be confirmed.

A study of the ephemeris reveals not just one but two dates on which the moon aspected the other heavenly bodies in ways that are consistent with Ficino's letter. The first of these, May 13, seems to introduce a ten-day period that was especially auspicious (Fig. 11). The second date, May 23, represents a culmination of those beneficial influences (Fig. 12). (See Appendix III.)

The planetary placements on May 13, 1482 are very favorable and would have been augmented in Ficino's mind by his partiality to the season of spring. He considered spring to be the most favorable time of the year for celestial benefits because it extends from fiery Aries to Fiery Leo, which sign is ruled by the sun. In the passage where he expressed this notion, Ficino also remarked, "As the sun rises toward the mid-heaven, it wonderfully fosters a vital and airy spirit in us."[167] Both comments apply to the planetary positions of May 13, 1482.

The date of May 13 is especially significant in the context of the *Primavera*. In his interpretation of the painting, Charles Dempsey called attention to the fact that Ovid assigned the Ides of May to the

13[168] of that month and indicated that they were sacred to Mercury.[168] Of course Dempsey saw this as support for his view of Mercury as a spring wind god, as identified by the rustic Roman calendar.

Here, it is possible to see Botticelli's Mercury figure extending his caduceus toward the heavens–now arranged according to the chart of May 13–in order to receive the many blessings of the planetary placements on that date.

As favorable as the planetary placements of May 13, 1482, would be for a horoscope, the placements of May 23 were even more auspicious. The benevolent aspects that existed between and among the planets on May 13 had blossomed under the warmth of the spring air. All of Ficino's requirements were met.

Either of these horoscopes would be considered propitious, and either would be one that any person who believes in the efficacy of the stars might wish to claim for his own natal disposition of the planets. Moreover, in relation to Lorenzo's natal horoscope and Ficino's astrological tenets, and in comparison to each other, they are particularly interesting.

First, these two "election"[169] charts have been drawn for the same hour (2:00 p.m.) that was given for Lorenzo's birth in the proposed natal horoscope. The fact that the planets were in such favorable positions on May 13 and May 23 at that same time recommends these charts as substitutions, in effect, for the less promising natal horoscope. What is fascinating is not the probability that Ficino would try to counteract the less favorable reality with more beneficial astrological conditions, but that it was possible for him to do so because actual planetary positions, which more than qualified, serendipitously presented themselves.

Ficino wanted Lorenzo's Luna to avoid the speed of Mars and the tardiness of Saturn. It would seem that her move from Aries (where she opposed Saturn but was in a rather salutary aspect to Mars) to Leo (where her aspects to these same two bodies were almost exactly reversed) conforms to this stipulation. And he told the boy that his moon should behold Jupiter, who represents human and divine laws. Her aspect to Jupiter on May 13 complies with that advice while the

conjunction with him on May 23 definitely assures her attention to him. The sun, who is God Himself, and Mercury, the representative of good advice, reason, and knowledge, must also be beheld by the moon, and in both charts she does, indeed, share their benefits. But, most of all, Ficino instructed the boy to direct his Luna to the humanity of Venus.

> For Humanity (*Humanitas*) herself is a nymph of excellent comeliness born of heaven and more than others beloved by God all highest. Her soul and mind are Love and Charity, her eyes Dignity and Magnanimity, the hands Liberality and Magnificence, the feet Comeliness and Modesty. The whole, then, is Temperance and Honesty, Charm and Splendour. Oh, what exquisite beauty! How beautiful to behold. My dear Lorenzo, a nymph of such nobility has been wholly given into your power. If you were to unite with her in wedlock and claim her as yours she would make all your years sweet and make you the father of fine children.[170]

In this passage Ficino is expressing the traditional meaning of the planet Venus, to whom is attributed "harmony, art, beauty, and affection [and] the ability to attract others and maintain relationships.[171] In addition, his emphasis upon her characteristics as constituting the notion of *Humanitas* corresponds to the astrological role of Venus in these horoscopes, which focuses on an harmonious interplay of the mind, soul, and body and seems to ask for the participation of such an integrated personality in humanitarian activities and worthwhile relationships. Indeed, her move into Gemini that resulted in her very close conjunction with Mercury in the chart of May 23 was the event that would have represented to Ficino a high point in, or climax to, a period of time that was uniquely propitious. Ficino quite understandably would have seen Venus as the planet around which the message of that horoscope was consolidated, around whom coalesced "Temperance and Honest, Charm and Splendour."

The reference to marriage in this passage raises the question of whether the *Primavera* had anything to do with the wedding between Lorenzo di Pierfrancesco and Semiramide d'Appiano that had been planned for May, 1482. Lightbown and, later, Levi-D'Ancona proposed that this occasion had motivated the commission of the painting.[172] Negotiations for the marriage had begun in 1480, and the engagement was confirmed in a contract signed in August, 1481. Certainly Ficino would have known of the upcoming ceremony when he wrote to Lorenzo on October 18, 1481. Yet, there is nothing in that letter about the marriage, nor is there any indication that it was on Ficino's mind or was of any real interest to him.

Furthermore, although Ficino's earlier letter to Lorenzo may not have been written in c.1477–1478, it appears that it must have been written before the arrangements for the wedding had been confirmed, which means that Ficino's plan for a "present of the heavens" predated those plans.

The fact that Ficino made no reference to Lorenzo's marriage, combined with the very personal nature of the messages in his letters, leads one to conclude that the wedding was not the reason for the commission of the *Primavera*. On the other hand, it is entirely possible that the wedding was planned for a date during the propitious eleven-day period between May 13 and May 23, 1482, because Lorenzo already knew that that time would be salutary.[173]

In the last analysis, it seems clear that Ficino's self-confessed identification with the young Lorenzo persuaded him to try to "correct" the adversities indicated in the boy's natal horoscope with the benefits from new horoscopes that would enable the boy to live more happily. In fact, Ficino hoped to effect a spiritual or psychological transformation for the sake of Lorenzo's future wellbeing. But, this must be related to the *Primavera* in a specific way to justify the notion that the philosopher's primary concern was the boy's character, humanitarian behavior, and ultimate salvation.

IX. The Astrological Charts and the Primavera

The most direct and persuasive way to prove the astrological component of the *Primavera* would be to find a chart insinuated within the composition of the painting. A simple demonstration shows that there is such a chart. When a square map is laid over the left side of a diagram of the *Primavera*, it confines six figures, excluding only the triad of Zephyr, Chloris, and Flora. This overlay makes it possible to interpret the painting in terms of the May, 1482, horoscopes. (Fig. 13).[174]

In his book, Leonard Barkan pointed out that the obsessions with astrology in the fifteenth century gave rise to all kinds of diagrams, especially in manuscripts, and usually featuring planetary gods.[175] Therefore, to suggest that a diagram of a horoscope might have been a feature of a painting is in keeping with that interest and practice.

The triad of Zephyr, Chloris, and Flora is a time indicator and therefore does not function astrologically. These figures act as in Ovid's descriptive passage: Flora's festival at the end of April and beginning of May introduced the latter month with its promise of new life and beginnings. In the *Primavera*, these figures direct the viewer's eye to the images on the left that are included within the map; they introduce the month of May or the sign of Gemini, the sign that holds the sun in the proposed horoscopes.

Now the appearance of Zephyr, the West Wind, on the right side of the panel is understandable. The use of a personification of the West

Wind on the right side of the painting is quite puzzling if one assumes that the *Primavera* depicts an earthly realm. But since an astrological map reverses the placement of the four cardinal directions, Botticelli must have placed the West Wind on the right side of this painting to indicate that the viewer is indeed confronting a representation of the celestial domain. This not only confirms the notion that the flattened space-distance and the positions of the images in the *Primavera* were purposeful and that it is, literally, a "present of the heavens." More than that, it establishes that the painting refers to a day or days in the month of May, which was introduced by the lead figure of Zephyr's triad, Flora.

The portrait image of Lorenzo di Pierfrancesco is contained within the eastern houses of the chart, on the left side of the diagram. Most of his body is in the first house, the mansion of the self and ego, where it logically belongs. The fact that the top of his head and his right arm are in the twelfth house can be seen as references to his natal Cancer moon; for then his reach toward the eleventh house could imply that the Mercurial Lorenzo is either revealing or disposing his progressed moon and Jupiter, both of which were in the eleventh house on May 23, 1482.

The central figure fills the western houses to complement Lorenzo's occupation of those in the east. Her swelling abdomen is centered in the seventh house of Aries, as if to suggest that Lorenzo's birth occurred when the sun was in that sign, in which case one could think of her as the Minerva whose temple at Sais carried the inscription that included the statement, "Sol is my son, the fruit that I have brought forth."

At the same time, the figure's lunar medallion is positioned so that it falls in Aries, almost exactly in a place that would correspond to the position of the moon on May 13. This emphasizes her identity as a moon goddess. The inclination of her head appears to be an allusion to the path of the moon between May 13 and may 23, when she advanced from Aries through the southern houses at the top of the chart to the eleventh house of Leo.

During this course the moon began the first quarter of her cycle. She was the new moon when she was in conjunction with the sun in Gemini. From there, as the waxing crescent, her fullness increased until the sun completely illuminated her in the third house of Sagittarius, opposite the flaming point of the putto's arrow. This phase of the moon's cycle, like the sign of Gemini and the month of May, signifies new beginnings, growth, and a search for a definite identity. It would have been an ideal time for Lorenzo's development under the propitiously aspected three Graces.

The *Primavera*'s moon goddess quite naturally directs the viewer's attention to those Graces. They revolve in their heavenly dance in accordance with the astrological reality—not only because they were under the rulership of Minerva in Lorenzo's natal horoscope, but because it was the moon's aspect to those planets that was so important to Ficino.

The Graces themselves do not fall in any of the houses of this graphic pattern. But, since the images of Lorenzo and the central figure seem to allude to Pierfrancesco's natal as well as the two election charts, it would be difficult to think of a composition that could put these three figures in one house that represents two different signs (Aries and Gemini) at the same time. Instead, they occupy the part of the chart that represents the terrestrial realm, as though they are personifications of the daemonic beings that descended to Lorenzo's spirit from these planets at the time of his birth.

The coloring of each of the Graces is markedly different, leading to the conjecture that Botticelli used color to identify the Graces. The Grace on the right with very light hair and a shining countenance, surrounded by pearls, should be the sun. Because of her slim elegance, her copper-colored hair, and her longing gaze toward Lorenzo, the middle Grace must be Venus. Finally, the Grace on the left whose drapery overlaps the Mercurial Lorenzo must personify the planet Mercury.

Lastly, the ninth house of Gemini is fully occupied by the cupid figure, and this is convincing evidence that an astrological map is a

part of Botticelli's composition. This putto should be Horus/Apollo or Horapollo, corresponding to the dual identity of the moon goddess as Isis/Minerva. Thus, he must be a daemon from the ruling deity of Gemini, Apollo, who shoots his arrow of Apollonian influence toward the Graces within and under his dominion.

Identifying the *Primavera*'s putto as an astrological daemon does not depend solely on his location in the ninth house of Gemini on the square chart that overlies the left side of the diagram of the *Primavera*. There is, in addition, external evidence that supports this view.

An extant alchemical manuscript, dated 1480 and attributed to Nicola d'Antonio degli Agli, features illustrations of planetary rulers, each of which is shown on an elevated platform or pedestal. The zodiacal constellations governed by each of the personified planets are represented by their traditional symbols inscribed in roundels that are placed against the base of the platforms.[176]

One illustration shows Venus, dressed in a short tunic and seated on an elaborate throne, accompanied by a curly-headed, blond cupid who wears a blindfold and has a quiver slung over his shoulder (Fig. 14). His left hand holds a bow, and his right hand is pulled back as though he is prepared to shoot an arrow. It is Venus, however, who holds the arrow with its point directed toward the sky above. She is shown directly above a roundel with a balance scale, the symbol of Libra, while the cupid is shown above a second roundel that contains an image of a bull, the insigne of Taurus.

During the Renaissance all the planetary rulers, excepting the sun and the moon, claimed two signs. Of these two, one was diurnal, or a day sign, and the other was nocturnal. In the case of the signs given to Venus, Libra was (and is) her diurnal constellation; Taurus is her nocturnal sign. The blindfolded cupid over the medallion that contains Taurus's bull suggests that this putto was meant to be a reference to the night sign, with the blindfold connoting nocturnal darkness. The cupid, in effect, is either another form of Venus or, more probably, her daemonic alter ego. If this is indeed the meaning of the manuscript's

blindfolded babe, one might reasonably extrapolate a similar meaning for the putto in the *Primavera*; for there can be no question that the images are almost identical.

Therefore, since Gemini is a night sign (whose diurnal companion under the rulership of the planet Mercury is the constellation Virgo), it is very possible that the painting's putto was intended to symbolize Gemini, who is also ruled by the deity, Apollo. This putto, then, would be an Apollonian daemon.

The foregoing has demonstrated that the composition of the *Primavera* serves as the foundation for an astrological chart whose divisions correspond to Botticelli's images, which, in turn, serve as functionaries in Lorenzo's horoscopes. This establishes the iconographical message of the painting in its specific astrological instructions, and its more general allegorical implications of harmony and balance. Ficino's writings supply even more evidence that supports this thesis while adding another dimension.

Ficino appended six little stories or fables to his 1481 letter to Lorenzo di Pierfrancesco, which deepen the meaning of the *Primavera* when they are read in the context of the astrological interpretations of the work. Gombrich translated one of these stories but could not see its pertinence to the painting due to his conviction that the central figure was intended to be Venus.

Each of the six short allegories concerns a different character or characters; and all but one of these characters seem to correspond to images in the painting. It would appear that Ficino wrote the allegories to explain the *Primavera*, allowing a different image to assume the leading role in five of the stories. The first fable, "A daemon heals a divine being with divine nourishment alone," features Mercury.

Once, in the gardens of the Pythian Apollo, Mercury, smitten by love, pursued Venus as she was picking various flowers and fruit. At last, with Phoebus as his informer and guide, he happily reached her and knew her with the greatest

pleasure. After this encounter, the boy arose and now was completely beautiful. Anyone would have easily recognized in him the sharp-sightedness of Mercury, the grace and loveliness of Venus and the splendor of Phoebus, all at the same time. Therefore, according to the fables told by our ancestors, his protector Apollo called him Mercury, whom the highest gods called the Logos. Apollo also judged that, to the extent that he has contributed to a beneficial and pleasurable generation of the species during his travels far and wide, to the same extent his brother, Cupid, has harmed the species with his arrow of noxious desire.

As I was saying, the subject of this fable [Mercury] was unknown to the people of the area and, while wandering about in the nearby forests outside the Pythian gardens, by chance he came upon some shepherds who were wonderfully delighted by the divine form and nature of this boy. Therefore, they kept him with them for a long time. These people fed this elegant subject of our story coarse food such as acorns, chestnuts and other similar things. After a while, because of this diet, he began to take on a brutish appearance, for he had been denied refined food. Finally, his protector, Apollo, showed his favor by extending his hand and leading the grateful Mercury back from the woods to the Pythian gardens, which today the Florentines call the Pinthian gardens. This story teaches us that a creature of divine origin prospers only when given nourishment fit for the divine.[177]

This fable operates on two levels. First, it seems to be a direct reference to the planetary positions that are of concern. On May 13, 1482, Mercury had advanced past the sun and the slower body, Venus. At this time he already had begun to go retrograde: i.e., he appears to be going backwards, pulling back to a close conjunction with Venus, behind the sun.

Since Gemini is ruled by Apollo, one may interpret the fable to mean that the Pythian or Apollonian gardens represent Gemini. Mercury's union with Venus under the laurel tree (Apollo's tree) stands for the conjunction of those two planetary bodies under the leadership of the sun. Ficino discloses that Mercury thrives in the gardens of Apollo but is "brutish" outside that flowering and fruitful environs. Astrologically, this means that the transiting planet Mercury has his greatest strength and is most beneficial when he is in his own "home," Gemini, the sign ruled by the planet Mercury and the god Apollo.

The second level of meaning is a didactic directive to Lorenzo that cautions him to feed his Mercurial Luna, the spiritual motion between body and soul, "divine nourishment" and to avoid unrefined substances lest they incline him toward "coarseness." Ficino seems to be telling the boy to expose his mind to the highest spiritual and intellectual ideas and refrain from coarse behavior and common talk.

Finally, the laurel tree is featured in this story. This tree was associated with Lorenzo by virtue of its connection with his namesake, St. Lawrence. It was also claimed by Apollo. The fact that this particular tree was the attribute of both the saint and the Greek god of reason and light helps explain why Ficino emphasized Apollo's influence over Lorenzo in the 1481 letter, and why the May, 1482, charts, where the Graces are in Apollo's domain, were so significant. The metaphorical use of the laurel tree in this story interrelates this fable, the letter to which it was appended, and the astrological charts of May, 1482.

Ficino headed the second allegory with the admonition, "The philosopher ought to avoid three things in particular: sensual love, greed and ambition." The story features "Philosophia."

When Minerva (whom the ancients called Wisdom because she was the only one born from the head of Jupiter) realized that it had been necessary for her father, a god, to produce her, a goddess, from his head, she went to him in supplication and finally prevailed upon him to let her, too, in emulation of him,

reproduce at least once from her own head. Thus she brought forth a daughter whose grandfather was Jupiter and who was, at the same time, very like herself, the child's mother. Indeed, from the moment of her birth, she displayed her grandfather's legacy not only in her mental judgments but also in the dignity of her countenance and carriage. In addition, she demonstrated the courage and modesty of Minerva, her mother, in her character as well as in her actions.

Her grandfather wanted her to be named Philosophia because of her mother, Wisdom [sophia]. He advised Philosophia that she owed her existence to Sophia, the daughter of the highest head of all things. Therefore, she should be at the service of all things, from the lowest plant life on earth to the highest head of things, and never should she associate with the inferior Venus or her poisonous son, Cupid. Moreover, for eternity Philosophia steadfastly will believe in a philosophy of moderation, for this is implicit in her name. And he added that, above all, she should avoid everything in the lower world of Pluto and the practices of his cults. In addition, he instructed her that if she were to drink the water and eat the plants from the stagnant river Styx because ambrosia and nectar were unavailable, she would be dining unhappily, because these are the lowest of all things. Finally, he warned her never to accompany the ambitious Juno, who flies around in the misty air. And she should not exchange clear weather for storms, or starry skies for cloudy ones.[178]

If Lorenzo's Luna, who, as the motion between his body and soul, represents a moderating spirit that will temper any tendency toward excesses, then this Philosophia, who has "within herself a philosophy of moderation," may be another personification for the notion of mediation. Recalling that the moon was under the protection of Minerva on May 13, advancing to Leo by May 23, coming under the rulership of divine Jupiter, one can believe that Philosophia is merely another name for

the central figure in the *Primavera*–the image of the moon in the square astrological map symbolizing both May 13 and May 23, 1482. For Ficino to refer to the central figure as Philosophia in this story is appropriate, considering the philosophical connotations of Minerva, as well as those of Isis, and the long tradition of both goddesses's associations with wisdom.

By using the lower Venus to personify sensual love, Ficino reminds his reader that Cupid, the son of Venus, is poisonous and should be avoided. This passage also distinguishes the higher, intellectual virtues of Minerva from the sensuality of the lower Venus in a way that makes it impossible to call the central figure of the *Primavera* Venus.

The third fable is entitled, "The impious never follow the Muses or the Graces but chase after magpies and furies."

> Once, while Orpheus was walking in the sacred Delphic groves, he impulsively called upon the courteous oracle Apollo, acting as though he had already appeased him. Then, when he looked to Apollo's right, he saw the Muses, accompanied by the three Graces, close at hand. At the same time, on Apollo's left and following at a distance, were magpies and furies. Greatly astonished, Orpheus exclaimed in a rather loud voice, "Oh, why do those hostile and unpropitious beings follow him who is the leader of this group?"
>
> Phoebus said that wise men understand. "To be sure, every day many people sacrifice to me, and by doing so, they hope to obtain the benefits of the Muses and the Graces through me. Those who perform sacrifices with clean hands do receive songs and favors from us while those who dare to approach holy beings with defiled hands take back, against their wills, magpies and furies."[179]

It is easy to see this story as a reference to the *Primavera* when one accepts the putto in the painting as an Apollonian daemon, for the

Graces are indeed to his right. On the other hand, teeming magpies and furies do not belong in a depiction of celestial harmony; hence they are not to be seen. Furthermore, Ficino indicates that they are following Apollo "at a distance."

What is new in this fable is the inclusion of the Muses along with the Graces; for until now there has been no indication that they were intended to be recognized in the painting or that they are connected with the Graces. On reflection, some kind of conflation of the Muses with the Graces is understandable, since, in the *Primavera*, the latter "follow" Apollo because they are in his sign of Gemini, while, traditionally, the former have always been acknowledged as his followers.

Ficino's lesson in this story can be summarized as a reminder to Lorenzo that he must maintain a pure or pious heart in order to receive and benefit from the salutary influences of the Graces (the sun, Mercury, and Venus); but, through the rhythmic dance of this triad under the leadership of Apollo, he may also benefit from the harmonies associated with the nine Muses.

The fourth story, "Power does not rule without wisdom," has a succinct moral that is in keeping with the other lessons of these fables, but the allegory does not seem to apply directly to the images in the *Primavera* and, since it is very brief, it may be paraphrased.

In this episode, Ficino used Prometheus as his protagonist. That titan, who is known for his disobedience to Jupiter because he stole the heavenly fire in order to bring life to man, ascends to the celestial realm where he confronts the father of the gods. Having observed that the sun and Mercury are always together in the heavenly cycle, he asks Jupiter why this is so. Jupiter replies that this is purposeful, for it shows that the sun, who is powerful as the leader of the planets, must be accompanied by wise Mercury. Similarly, on earth, power should never be exercised without wise counsel.[180]

The moral of this story is implied in its title: Power must be guided by wisdom, lest it corrupt. As a Medici, Lorenzo would undoubtedly expect to wield some degree of power in Florence. Thus, Ficino cautions

him to use it prudently. This is consistent with the two horoscopes of May, 1482, both of which suggest a leadership role for Lorenzo in civic or humanitarian enterprises. It seems clear from this reinforcement of Ficino's astrological advice that the philosopher was troubled by the boy's tendencies toward self-indulgence and insensitivity toward others.

The reason behind Ficino's choice of Prometheus for the leading role in this scene is less obvious. That titan ordinarily has been seen as a benefactor of mankind through his defiance of Jupiter. However, he had to suffer the consequences of his disobedience when Jupiter chained him to a rock where, every night, an eagle tore at his liver. Each morning the liver was restored in order to perpetuate his torture. Eventually, Prometheus was rescued by Hercules, and Jupiter accepted him as a god so that his suffering was redeemed. The nature of this myth suggests that Ficino was offering the story of Prometheus as a model for Lorenzo: The boy must try to benefit mankind despite any difficulties or trials he might have to endure; for, finally, he would be rewarded.

In the fifth fable, "On the passage from his book on love, which was sent from Alamanno Donato to Lorenzo de' Medici," Ficino lets a young man, Alamanno Donato, demonstrate his own mature understanding of his experience with a "cupido" in such a way that he seems to be setting an example for the boy Lorenzo.

> Not long ago, when Alamanno was strolling among the laurel trees, as was his custom, he at last captured a cupid who had been flying among the trees rather frequently, attacking them furiously. The kind adolescent quieted the little one, soothing him with gentle strokes. Then, since he realized that the infant was a god, he adorned him with garlands and flowers. While he was decorating him, he questioned him. "Cupido, what extraordinary wind carried your wings to this place? Should you not be at Cythera or Paphos or Idalium?"[181*]
>
> Sighing deeply, the god replied, "Alas, for a long time, anxiously and eagerly, I have looked far and wide for my own dear

mother. I did not find her at Paphos or Idalium or even at lofty Cythera. However, Apollo, alone of everyone, felt sorry enough about my long wanderings to guide me with these words:

"Oh, Cupido, at one time your mother was honored only with insignificant songs and unimportant dances. But then, she who is a refined creature, became more ambitious. She began to grudge Achilles his Homer and Aeneas his Virgil, and soon she ardently longed for a poet who would do for her what these others had done for their heroes. She longed for a poet who would make her skills and glories resound even more sublimely at Cythera. Finally, after many generations and after she had been recognized as Venus, she found such a poet–a grey-haired man named Lorenzo–among the laurels in the land of the Tuscans, in the very same place, Careggio, that belongs to the Graces. Now she is praised there in the sweetest verses that sing of her glories, and there she reposes most comfortably, having forgotten everything else. From this time on, Cupido, your Venus shall rest among the modest muses. Thus, you indeed may join your mother there and live with her always.

"Thusly did Phoebus advise me, Alamanno. For this reason, I, who am and have been overwrought for such a long time, am finally searching for this Careggio through the cypress that has been abandoned and the ivy and myrtle that have been neglected. If you would lead me to my mother, I would be kindly disposed toward you, would look upon you more favorably than on anyone else, and I would unite you with my beloved mother in a kind of perpetual reciprocation."

Then Alamanno graciously said, "Cupido, whom I hold in my hand, you are the most precious of all flying creatures. Indeed, I have often trod the path that wends toward Careggio. Lucky me, into whose hands flew a most blessed infant on this day! Now, divine boy, spread your gossamer wings and go forth. With the auspicious guidance of Apollo, let us both head for

Careggio by way of the path next to the city walls of Faventina.
I, of course, will go on foot, but you will fly."[182]

The key to this long and rather difficult passage lies in its title, which indicates that Ficino repeats an allegorical tribute written by Alamanno in honor of Lorenzo il Magnifico. The allegory specifies that Careggio, Ficino's county villa where his Academy members met to study and emulate Plato, is the place where he, Alamanno, also expects to find a heavenly Venus, since it was there that il Magnifico had undertaken the task of writing of her glories and benefits under Ficino's tutelage. Because the Venus of this story contrasts so sharply with the mother of the poisonous cupid in Ficino's other fables, this allegory may not seem consistent with them; but there is at least one good reason why the philosopher might have considered it appropriate for the younger Lorenzo and the *Primavera*.

According to his own writings, il Magnifico was preoccupied with a celestial "lady," who may be compared to the pure Venus of Plato's *Symposium*.[183] Ficino's deference to the Minerva who instructed him in his relationship with the young Lorenzo demonstrates a similar attitude toward her that il Magnifico showed toward his own heavenly "lady." In other words, the philosopher shared Pierfrancesco's obeisance to the boy's natal deity, while the elder Lorenzo was devoted to a celestial Venus.

It is now possible to summarize the lesson of the allegory. Il Magnifico's verses about his Venus had inspired Alamanno's search for her at Careggio. So, too, should Pierfrancesco be inspired to pursue his three Graces of Minerva under the guidance of Ficino, who lived at Careggio and had sent the letter of October 18, 1481–including these stories–from there.

The imagery in this tale makes a comparison to the *Primavera* inevitable. The description of the path to Careggio compares to the setting in the painting. Just as the cupid of the allegory flies about among laurel and cypress trees, so does the Apollonian daemon of the

Primavera disport himself in the same combination of evergreens.[184] Like the Pythian gardens mentioned in the first of these stories, these are under the auspices of Apollo, suggesting that the role of the cupid in the fable may be seen as a daemon of Gemini's ruler. The verdant copse through which he flies then becomes an allusion to his astrological home, in correspondence to the painting. Finally, Ficino's description of Alamanno compares to the Mercurial Lorenzo of the *Primavera*.

The last of Ficino's fables was translated by Gombrich. Despite its length, it bears quoting in its entirety, for it completes the philosopher's dramatization of the *Primavera* by featuring the triad of Zephyr, Chloris, and Flora. Ficino called it, "Wherein Lucilia, that is, the soul, fares badly when she leaves Phoebus, who is God."

> Among the many pieces of advice which Phoebus, the light of life and author of life-giving medicine, gave to his daughter Lucilia, the main counsel was that she must never leave her father's side or else she would suffer diverse grievous ills. At first Lucilia obeyed the commands of her father, forced by the rigour of winter. But later, reassured by the happy smiles of spring, the maiden began to stray farther from her father's house, and to stroll among the beautiful gardens of pleasant Venus across the gaily painted meadows; beckoned on by the charm of the fields, the beauty of the flowers and the sweetness of scents, she began to make wreaths of garlands and even a whole garment of ivy, myrtle and lilies, roses, violets and other flowers. Soon she began plucking the sweet berries and bland fruits all around her, not only tasting them but devouring them with eager mouth. Then the pride that she felt in her new ornaments made her bold; she became vain and conceited and quite forgetting her father, she entered the nearby city. But meanwhile the snakes hidden among the herbs constantly bit the feet of the dancing maiden, and the bees hidden among the flowers of her garlands strung her cheek, neck and hands. Swollen with the richness

of her unaccustomed food she was sorely grieved. Then the ungrateful Lucilia, who had already been seduced by pleasure to despite her father, the healer, was compelled by her great pains to return home and to acknowledge her father, whose help she demanded with these words: "Ah my father Phoebus, come to the aid of your daughter Lucilia. Please hurry, oh dearest father, help your daughter, who will perish without your succour." But Phoebus said: "Why, vain Flora, do you call Phoebus your father? Stay now you, immodest wretch, stay, I tell you, I am not your father, you just go to your Venus, impious Flora, and leave me instantly." But imploring him even more with many prayers and beseeching him not to take the life of the only maiden to whom he had given it, she promised him she would never again disregard his paternal commands. At last her loving father forgave her and admonished her with these words: "I do not want to heal you before you have divested yourself of those tinsel ornaments and lascivious trappings. Let it be your lesson, the lesson of your temerity, that while you stray far from your paternal home you buy a brief and slight pleasure at the cost of such long and grievous pain, and that the little honey you win by disregarding the commandments of the true healer will bring you much gall."[185]

This allegory is reminiscent of the Ovidian story, in as much as Ficino gave his disobedient nymph the name of Lucilia in the first part of the fable and then switched to the name of Flora in the last section. In fact, this reference to Flora, and the implication of a transformation from one nymph to another, tends to confirm Warburg's citation of the passage from Ovid as the source of Botticelli's triad in the *Primavera*; and it suggests that Ficino was giving his own interpretation of that transformation in this story.

If the Chloris figure is now Lucilia, Ficino used her to personify the moon, as she courses through the zodiacal signs that correspond to the

winter and spring months of the year. In the harsh months of winter, says Ficino, Lucilia obeyed her father, Phoebus; but when she entered Taurus she was seduced by the enticements of pleasure and neglected her father. She adorned herself with garlands, made an entire garment of greens and flowers, and sated herself on the sweet berries. Now, when she wanted to return to her father, Phoebus addressed her as Flora, telling her that she belongs with Venus, who rules Taurus as both its guardian deity and planet. It is obvious that the image of Flora in the *Primavera* corresponds to Ficino's description of the nymph with her garment "of greens and flowers." And it is significant that the festival of Flora introduced the month of May, for this circumstance associates Flora with the sign of Taurus. However, the moon at last would enter Gemini, at which time she would return to her father, Phoebus Apollo.

The fact that Ficino chose the unusual name of Lucilia for his nymph may indicate that he was not referring to the moon–who more properly would be called Lucina–but was feminizing the sun.[186] In that case, he would have been describing the sun's course through the signs of the zodiac and referring directly to the months of the year but seeing the sun as a female nymph in order to distinguish it from Apollo, the ruler of Gemini. Although this interpretation does not seem to be consistent with Ficino's personality and literary mannerisms, it does correspond more closely to the astrological message of the *Primavera*. Either way, the allegory suits the temporal function of the triad on the right-hand side of the painting.

Ficino's title to this story explains the philosophical level of meaning that pertains to his instructions to Lorenzo: The boy must be sure that his own soul enjoys the enlightenment of Phoebus who is God. He must not neglect his religious training and practices, since these ensure his salvation, and he must shun material and physical pleasures for a life free from indulgence in such allurements. Otherwise, he will be condemned in the eyes of God.

As a whole, these six fables exhort Lorenzo di Pierfrancesco to be pious, disciplined, ascetic and obedient. They echo the letter of c.1477–

1478 in which Ficino warned the boy that he would not experience happiness without effort and the hard work implicit in "disposing" his heavens anew, for these imply an unquestioning acceptance of a strict regimen as well as an adherence to Ficino's beliefs.

The analysis of the astrological content of the *Primavera* would not be complete without discussing in greater depth Ficino's emphasis on Apollo, which runs through the six allegorical fables and governs the meanings of the May, 1482, horoscopes.

Having conflated Apollo with Horus as Horapollo, Ficino addressed him as the sun. Further, Ficino used the adjective Phoebus, meaning "radiant," as a metonymical name for Apollo. Since there are differences between the body of the sun and the personality of the deity, Apollo, it appears that Ficino once again was consistently inconsistent, being no more inclined to keep careful distinctions between and among the identities of the sun, Phoebus and Apollo than he was for those of the moon goddess or those of the three Graces.

Indeed, he introduces the *Liber de Sole* with all three names. After quoting a passage from Pythagoras, which indicates that the Florentine associated the ancient Greek philosopher with a reverence for the "light of God" that resembles the sensible light (the sun), Ficino states that the purpose of his essay is to present an allegory that would be pleasing to Phoebus, and he adds that the Muses do not argue with Apollo but instead sing for him.[187] Further on in this book, Ficino notes that it was his belief that the ancient theologians called the sun Apollo and considered him to be the author of all harmony and the leader of the Muses, because he frees souls from disorder and confusion.

What emerges from Ficino's book on the sun is the fact that he saw the sun as a metaphor for a divine "light." In the very next chapter he informs his reader that, "nothing is found in the world that compares to the Holy Trinity like the sun." This assertion is followed by his argument that there are three substances in the one sun, distinct from each other but united together. These are, first, a natural fecundity, entirely hidden from our senses; second, a light that is similar to intelligence and

compares to the Son, who was conceived with intelligence; and last, a warmth that represents the warmth of the loving Spirit. This same section also includes a discussion of the three hierarchies of angels that are around the divine Trinity, each of which has three subordinate parts around the sun.

The philosopher's syncretism made it possible for him to give mythological counterparts to his Christian subdivisions of the sun. Thus, after stating that the ancients placed spirits–those from the higher gods were followed by spirits from the nine Muses–around the sun, he said the sun has both substance and powers that are named for the higher gods. In the substance of the sun are essence, life and intelligence; he calls essence the sky, while life is called Thea and intelligence is named Saturn. The powers of the sun are the same as those attributes that Ficino earlier had given to the Trinity: Fecundity now is recognized as Jupiter and Juno; light compares to Apollo and Minerva; the sun's warmth is incorporated in Venus and Bacchus. Ficino would have equated Jupiter and Juno with the First Person of the Trinity, Apollo and Minerva with the Second Person, and Venus and Bacchus with the Holy Spirit.

His identification of the divine beings from the nine Muses that are around Phoebus specifies that these are Apollonian beings, distributed from the sun to the nine spheres of the universe. Here Ficino says that the nine spheres are the seven orbits of the planets plus the sphere of fire and, beneath it, the sphere of air. The divine Apollonian beings, invisible to the eye, are evenly distributed throughout these nine spheres and are dedicated to singular stars that, Ficino says, were called angels by Proclus but which Iamblichus went so far as to call archangels. Then Ficino explains that the ancients addressed the Muses as rulers of all knowledge, but especially the knowledge of poetry, music, medicine, atonements, oracles, and prophecies.[188]

This chapter from the *Liber de Sole* is particularly interesting because it not only explains that Ficino revered the sun as a metaphor for the Christian Trinity; it also gives information that applies to the content of the *Primavera*. Now one can understand why Ficino would link the

Muses with the Graces in his third fable, for one of the Graces is the sun. And, since the nine Muses themselves originate with the sun, the divine beings of the Muses must be Apollonian in nature.

In another comparison of the sun with God, Ficino again used a figure of speech. After explaining that the sun must first warm opaque materials, thereby purifying them so that they can be illuminated and then, warm and light, be elevated to the sublime, he says that, in this way, Apollo pierced, purged, destroyed, and elevated the Python with the arrows of his rays.[189]

This same metaphor is repeated in Ficino's summary of Plato's *Cratylus*, where he gives five meanings to Apollo. In order, Apollo signifies (1) the honesty of a divine and angelic substance; (2) the power by which God purifies and liberates souls; (3) the benefit by means of which God conjoins liberated souls to better things; (4) an arrow-like virtue whose sharp point enables God to shoot His favors so that they penetrate, and also makes it possible for Him to destroy injustices; and, (5) the efficacious mean proportion that turns everything around in musical measures.[190]

Apollo's archery is one of his traditional abilities. Ficino's metaphorical use of that skill in these two passages is in harmony with the letter of 1481 and the *Primavera*. The stories in which a putto flew around in the gardens of Careggio as the protector of Mercury, the oracle, or as the worthy Cupido describe cases where benefits and/or virtues were bestowed by that infant, just as they are bestowed by Apollo's arrow in these passages. And, the Apollonian daemon in the *Primavera*, as the agent of Apollo himself, oversees the revolution of the dancing Graces in the ninth house of Gemini at the same time that he is about to penetrate them with a sharp point that carries God's favors.

Ficino's letters to Lorenzo di Pierfrancesco, his allegorical stories and definitions of Apollo's nature coalesce in an iconographical interpretation of the *Primavera* that accounts for its setting and all the images and their interrelationships and demonstrates that there is a remarkable consistency and logic between these seemingly disconnected and/or fanciful references and the visual evidence of the painting.

Finally, then, the astrological references in Ficino's c.1477–1478 letter have been explained. The key to understanding them was the recognition of the central figure as the universal moon goddess. Her importance to Ficino in the guise of his favorite goddess, Minerva, has been demonstrated, and Minerva's astrological role and function in relation to the life of Lorenzo di Pierfrancesco have been discussed in great detail. Yet, the central figure in the *Primavera* looks like the Egyptian goddess, Isis; she does not bring Minerva to mind. Why, then, if Ficino intended the painting to be an astrological lesson to the young Lorenzo, featuring Minerva, did he allow Botticelli such latitude in his depiction of her?

The answer can only be that Botticelli's central figure needed to serve more than one purpose. Indeed, this may be the reason why the central figure in the *Primavera* does not carry obvious, specific attributes that would confine her identity to only one deity. Further, not only would Ficino's syncretic inclinations permit him to overlay one identity with another, but one might suspect that he took for granted the circumstance that required the goddess in this remarkable painting to perform more than one role. As Minerva, her role is astrological; as Isis, this same moon goddess is associated with the occult science of alchemy. Therefore, because of an analogical relationship between these two processes, one should expect to find an alchemical component in the *Primavera*, paralleling its astrological reading.

X. The Alchemical Process and the Primavera

In the discussion of the astrological content of Botticelli's *Primavera*, alchemical illustrations supported identifications and interpretations of the painting's imagery. The fact that they were alchemical is not accidental.

In his book on alchemy, Titus Burckhardt points out that, since both astrology and alchemy in their Western forms "derive from the Hermetic tradition, [they] are related to one another as heaven and earth. Astrology interprets the meaning of the zodiac and the planets, alchemy the meaning of the elements and metals."[191] This explanation identifies a fundamental relationship between the two occult sciences that argues for an alchemical correspondence to the astrological reading of the *Primavera*.

This correspondence is immediately confirmed by the medallion worn by the central figure. The Seventeenth Century illustration of Isis (Fig. 2) shows her with an almost identical crescent moon. This illustration, as already noted, is from an alchemical manuscript. As already cited, the alchemical illustration that features the same kind of moon, an almost closed, illusionistically three-dimensional crescent surrounding a firey phase of the process supports this connection (Fig. 4). Therefore, just as the universal moon goddess as Minerva directs the astrological component of the *Primavera*'s message, so must she be overseeing an alchemical procedure in the name of Isis, for the Egyptian goddess is the traditionally recognized female custodian of that occult art.

The connections between astrology and alchemy stem from their common histories. In his discussion of the latter art, Kurt Seligmann observes that there is no evidence that the ancient, pre-Christian Egyptians ever practiced alchemy, but "everything relating to [it] leads us back constantly to Egypt." Citing Stephanus, from the seventh century C.E., who equated sulphur and lead with Osiris, he continues: "This God [Osiris], Isis, and the evil Typhon are mentioned often in alchemical writings, and most of them name Hermes Trismegistus as the master of alchemical philosophy."[192]

Although another writer on the subject, Frank Sherwood Taylor, did not try to date the origins of alchemy precisely, he wrote, "It is generally thought to begin somewhere in the great period of Greek science which commenced about 300 B.C.E. in Alexandria and had much declined by about 200 C.E. All that remains of [the early alchemists] are a number of manuscripts which contain the disordered fragments of a few of their works."[193] Evidently both astrology and alchemy arose from the mystical/Gnostic climate of ancient Alexandria, but later writers traced them back to the legendary Hermes Trismegistus.

Of particular importance to medieval and Renaissance alchemists was a passage that they believed had come from an "emerald tablet," allegedly preserved with Hermes's mummy in Egypt until its discovery during the early Christian period. In truth, this passage probably was written in the second or third century C.E. Referred to as the "credo of the adepts" by Seligmann, it is short enough to be quoted in its entirety.

> 'Tis true, without falsehood, and most real: that which is above is like that which is below, to perpetrate the miracles of one thing. And as all things have been derived from one, by the thought of one, so all things are born from this thing, by adoption. The sun is its father, the moon is its mother. Wind has carried it in its belly, the earth is its nurse. Here is the father of every perfection in the world. His strength and power are

absolute when changed into earth; thou wilt separate the earth from fire, the subtle from the gross, gently and with care. It ascends from earth to heaven, and descends again to earth to receive the power of the superior and the inferior things. By this means, thou wilt have the glory of the world. And because of this, all obscurity will flee from thee. Within this is the power, most powerful of all powers. For it will overcome all subtle things, and penetrate every solid thing. Thus the world was created. From this will be, and will emerge, admirable adaptations of which the means are here. And for this reason, I am called Hermes Trismegistus, having the three parts of the philosophy of the world. What I have said of the sun's operations is accomplished.[194]

The language of this document is obscure, if poetic. Nevertheless, it was thought to contain a recipe for the process whereby a base metal could be transmuted into the pure metal, gold. The enigmatic character of the inscription allowed for individual interpretations and personal adaptation. Not surprisingly, idiosyncratic practices accrued throughout the ancient and medieval worlds wherever the art was practiced. Alchemical treatises reflect the conglomerate result by describing the process with abstruse allusions and figures of speech. It is possible, of course, that at least some of the vague descriptions were intentional in order to protect the secrets of the transmutational procedures. Despite these obfuscations, modern writers on the subject have extracted what seem to be the essential components of the process and its purpose.

At its simplest level, alchemy was an attempt to produce chemical reactions that would change a base metal to gold through a step-by-step process, which could have taken several months to complete, in accordance with specific procedures. Alchemy was, however, more than that. The material transmutation that the alchemists sought was also a metaphor for the process whereby one might attain spiritual rebirth. Even so, alchemical treatises were cast in metallurgical terms, and

the experiments undertaken by practitioners probably did contribute to modern chemistry. Ironically, the ancient mysticism associated with Isis may have provided the ground from which a modern science grew, one that, ironically, would help remove her name from common knowledge.

The alchemical procedures may be described in several ways, allowing for a layering of interpretations. Burckhardt believed that the oldest method for identifying the stages of the process was based on color changes that may have corresponded to metallurgical changes. This scheme starts with a black phase; the material being transmuted then changes to white. The last stage is reached when it becomes red.

In the *Primavera*, a processional development from right to left complies with the three-step color scheme. With the central figure, now seen as Isis, overseeing the process, the darkened, shadowed environs or Zephyr begin the mutation. The Graces are the whitened phase, and the culmination is expressed by the red-robed Lorenzo-Mercury.

Ordinarily the process was not so simple. Usually it was divided into a "lesser" work and a "greater" work. These tended to correspond to the blackening and the whitening phases, with the reddening designated as the "goal" of the work. The lesser and greater works were, in turn, subdivided into three steps each, and each of these was identified by a different metal. It is here that an astrological component entered the process, for the metals that were supposed to emerge are the ones associated with the planets, with one exception, and share their symbols.

Thus, the base metal with which the alchemist traditionally began his transmutations was lead, the black metal of Saturn. The next step, dominated by Jupiter, produced that planet's metal, blue-white tin. The third step resulted in quicksilver or mercury and was controlled by the moon. The appearance of quicksilver brought the material to the end of the lesser work.

Quicksilver is the only elemental metal that is fluid at ordinary temperatures. As it flows, it seems multicolored because of the reflective nature of its silvery quality. The volatility of quicksilver, also called the

Mercury of the Wise, was considered a feminine trait. In addition, the "silver" in quicksilver relates the metal to the moon, the premier symbol of the feminine. Therefore, although this metal shares its chemical symbol with the planet Mercury, it is not to be confused with that planet in the alchemical process. Throughout the work, its feminine characteristics place it under the domination of the moon, until the power of the sun supersedes that domination.

As the lesser work is completed, the lunar influence whitens the multicolored quicksilver in preparation for the greater work. The alchemist would now be ready to begin this phase of the process, which would culminate under the masculine principle of the sun.

The planet Venus rules the fourth step, resulting in her metal, copper. The fifth step is dominated by Mars, inducing iron. The sixth step occurs under the influence of the fiery sun. Now the heat of the solar body brings forth the goal of the work, the red philosopher's stone, also called the Red King or the Red Rose.

Looking at the *Primavera*, the viewer can see the elaboration of the color changes that begin with the triad on the right. The shadowy realm of Zephyr gives way to the blue-white veil of Chloris. She, in turn, is transformed into Flora, representing the multicolored changeability of quicksilver. On the left, the middle Grace with the copper-colored hair must represent the fourth step ruled by Venus. Her companions personify the fifth and sixth steps, bringing the viewer to the goal of the work in the Red King of Lorenzo/Mercury.

The metals that emerged at each step of the two works were, themselves, allegorical. The alchemists probably did not begin their experiments with real lead. The treatises all refer to a *materia prima*, whose composition was kept secret. Nonetheless, it must have contained some quicksilver and, as well, some sulphur, because the alchemists believed that all metals were composed of these two substances in varying amounts. For example, lead contained a large proportion of sulphur while gold contained very little. Copper, it was thought, contained almost equal amounts of sulphur and quicksilver.[195]

The purpose of the lesser work, then, was to free the quicksilver from impurities, which meant that it had to be released from its bonding with sulphur. This theory of metallic composition makes it clear that quicksilver was more than just one step in the process. In fact, it can be considered the subject of the work because its relationship to sulphur underlies the entire transmutation.

Sulphur was never designated a planetary metal, but it was essential to the alchemical process, probably because its combustibility connoted heat. Analogically, it represented the fiery, aggressive passion of the male principle in opposition to the cool passivity of the feminine mercury.

In order to release the quicksilver from the *materia prima*, the alchemists needed an agent that would effect the desired reaction. Called the "secret fire," this agent in the lesser work has been described as a "dry water that does not wet the hands and as a fire burning without flames."[196] Apparently, they used some kind of salt, which was mixed with the *materia prima*, moistened, placed in a hermetically sealed vessel, put into an oven called an athanor, and kept at a constant temperature for weeks or months.

The alchemists never wrote about chemical reactions. Their language was always allegorical, employing personifications and erotic symbolism to express the stages of the works.

For example, in the lesser work the masculine sulphur interacted with the feminine quicksilver in a violent sexual act that destroyed them both. Called the marriage of the King and Queen or the sun and moon, their self-destruction was a dissolution of the two into the Mercury of the Wise. From their dark putrefaction or death came the newly purified, impressionable, and virginal quicksilver.

The greater work, in which the volatile quicksilver was fixated in order to emerge as the philosopher's stone, also required the agency of a secret fire followed by more time in the alchemical oven. The function of the secret fire in this work was to reunite quicksilver and sulphur, but now their proportions changed. The amount of quicksilver gradually increased, but its color was modified by the sulphuric content in the

mixture. In this, the greater work, the two who had been destroyed in order to bring forth the Mercury of the Wise now were reformed as the Sulphur of the Wise.

Thus, a second marriage between the King and the Queen or the sun and the moon transpired. Now the lovers who came together were volatile. The secret fire must solidify them in a union of their opposite natures.

Returning to the *Primavera* a third time, the viewer can see the images in the painting as personifications of the allegorical marriages. On the right side of the panel, Zephyr and Chloris represent the marriage of the lesser work in which the King and Queen die in a dissolution that will emerge as quicksilver or Flora. Quite obviously, the triad recalls Ovid's account of the marriage of Zephyr and Chloris. It also recalls the words of the "emerald tablet": The "wind carries [the *materia prima*] in its belly."

It is appropriate and inevitable to note that the *materia prima* was associated with the West and the Tree of the World, which grew in the West. This is consistent with the role assigned to the West Wind, or Zephyr, as the signifier of the astrological map in the *Primavera*.

On the left side of the panel, the Graces are the whitening phase of the greater work. Each represents one of the three steps in the transmutation of the volatile quicksilver that occur before it can emerge as the fixated stone.

Now the secret fire is visually expressed in the flame-tipped arrow of the putto. He directs the arrow toward the heart of the center Grace in a line that, if continued, would terminate at the tip of Lorenzo's sword. At this point, under Venus, the metal has almost equal proportions of quicksilver and sulphur; the effect of the coloring power of sulphur shows in her copper-colored hair.

She looks plaintively toward Lorenzo/Mercury. Her glance seems to be one of longing and desire, which might lead one to think that Botticelli wanted to convey the notion of the second marriage. However, alchemically, that would be anomalous. She is the first phase of the

greater work; he is the goal of the work. More likely, hers is a look of recognition and anticipation of the final stage when the Red King is refined and purified.

This same step is referred to in the alchemical manuscript by Nicola d'Antonio degli Agli, which was cited above to support the notion that the putto in the *Primavera* functions astrologically as an Apollonian daemon of Taurus, the night sign ruled by the planet Venus (Fig. 14). Stanislas Klossowski de Rola, who included it in his book, *The Secret of Alchemy*, has explained its occult meaning.

> Venus and vulgar copper share a symbol; but here, with her winged helmet of volatility and the arrow of the secret fire, she represents the mercurial, white, female element in the drama of the Great Work.[197]

It seems clear that this illustration confirms Botticelli's blindfolded putto as an alchemical device, but that does not negate its astrological role in the painting. In fact, it serves to demonstrate the interrelationship between the two sciences.

Ready to receive the stabilizing heat of the masculine principle, the volatile feminine principle is conjoined by her sisters in a revolution that represents the steps of the greater work, which must transpire before the revelation of the philosopher's stone. The Grace to her left has already been informed by the secret fire. The alchemical metal of the work is said to expand as its moist nature is absorbed when the fire is used, so this Grace illustrates the increase of the dry, hot heat. Her hair is lighter; the coloring power of the sulphur now prevails over the volatile quicksilver.

The fair-haired Grace on the right reflects the sun's light, giving evidence that she feels his heat and is ready to be delivered of the stone. According to de Rola, the Red King "appears out of the womb of his mother and sister, Isis or mercury, *Rosa Alba*, the White Rose."[198]

Another fifteenth century alchemical manuscript depicts the Red King in the transforming vessel (Fig. 15). He carries the caduceus of the

mythical Mercury, but here he symbolizes the transmuted quicksilver. The similarity to Botticelli's figure is remarkable, even to the golden flecks on the Red King's tunic that recall the golden flames sprinkled over Lorenzo/Mercury's chlamys. The golden flecks and therefore the golden flames refer to the potential of the stone that enables it to be transmuted into pure gold. The greater work now has been completed.

This discussion of alchemy and the *Primavera* began with the recognition that the metallurgical transmutation sought by the alchemists was not just a chemical process but was also a metaphor for the enlightenment and perfection of one's soul. Ficino used astrology to affect the spiritual development of Lorenzo di Pierfrancesco; he undoubtedly intended the alchemical content of the painting to contribute to that end as well. As a spiritual allegory, alchemy has been summarized by H. Stanley Redgrove in the following words.

> In the metals the alchemists saw symbols of man in various stages of his spiritual development. Gold, the most beautiful as well as the most intarnishable metal . . . was the symbol of regenerate man Silver was also termed "noble"; but it was regarded as less mature than gold . . . , therefore [it] was considered to be analogous to the regenerate man at a lower stage of his development [L]ead, to the alchemists, was a symbol of man in a sinful and unregenerate condition.[199]

In the lesser work, the destruction of the male and female principles represents the need to recognize one's fallen state. Impressionable and virginal, the unformed soul is separated from its base or impure tendencies in a process of rebirth. She is now unstable and will not be constant until informed by the purity of her opposing principle. In Burckhardt's words, this principle is the stabilizing "Spirit-Intellect."

> This pure ground of the soul can be known only in its response to the pure Spirit. The soul uncovers itself when united as bride

to the Spirit-Intellect. This is what is referred to when one speaks of the marriage of the sun and moon. . . The "uncovering" of the receptive ground of the soul and the "revelation" of the Creative Spirit take place at the same time.[200]

The individual who is sincerely concerned about the salvation of his soul must understand that the way to enlightenment is obstructed with setbacks and difficulties. It will be a painful journey, but it must be undertaken willingly if success is to be achieved. Just as the alchemists failed again and again to transmute lead into gold, so will the adept stumble many times on his quest.

This challenge recalls Ficino's charge to Lorenzo to arrange his heavens in a propitious manner. Indeed, the message of alchemy replicates the astrological lesson of the *Primavera*. References and allusions have rebounded from one to the other of these two processes, but the following observation by De Rola regarding the difficulty of isolating the *materia prima* is especially interesting in the context of the painting.

> This is no small undertaking in itself, and the casting of a horoscope is necessary to determine the most favourable time. The Work may only be begun in the spring, under the signs of Aries, Taurus and Gemini[201]

These are the signs that most affected Lorenzo di Pierfrancesco. His natal sign was Aries; the progressed charts fell under Gemini. Perhaps Ficino expected that it would take the boy several months to "arrange his heavens" propitiously; perhaps he intended that the process span the spring months of the *Primavera*.

XI. The Primavera's Alchemical Symbols

The foregoing discussion of the alchemical and spiritual transformations in the imagery of the *Primavera* receives support from iconographical details in the painting that have been ignored in other discussions of the work. Two of these already have been explained. The blindfolded putto has been considered in both its astrological and alchemical contexts, and the amulet worn by the central figure not only identified her as a moon goddess but as that deity in the form of Isis, thereby assuring an alchemical interpretation of the painting. In addition to these, there are other symbols in the painting that become meaningful when its Hermetic theme is understood.

The first of these is the sword of the Mercury figure. It already has been noted that Levi-D'Ancona identified this fifteenth century sword as an emblem of Lorenzo di Pierfrancesco (see above, p. 20). This supports the belief that the Mercury figure is an idealized stand-in for the boy, but since the sword is a well-known alchemical symbol, it has a particular iconography in the *Primavera*.

According to De Rola, the sword, like the arrow, is a symbol of the "secret fire." In his book, De Rola included a reproduction from an eighteenth century French manuscript that depicts a knight in armor carrying a sword.[202] The knight is a unifying principle and the sword represents the fire that is necessary to the fixation or unification of the stone. The fact that the putto's arrow is directed

toward the tip of the sword as it penetrates the heart of the middle Grace suggests that an alchemical connection between the two weapons was intended. If so, it could be a reference to the fixation of the stone in the greater work.

The sword also may be viewed as a symbol of rebirth. In the painting, it begins an arc whose line of direction is continued in the raised arm of Lorenzo/Mercury, culminating in the clouded realm above the trees. The psychologist, Carl G. Jung, pointed out that, astrologically, Mercury and "spirit" always have been linked. Mercury was the god of revelation and the "soul of the bodies." Jung wrote: "He is a spirit that penetrates into the depths of the material world and transforms it. Like the *nous* (with which he is also identified), he is symbolized by the serpent."[203] In other words, this sword of Mercury is the sword of the transforming spirit of the god, Mercury.

Jung's reference to the serpent in connection with Mercury introduces another alchemical symbol, one that is especially interesting in relation to the *Primavera*.

The serpent is seen in two forms in alchemical treatises. The first is the ouroboros, the snake that bites its own tail, forming a circle. In his book on alchemy, Taylor reproduced a page of alchemical symbols that may date back to the second century, C.E. Called the *Gold-Making of Cleopatra*, this page features the ouroboros with a Greek inscription that translates, "one is all." This kind of serpent, then, is one of the earliest symbolic expressions of the alchemical process.[204]

De Rola features an illustration of the ouroboros from a much later manuscript (Fig. 16). He defines it as "an emblem of the Great Cycle of the universe."[205] Others, however, have attached slightly different meanings to it. For example, Seligmann explains it as follows.

> The evil serpent of paradise was transformed by the Gnostics [of the early Christian era] into a beneficent Ouroboros. The Ouroboros was changed into the alchemist's dragon, and its body being light and dark found a chemical interpretation. . . .In the

alchemist's work the first stage is decay. The dragon, mercury, must be killed.[206]

Burckhardt's words seem to confirm this interpretation when he describes the ouroboros "as the symbol of unredeemed nature or unformed materia"207

The ouroboros is not shown in the *Primavera*. However, it is found in the numismatic legacy of Lorenzo di Pierfrancesco. In his study of Renaissance symbolism, Ernst Gombrich called attention to two medals that feature profile portraits of Lorenzo. One of these already has been cited in connection with the suggestion that the figure of Mercury in the painting is an idealized version of Lorenzo. On the reverse of each medal appears the ouroboros (Fig. 17). The use of this symbol on Lorenzo's medals is compelling. Perhaps Jung's equation of Mercury and the serpent explains why it became so closely associated with Lorenzo that it could be used as an emblem of the boy. Another source gives the following interpretation of the ouroboros. " In alchemy, the ouroboros is a purifying sigil that represents the spirit of Mercury (the substance that permeates all matter) and symbolizes continuous renewal, the cycle of life and death, and harmony of opposites. It keeps the cosmic waters under control, and is symbolic of the cyclical nature of alchemical work."[208]

In alchemical terms, the ouroboros, like the sword, is a symbol of the refining process that turns the base into the pure. It is not too fanciful to suggest that Ficino may have been involved in the selection of this emblem, for, indeed, what could be more appropriate in the eyes of the mentor who wished to "refine" Lorenzo's personality. But there are other aspects of this subject that may be considered.

Gombrich did not try to interpret this symbol in connection with Lorenzo or explain its use on his medal. Instead, he introduced it after discussing the highest and truest of Plato's three modes of knowledge. "We can only hope to achieve this true knowledge in the rare moments when the soul leaves the body in a state of *ek-stasis*, such as may be

granted to us through divine frenzy." The desire to achieve this state, Gombrich continues, was the impetus behind "the efforts of Renaissance painters to claim for their own pursuits the . . . state of divine *afflatus*" These efforts, in turn, produced "the special kind of artist" who was a "deviser of visual symbols."[209]

This context allowed Gombrich to introduce an allegedly ancient source in which the ouroboros was described and defined. Called the *Hieroglyphica*, this source was attributed to Horapollo. A collection of arcane Egyptian symbols, it was accepted as an authentic record of the revealed words of the son of Isis throughout the Middle Ages and the Renaissance. Today, scholars recognize it as another product of the Alexandrian Gnostics who promulgated the Hermetic beliefs and practices in the early Christian era, and most date it to about the fourth century, C.E.[210] By introducing the *Hieroglyphica,* Gombrich brings the reader back to Marsilio Ficino.

According to George Boas, who translated this collection, it is possible that four copies of the *Hieroglyphica* were known in Florence during the fifteenth century.[211] One of these was purchased in Greece and is inscribed with the date, 1419.[212] It seems clear that the *Hieroglyphica* became popular during the *Quattrocento* because it supported the Plotinian belief that "behind the sensible world of things [lies] the intelligible world of ideas," which was "one of the major contributions to aesthetic theory of the whole [Neoplatonic] movement."[213]

Today no one questions Marsilio Ficino's knowledge of the *Hieroglyphica*. His comment on a passage from Plotinus, which expressed the belief that hieroglyphics are Platonic ideas made visible, is one proof of that knowledge. Both Gombrich and Boas included a translation of Ficino's gloss on that passage from Plotinus in their discussions of the *Hieroglyphica*. Boas's version reads, in part, as follows.

The Egyptian priests, when they wished to signify divine things, did not use letters, but whole figures of plants, trees, and animals; for God doubtless has a knowledge of things which

is not complex discursive thought about its subject, but is, as it were, the simple and steadfast form of it.[214]

The hieroglyph, then, communicates directly in one visual image, conveying its meaning all at once, beyond mere words. This "mode of writing," according to Gombrich, must have "held a particular fascination" for the Christian Neoplatonist. "Both its form and its content . . . reflected a higher knowledge."[215]

More recently, Ioan P. Couliano expanded upon Ficino's regard for the pseudo-Egyptian hieroglyphs. In his book, *Eros and Magic in the Renaissance*, he explored the "historical vicissitudes that affect notions of *human imagination* as revealed in documents relating to eroticism and magic in the Renaissance." Noting that modern ideas about magic are far removed from the concept that prevailed in the fifteenth and sixteenth centuries, he states, "The magic that concerns us . . . is theoretically a science of the imaginary, which it explores through its own methods and seeks to explore at will."[216]

Couliano calls Ficino "the classic source of the revival of magic" and offers an in-depth discussion of the sources and manifestations of Ficino's doctrines on cosmology, astrology, and magic.[217] Basic to these doctrines was a belief in the power of visual images to impress knowledge upon an individual's soul through the vehicle of the spirit, which apprehends and transforms messages grasped by the five senses of the physical body, but especially from the sense of sight. A message thusly converted and communicated is called a *phantasm*. What this means is that the spirit translates "the surrounding world into [a] make-believe language [of phantasms] so that the soul may learn about it."[218]

According to Couliano, for Ficino "the phantasmic expression of the intelligential world did not assume [concrete forms but] . . . ought to be something mysterious, unreachable by the profane."[219]

These remarks contribute to an understanding of the importance of the *Hieroglyphica* to Ficino. He granted to the symbols a magical power that could act on the soul through the efficacy of the spirit to

induce the divine frenzy through which one might acquire Plato's true knowledge.

In Ficino's gloss on Plotinus's passage, he included one—and only one—reference to a hieroglyph, specifically the ouroboros. According to Horapollo, the creature symbolizes the universe with the stars of the heavens represented by its scales. Ficino, however, said it was winged and ascribed to it the notion of time, which "is speedy and by a sort of revolution joins the beginning to the end."[220]

Ficino may not have seen these definitions as discrepant. In his commentary on the *Timaeus*, he wrote that time and motion coincided in the creation of the universe and therefore are alike.[221] But Gombrich noticed the divergence between them and saw it as an indication of the essential nature of a symbol. "The symbol that presents to us a revelation cannot be said to have one identifiable meaning . . . All its aspects are felt to be charged with a plentitude of meanings that can never be exhaustively learned.[222]

Accordingly, Ficino's comment on the ouroboros gains in significance. Surely it held special significance for him, since this is the only symbol he analyzed. This fact may be seen as support for the notion that the choice of the ouroboros for Lorenzo's emblem on his medals was directed by Ficino. Although one cannot know with certainty if that was the case, all of the above factors along with the specific alchemical associations with transformation aand rebirth offer a plausible rationale.

The alchemical interpretation of the *Primavera*, like the astrological reading, addresses the spiritual growth of the young Lorenzo. As an adolescent, his soul would correspond to the state of the base metal before transmutation. The ouroboros as unformed *materia* symbolizes that state. This serpent, then, would have been a reminder of the challenge facing Lorenzo: the salvation of his soul.

The serpent is featured in alchemical symbology in another, more familiar form, and this one brings the iconographic program of the *Primavera* into sharp focus. The following passages from Burckhardt

identify and explain this form of the serpent as it contrasts to the ouroboros.

> In the Hermetic tradition, Universal Nature in her latent condition is represented as a coiled up reptile. This is the dragon ouroboros which, curling into a circle, bites its own tail.
>
> Nature in her dynamic phase, on the other hand, is portrayed by means of the two serpents or dragons, which, in the form of the well-known model of the staff of Hermes or caduceus, wind themselves round the axis—that of the world or of man—in opposing directions. . . . For alchemy the two forces represented as serpents or dragons are Sulphur and Quicksilver.[223]

Burckhardt continues with the traditional account of the mythical Hermes, who struck two fighting serpents, thereby taming them so that they willingly wound themselves around themselves around his staff. "This means the transmutation of chaos into cosmos, of conflict into order, through the power of the spiritual act, which both discriminates and unites."[224]

The philosopher's stone, the Red King or the goal of the work, is the fixated Lorenzo/Mercury, who lifts his caduceus to the clouds as though the cosmic power of its reconciled oppositions will reveal his transformed soul—the gold of the final work. The unformed Lorenzo of the ouroboros will have evolved—been transformed—into the enlightened and purified Lorenzo of the caduceus.

Finally, there are two other details in the *Primavera* that elsewhere have not been discussed iconographically. Two of the three Graces wear medallions or brooches. Others may have assumed that these were merely decorative conceits on Botticelli's part; but such an assumption is not consistent with the imagery and iconography of this painting. Since the amulet worn by the central figure has been established as an alchemical symbol, it is logical to think that the brooches of the two Graces carry similar meanings.

The medallion worn by the Grace on the left, whose back is next to Lorenzo/Mercury, has eight gold leaves embellished with four pearls, which surround a deep red, rough stone in the center. It is conventional to recognize the pearls as references to purity, and in the context of alchemy, they can refer to the purification process represented by that art. The red stone surely alludes to the forthcoming emergence of the Red King under the sun's sign. Gold, of course, is the metal of the sun and symbolizes the final salvation of the soul in the heavenly afterlife.

Ficino's writings reveal a fascination with numbers that reflects the almost obsessive interest in them attributed to the Pythagoreans. Therefore, it is probable that the numbers of pearls and gold leaves were significant. In Pythagorean/Platonic numerology, the number four signified the four elements: fire, air, earth and water. Although these elements do not appear to be important to the *Primavera*'s meaning, they were essential to alchemy.

Eight, the number of the gold leaves, was the number of the celestial spheres, doubling the four earthly elements. In addition, in his commentary on Plato's *Republic*, Ficino credited the Pythagoreans with identifying the number eight with justice. "This is the first of the solid numbers and the first to be broken into numbers, all of which are likewise even"[225]

The theme of the *Republic* is the search for justice. According to Plato, the just men and women who will inhabit the ideal state of the republic will have been educated in arithmetic, music, geometry and astrology. Thus, justice is achieved by mastering the four sciences of the quadrivium. Of even greater interest is Plato's view of justice. For him, it was a kind of virtue that implies goodness, wisdom, and a harmony of the soul–the very attributes that Ficino wanted Lorenzo to develop. The importance of justice to Ficino has been established by his personifications of it, all of which alluded to Isis. The brooch worn by the left Grace confirms that this essential identity of the central figure is the key to the painting.

The medallion worn by the fair-haired Grace on the right is more intricate (Fig. 18). It hangs from a thin chain that almost coincides with her braids, which have been brought together at her throat. The

medallion, from the top down, consists of a dark metal disc from which rises a small pyramid. Two leaves spread symmetrically from this disc; upon each is a white rosette with five petals. Below, and constituting the middle section of the piece, is a larger pyramid cut from a rose-red stone. One pearl hangs from each of the leaves and the red stone.

The leaves and pearls appear to surround the red stone; they add to five. Five was the Pythagorean number of marriage, which Ficino noted and explained in his commentary on the *Republic*.[226] Plutarch states in his essay, "of the Word *EI* Engraven of the Gate of Apollo's Temple of Delphi," that five is the marriage of the first male number (three) and the first female number (two).[227]

Here again, the stone is red. In alchemical terms, this brooch refers to the impending "birth" of the philosopher's stone from the marriage of the Red King or Rose and the White Queen or Rose. The rosettes, with five petals each, seem to confirm that this Grace is the White Queen or the White Rose.

It is noteworthy that three of the female figures in the *Primavera* wear medallions, and that each contains a red stone. The reds vary from the earth red of the central figure's amulet to the rose-hued pyramid worn by the White Rose, to the deep red stone of the circular brooch worn by the Grace on the left. All may refer to the philosopher's stone, whose reddish coloration would change in value or intensity at different stages of the process. De Rola refers to the three "degrees of perfection" within the alchemical process as stones; this terminology can explain the three red stones in the painting.

There are three stones, or three works, or three degrees of perfection, within the Work.

The first work ends when the subject has been perfectly purified . . . and reduced into a pure mercurial substance.

The second degree of perfection is attained when our same subject has been cooked, digested and fixed into an incombustible sulphur.

The third stone appears when the subject has been fermented, multiplied and brought to Ultimate Perfection, a fixed, permanent, tingent tincture: The Philosopher's Stone.[228]

Like his astrology, Ficino's alchemy in the *Primavera* reflects his understanding of an interest in Plato's cosmology. Of all the commonalities between those two arts, one of the most significant was Plato's concept of the quintessence, which has already been discussed. Not only did it underlie them both; it must have helped Ficino reconcile his Christian beliefs with the knowledge of the pre-Christian authorities he so much admired.

This essence, the fifth element, the world spirit, and the mean between the world soul and the world body, might be drawn from the celestial realm to those below through daemonic agents, if appropriate prayers and incantations were offered under the most propitious circumstances. In one passage from *De vita coelitus comparanda*, Ficino advises his reader that it is possible to take more and more of this essence into oneself if one knows how to separate it from impurities. This can be accomplished through the special agency of the sun.

This belief in the efficacy of the quintessence was not confined to Ficino. In fact, Seligmann pinpointed the alchemical importance of the quintessence in the following passage.

> There are four essences in the universe upon which . . . all the learned through the centuries have agreed. These are fire, water, earth and air. However, there is a fifth essence of quintessence, which permeates everything above in the stars and below upon earth. It is the world soul-spirit which animates all bodies . . . Yet, it is omnipresent, and he who can free this fifth element from the matter that it inhabits shall hold in his hand the creative power with which God has endowed the world of matter. *The ancient goddesses of growth and vegetation, like Isis, were nothing more to the alchemist than the emblems of the*

quintessence, the generative power that resides in the philosopher's stone.[229] (Emphasis added.)

Indeed, this passage seems to summarize and simplify the complexities of Ficino's occultism in the *Primavera*.

Now there remains one final consideration: How important was the original setting of the *Primavera*? Did Ficino intend that it be seen in conjunction with its companion paintings in the antechamber to Lorenzo's bedroom? Is there a connection between the *Minerva and the Centaur* and the lost tondo of a Madonna and Child? The question has to be asked; the answer is probably "Yes"; any explanation, however, can be only conjectural.

XII. Conclusion

The publication in 1469 of Apuleius's novel about Lucius's metamorphoses came at a time when Marsilio Ficino again was suffering from the depression that had distressed him in 1467. His despair at that time recalls the anguish expressed by Lucius over his asinine form and the humiliation he was forced to endure as a result . Curiously, other events in Ficino's life parallel episodes in *The Golden Ass*.

For example, like Lucius, Ficino experienced visions. The Virgin Mary answered a prayer by appearing to him in August, 1474, assuring him that he would recover from an illness that had befallen him during that month.[230] Therefore, just as Isis responded to Lucius's prayer by appearing to him at Cenchreae, so did Mary visit Ficino. Both men were priests. Lucius became a priest in the cult of his goddess, and, after journeying to Rome on her instructions, was initiated into the cult of her consort, Osiris. In 1473, Ficino was ordained a priest in the Church of Rome.

These parallels imply that Ficino could have identified with Apuleius's protagonist and consequently would have compared Isis to Mary. It is likely that he would have seen Mary's virtues in the character of Isis, since Isis most surely was the model for the Christian Virgin.

In his study of Isis, Witt devoted his concluding chapter to the Isis/Mary conflation, citing literary and visual evidence of Mary's inheritance of the Egyptian deity's attributes, virtues, role and essence. The connection between Isis and Mary is not just a modern assessment;

Witt observed that Christine de Pisan (b. 1364) linked the two.[231] Thus, Ficino undoubtedly knew of the debt owed by the Christian Virgin to the pagan goddess.

That Isis was the forerunner of Mary does not conflict with the tradition that equated Isis with Minerva. On the contrary, during the Middle Ages Minerva as well as Isis was likened to the Christian Virgin. Rudolf Wittkower gave a reason for this in his article, "Transformations of Minerva in Renaissance Imagery," when he observed, "[the] ancient conception of Minerva's virginity was kept alive right through the Middle Ages, so much so, indeed, that the goddess even appeared as a symbol of the Virgin Mary." In support of this statement, Wittkower cited the example of a seal of the chapter of Notre Dame at Noyon, dated 1296, which shows the head of Minerva and carries the legend, *Ave Maria gratia plena.*[232] Thus, both Minerva and Isis presaged Mary, and each contributed qualities that were essential to the nature of the Christian Queen of heaven.

Isis/Minerva represents a congruence of identities that united the ancient goddess of vegetation and growth with the Greek personification of wisdom and justice. She is both spouse and virgin, source and fruition, harmonizer and reconciler and the embodiment of the *Hermetica* and the *Platonica*. These qualities describe Mary, as well, but she is more than the mother of God: she is the most exalted and revered expression of the feminine principle of mediation. And, as a Christianized goddess, she is not merely a symbol of abstract principles and virtues but is herself a promise of them.

The link between Isis/Minerva and Mary brings another dimension to the function and purpose of the *Primavera*'s iconography. The message to Lorenzo de Pierfrancesco was intended to help him achieve a disciplined life of contribution and beneficence that would lead to spiritual rebirth in a heavenly afterlife. This education and its fundamentals are represented by Isis as a symbol of the ancients who discovered them, and by Minerva as the symbol of the Greeks, who systematized and inscribed them for their followers.

Only the Christian Mary can intercede for the soul that has mastered the lessons of celestial harmony. Only she holds the promise that the soul will return to its Redeemer upon the death of the body. In her capacity as intercessor between man and God, the Virgin gives meaning to the kind of life Ficino outlined for the boy in the *Primavera*, a life of devotion and dedication motivated by the hope for salvation and eternal bliss.

The Medici inventories of 1498, 1503, and 1516 show that the *Primavera* was hung over a storage bench on one wall of an antechamber to Lorenzo's ground-floor bedroom. The painting that has been taken for Botticelli's *Minerva and the Centaur* (Fig. 21) was on another wall, over a doorway. The large, gilt-framed tondo of the Virgin and Child, now lost, presumably was placed opposite the *Minerva*.

A circumstance that combined a painting of Minerva and a painting of Mary in the same room with the moon goddess of the *Primavera*, who has a traditional connection with Mary, would not seem to be accidental. In fact, one may see in these three paintings aspects of the same female principle that is divine in nature and intercedes for mankind. This implies that these paintings are iconographically related. It is not possible to examine a relationship between the panel and the lost tondo, painted by an unknown artist, but it is possible to explore a connection between the *Primavera* and the *Minerva and the Centaur*.

In his article on these paintings, Webster Smith saw the *Minerva* as iconographically affiliated with the *Primavera*.[233] Although the date of the former work is no more certain than that of the latter, Smith accepted the widely held supposition that the *Minerva* was executed several years later than the *Primavera* and argued that it contains a reference to the panel painting. There are obvious differences between these two paintings, such as their sizes and formats, the scale of the figures, and that the *Minerva* is on canvas. But there also are similarities between the two works, especially between the two female figures who dominate their respective compositions. Because of these similarities, Smith would change Minerva's name to Venus and claim that each is a depiction of an unusual kind of Venus referred to by Pausanias.

Certainly there are resemblances between these two female figures. But it is not Minerva who has been miscalled. The resemblance between the two figures in these paintings, which is explained by the Uffizi drawing (Fig.5), argues that both images represent the universal moon goddess in one or another of her manifestations. Neither one is Venus. Therefore, one need not quarrel with the traditional name of the female who accompanies the centaur in Botticelli's vertically composed canvas.

Ernst Gombrich's reading of this painting was based on the nature of Minerva as the goddess of wisdom. Gombrich's view holds that the painting is a moral allegory of Ficino's dualistic concept of man, whose soul and body co-exist in an uncomfortable alliance as long as he is on this earth. He summarized Ficino's attitude in the following words.

> Only Divine Grace can resolve the paradox of human existence. Only the immortality of the soul gives meaning to our toil on earth. While dwelling in the body, the soul cannot attain to the state of perfection and happiness for which it is destined.[234]

It is the centaur that stands for this paradox of human existence. According to Gombrich, Minerva or divine wisdom "takes him gently by the head to still his fretful motion and lead him on his way."[235]

This allegory fits very nicely with the didacticism of the *Primavera* that has been proposed herein. Indeed, it seems that one need not look further for the intention behind Botticelli's *Minerva and the Centaur*. However, Gombrich's interpretation bypassed a visual fact that should not be overlooked. In truth, a problem with the assumption that the female figure in this painting is Minerva lies with the halberd that the goddess carries in her left arm. Some have thought that this was Botticelli's way of showing Minerva's spear, but Ronald Lightbown pointed out that this halberd is quite different from Minerva's attribute and instead signifies guardianship. Therefore, he proposed that the

female figure in the *Minerva* is a guardian of some sort. His support for this rests on the fact that the 1498 Medici inventories give the name of a minor goddess, Camilla, to a female figure in a painting that Shearman, Smith, and Lightbown all have taken to be the so-called *Minerva and the Centaur.*[236]

After pointing out that Minerva was one of three aspects of a triple lunar goddess–Minerva, Diana, and Hecate/Lucina–Lightbown informs his reader that Camilla means "servant of Diana." On this account there is a loose connection between Minerva and Camilla, which, Lightbown has suggested, might have been the reason for the change in the female figure's name in later inventories or records. Regardless, Lightbown's reasoning is that a servant of Diana could be a guardian of the goddess's territories, protecting them from the lust of a hunting centaur. This would justify the halberd.

However, Lightbown's interpretation of the female figure as a guardian who is aggressively chastising the centaur does not fit the interaction between the two figures, which is pathetic rather than antagonistic. But this inconsistency does not refute the possibility that "Minerva" is a servant of Diana, or even is Diana herself.

Diana had multiple manifestations. As a moon goddess, she was another incarnation of Isis as well as Minerva. Ficino's interest in the connection between Diana and Minerva is suggested in his commentary on Plato's *Symposium* in which Tommaso Benci observed that the guests assembled there were consecrated to both Diana and Minerva.[237] While that remark links the two goddesses, it does not offer a reason for their partnership.

The astrological reading of the *Primavera* suggests that Diana may have had significance in that context. The zodiacal sign given to Diana's rulership was Sagittarius, also known as the sign of the archer. This is important, because the archer who symbolizes Sagittarius is traditionally accepted as the wise and gentle centaur, Chiron, who was not a lustful beast but, on the contrary, was the learned student of Apollo in the art of medicine.

If Shearman, Smith, and Lightbown are correct in saying that the 1498 inventory does in fact refer to the work known as the *Minerva and the Centaur*, and if the female figure in that work is Camilla who is a servant of Diana, then the centaur in the painting must be the kindly Chiron.

The story of Chiron's death may have even greater relevance to the imagery of the *Minerva and the Centaur* than does his connection with Apollo. According to legend, the aged Chiron was struck in the knee by a poisoned arrow shot by Hercules. Since the two had been friends, Hercules withdrew the arrow and tried to help Chiron, but the pain from the wound sent the old centaur to his cave where he continued to suffer. Finally, Chiron willingly surrendered his immortality in exchange for death, which would release him from eternal agony.[238]

Looking at the expressions on the faces of the centaur and the female figure in the *Minerva*, and observing their positions and gestures, one can believe that the servant of Diana, or Diana herself–the moon goddess who not only mediates but represents the life process that must terminate in death–has come to comfort this creature. She lifts the head of this suffering creature as if to reassure him that soon his pain will be alleviated.

There are other details in this painting that support the notion that it depicts Diana and Chiron. For example, the centaur holds the weapon that caused his agony as would a Christian martyr hold his attribute. In this connection, it is not surprising that the creature's face resembles Botticelli's John the Baptist in the so-called *Bardi Madonna* of 1485, an observation that Gombrich made in his study of this painting.[239]

The beast lifts his left front leg as though he might be favoring it because of the injury to his knee. There is no doubt that this poor creature is suffering. His eyes have the glazed, vacant expression of one who has endured much and senses that he has reached the limit of that endurance. Lightbown's observation that the halberd signifies guardianship is most appropriate in this context. The symbol speaks to the role of Diana as the guardian deity of Sagittarius; surely she would

attend to her archer, comforting and interceding for him, for she is his ruler and protector.

This interpretation of Botticelli's *Minerva and the Centaur* is relatively uncomplicated at the same time that it is consistent with Ficino's taste for allegory. It corresponds to the reading of the painting offered by Gombrich; but, since it accounts for the halberd and changes the centaur from a personification of Ficino's soul-body conflation to the tormented but wise and learned Chiron, it gives that image a particularity and human consciousness. Chiron chose death over immortality, for he understood and had experienced the pain of life.

Another observation about this painting connects it to the *Primavera* even more closely. The setting of and interaction between the two figures bring to mind the episode in which Isis first appeared to Lucius at the harbor of Cenchreae, where he had retreated to a cave, completely despondent. That setting corresponds to the environment shown in the *Minerva*, and the tender glance of this goddess as she lifts the head of the pitiable beast is consistent with Apuleius's narrative. At the same time, an analogy between Chiron's physical pain and Lucius's spiritual agony can be inferred, for each moved a goddess to express merciful love.

There is, of course, a significant difference between the Diana/Chiron story and the episode from *The Golden Ass*. Although both feature the intercession of a compassionate goddess, Chiron was released from his physical agony through death while Lucius was released from emotional and psychic anguish by a goddess who asked for his devotion. Consequently, Lucius was converted to her worship and received spiritual enlightenment in this life.

Whether or not Isis and Lucius are implied in this painting, the similarity between their story and those of Minerva and the Centaur and Diana and Chiron suggests that an iconographical theme links the two paintings.

Another similarity is more telling. Both the *Minerva* and the *Primavera* feature female deities who are dual in nature. Diana/Minerva

commands the one while Minerva/Isis directs the action in the other. The fact that Minerva's identity has emerged in both works implies not only a connection between the two but also a progression from one to the other.

Internal evidence for this progression lies in the difference in Botticelli's depiction of space-distance in the two paintings. The *Minerva and the Centaur* clearly depicts the three dimensions of a terrestrial setting that denotes the temporality of the microcosm. The *Primavera*, on the other hand, shows a two-dimensional representation of the ordered harmony of the celestial macrocosm. Further, since the *Minerva* seems to recount the story of Chiron's death, it is illustrative of an earthly experience. Therefore, as the heavenly always supersedes the earthly, so should there be a progression from the brief and difficult life on earth to an everlasting and blissful existence after death.

If such a progression between the *Minerva* and the *Primavera* was intended, the lost tondo must have completed the ascent from the material world to the immaterial heavens above. Imagining that the *Minerva* was on a wall to the right of the *Primavera*, with the tondo on the wall to its left, one would read the paintings from right to left, taking them as three parts of a "triptych" and reading them in accordance with the compositional thrust of the *Primavera*. The *Minerva* thereby becomes an introduction to a Ficinian parable, a parable that speaks of a Christian answer to the human dilemma.[240]

Here, in the painting of the beast and Diana/Minerva, the viewer confronts an earthly realm where the fate of man unfolds in time. This is a life of hopeless despair until one lifts his eyes to a heavenly queen who responds to his anguish with merciful compassion. With and through her lies a promise of release and salvation, which is not yet realized or even revealed.

Confronting the horizontal *Primavera*, the viewer now is told how he must live and what he must try to accomplish in order to transcend the temporal realm. Through the guidance of the goddess of many names and with her help, the path and means are understood

and become accessible. Minerva/Isis is the deity through whom the viewer's soul will be elevated beyond this earthly confinement, for she is the one who teaches him about the perfect harmony created by the supreme Being. Indeed, the glory of the heavens is there for him who heeds her.

The tondo is the climax to this lesson about man's transformative journey. Enclosed within a circle of eternity is the real Queen of Heaven with the true Light of the world. The queens of *Minerva and the Centaur* and the *Primavera* could only anticipate her, the true Queen. Now, to the left of the *Primavera* and beyond its frame, her essence is revealed in the image in the tondo. Surely the divine radiance of her Son was meant to be the source of light in the *Primavera*. It enters the panel from the left, illuminating the "way."

Together, these paintings form a visual manifestation of the Hermetic belief in the return of Man from body to soul. From the mortal to the immortal, from the base to the pure, from the temporal to the eternal, Man will rise through the spheres of the cosmos, ascending to the absolute harmony of the Almighty Creator.

Is it conceivable that Ficino would have composed such an elaborate program just to effect a spiritual, emotional and psychological transformation of Lorenzo di Pierfrancesco? If one follows the thinking of Couliano, it is most assuredly conceivable.

In his discussion of Ficino's kind of magic, Couliano reminds his reader of the Art of Memory, "a technique for the manipulation of phantasms, which rests on the Aristotelian principle of the absolute precedence of the phantasm over speech and of the phantasmic essence of the intellect."[241] Basing his résumé of this Art on the contributions of Paolo Rossi and Frances Yates, Couliano continues.

The precise inference drawn from it, expounded by St. Thomas [Aquinas] in his commentary on Aristotle's *De memoria et reminiscentia*, is that whatever is seen, thanks to the intrinsic quality of *image*, is easy to remember, whereas abstract concepts

or linguistic sequences require some phantasmic support or other to charge the memory.[242]

Couliano then briefly "reconstructs" Yates's and Rossi's function of art, based on the theories of the Art of Memory.

> Owing to the fact that perceptions have an intrinsically phantasmic character, and are thus readily committed to memory, the task is to superimpose any contents linguistic or conceptual–for example a poem or classification of virtues–onto a succession of images.[243]

Although the history of and theories behind the Art of Memory need not be explained here, the Art itself can be summarized by saying that an individual who wished to learn something by heart was expected to spend time alone, concentrating and meditating on the contents associated with particular images, in order to memorize the contents. The purpose of the process varied–it could be a disciplinary exercise or a teaching device–but its practice during the Renaissance indicates the extent to which images and symbolic visual references were valued for their power to affect, influence, and/or teach individuals.

So, in front of Botticelli's grand visualization of Ficino's spiritual lesson, placed in the privacy of a bedroom's antechamber, perhaps there once stood a young man who would have raised his eyes to contemplate and meditate upon the path to salvation that was before him. There, before his eyes, he would have seen his own idealized image gesturing aside the clouds that conceal from mortal men a glorious vision of the heavenly realm; he would have seen himself looking through those clouds, coming face to face, like Tat the son of Hermes, with the Divine One.

This remarkable confrontation between that young man and the moralizing images in front of him raises some questions that may never be answered. As Lorenzo di Pierfrancesco passed by the *Primavera*,

did he reaffirm a dedication to Minerva, the "lady" of compassionate wisdom, as he watched her lead the pitiful centaur? Did he renew a vow to Isis, the goddess of wise compassion, when he turned to his own image dressed as Hermes, her ancient adept, or recall the transformation of Lucius and promise to emulate that pious priest? Or, did he relive a penitential experience that was meant to reform his character and refashion his ambitions?

In truth, he may not have heeded the lessons that Ficino hoped he would assimilate, and he also may have avoided the dark depression from which Ficino suffered and which the philosopher feared the young man would also have to endure; but it is apparent that Lorenzo's relatively short life would not be free from difficulties. For example, the evidence indicates that he would not let go of the bitterness he first felt toward il Magnifico in 1485 over the latter's handling of his and his brother Giovanni's inheritance. Despite attempts to settle their financial disagreements, they could not be resolved satisfactorily and would underlie family disputes throughout the last years of the Fifteenth Century.

After il Magnifico died in 1492, his son, Piero the Unfortunate, took over as the *de facto* lord of Florence, squandering the Medici wealth in the process. The relationship between Piero and his cousins was antagonistic enough for him to support their April, 1494, exile by the Florentine council, allegedly for conspiracy against the city's government but actually due to their friendship with King Charles VIII of France and Ludovico Sforza, enemies of Piero. With their help, Lorenzo and Giovanni stayed outside Milan, returning to Florence after Piero himself had been forced to flee the city in November of that year.

But perhaps nothing speaks to Lorenzo's profound resentment more loudly than his and Giovanni's decision to change their name from Medici to Popolani shortly after their return from exile.[244]

Whether or not these thoughts went through his mind, one thing is certain. The *Primavera*, in a setting that included the *Minerva and*

Centaur and a tondo of the Madonna and Child, was a constant reminder to him of Ficino's belief in the efficacy of the occult arts in achieving a transformation of the spirit and an acquisition of Christian virtues.

Lorenzo di Pierfrancesco de' Medici died of unknown causes on May 20, 1503, less than two months after his fortieth birthday. On that date the three Graces once again were together in the sign of Gemini. However, this time it was Jupiter himself, instead of Mercury, who accompanied the sun and Venus, following them into Venus's night sign, Taurus. The moon found herself under Pallas's rulership in Aries, holding a sextile aspect to the Graces. It is striking—even unsettling—that the positions of these planets comply so well with the instructions given by Marsilio Ficino to the young Lorenzo so many years before.

Ficino, who had died in 1499, would have deemed these placements exceedingly propitious. This in itself makes the death of Lorenzo on such a date an incredible coincidence. Almost exactly twenty-one years earlier he had been asked to dispose his own heavens in accordance with the *Primavera*. One cannot know if he tried to live his life according to that message, but it is certain that the Apollonian soul of Lorenzo left its earthly prison on a day when it could be returned to its own celestial home. There it would find the warmth, radiance, and splendor of the three Graces. With his death, Lorenzo di Pierfrancesco de' Medici finally responded to the challenge of Marsilio Ficino. With it, the promise of the *Primavera* was fulfilled.

Appendix I: Additional Analysis of the Literature

Arnolfo B. Ferruolo saw Botticelli's *Primavera* and Politian's *Stanze* as belonging to the same broad cultural tradition; for him, both reflected Ficino's Neoplatonic concept of love.[245] In his view, Ficino's thought was composed of two themes: light and love. "Light is the splendor of divine beauty . . . Love is the vital principle of universal existence." Claiming that these two themes are implicit in the *Stanze*, Ferruolo explained the connection between beauty and love: "There is a downward way and an upward way of love; and the latter ends where the other begins. It is a circle: beauty begets love, and love leads to the fruition of beauty." Then Ferruolo cited Botticelli's *Birth of Venus*, *Primavera* and *Venus and Mars* as examples of "the same process of thought with which Poliziano's poem is informed." These works are "variations . . . of a single theme," which is the circle of love.

Ferruolo offered no new sources to support his thesis. Instead, his explanation was an effort to reconcile Politian's poem with Ficino's philosophy of love, expressed visually in Botticelli's art. The importance of this approach lies in the fact that it gives Botticelli's "mythologies" an abstract philosophical context: Ficino's Neoplatonism governs their messages.

Edgar Wind pursued this same path, developing the notion that the *Primavera*'s meaning was derived from Ficino's concept of the circle

of love while maintaining that Politian contributed something to the painting, if only its lyrical or poetic character.[246] Wind's interpretation is notable for the emphasis it gives to the composition of the *Primavera*. Accepting Ovid's description of Flora from the *Fasti*, he saw this as the literary source for the triad on the right side of the panel and interpreted it as a description of the metamorphosis of Chloris into Flora, following Zephyr's rape of and marriage to Chloris. Further, Wind took Botticelli's rendition of this metamorphosis to be a visual metaphor of Ficino's "productive triad." The middle Grace, Castitas, takes Pulchritudo (the Grace on the right) "as her term of departure" and "moves toward Voluptas," the third Grace. It is this triad that, according to Wind, provides the clue to the painting's message. Mercury, who looks heavenward while moving the veil of clouds with his caduceus, connotes ascent, and the Graces become a middle term between descent and ascent. Therefore, the painting depicts "the three phases of the Neoplatonic dialectic: *emanatio-conversio-remeatio*; that is, 'procession' in the descent from Zephyr to Flora, 'conversion' in the dance of the Graces, and 'renascent' in the figure of Mercury." Mercury and Zephyr are the "two complementary forces of love, of which Venus is the guardian and Cupid the agent."[247]

Wind's argument is cogent and difficult to refute if one accepts the metaphorical function of the two triads. However, the asymmetrical reading of the painting's composition is not entirely satisfactory, and there are other problems left unresolved. Why, for example, would Botticelli deem it necessary to place his figures in an elaborately bedecked rural setting when the theme suggested by Wind does not require it? And, again, why is Venus so oddly attired?

Another poetic discussion of the *Primavera* is found in Ronald Lightbown's two-volume work, *Sandro Botticelli*. [248] Of course, Lightbown knew that Medici inventories placed the painting in Lorenzo's townhouse in Florence, at least by the end of the fifteenth century. With this information, he was able to see the painting in a context completely different from the rural villa at Castello.

Rather than call the setting in the *Primavera* the "realm" of Venus, Lightbown interpreted it as the mythical garden of the Hesperides in which Venus's golden apples grew. Within this garden the central figure, a matronly Venus, gestures toward the Graces, who represent virginal purity. Cupid aims his arrow, which is destined to "kindle the flames of love," at the heart of one of the Graces, as described in Politian's *Stanze*. [249] Lightbown has seen the triad of Zephyr-Chloris-Flora as an "exact representation" of Ovid's passage and the Mercury figure as a guard to the garden because of his unusual helmet and sword. Finally, finding no reason to date the painting before c.1480, Lightbown argues that its "principal action lies between Venus and Cupid and the Grace whose heart they intend to pierce with the arrow of love and to fire its flames. That love . . . is one that will enjoy a lawful fruition in marriage." The marriage to which he refers was Lorenzo's own to Semiramide d'Appiano, which originally had been scheduled for May, 1482. [250]

Appendix II: Ficino's World Soul and World Spirit

Ficino's World Soul

Timaeus explains the composition of the world soul in the course of his description of the creation of the world. "From the being which is indivisible and unchangeable and from that kind of being which is [divisible and corporeal], [God] compounded a third and intermediate kind of being. This third and new being is the mean of the first two. "He did likewise with the same and the different, blending together the indivisible kind of each with that which is portioned out in bodies. . . [and] divided this whole into as many portions as was fitting, each portion being a compound of the same, the different, and being."[251]

Ficino discusses the composition of the world soul in chapter XXVIII of his commentary. He says the soul is composed of divisible and indivisible natures, which correspond to even and uneven numbers. Since all the even and uneven numbers of the universe are contained in the decad (the numbers 1-10), the perfect mean of the universe is the number 5. This is also the number of the soul, since the mean of the universe is identical with the soul. The

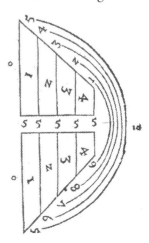

number 5 also signifies the substance of which the soul (and all living things) is composed: essence, the same, the other, status, and motion. He includes a diagram that shows the number 10 as the sum of 9+1, 8+2, 7+3, etc. The number 5 is shown to be the critical component and the mean of each computation.[252]

Having explained the composition of the world soul, Timaeus goes on to say that the portions into which the compound was subdivided have a rational relationship, one to the other, indicated by the numbers 1, 2, 3, 4, 9, 8 and 27. Arranged pyramidally in what is called the Nicomachaean Lambda, they appear as follows:

$$
\begin{array}{ccc}
& 1 & \\
2 & & 3 \\
4 & & 9 \\
8 & & 27 \\
\end{array}
$$

It can be seen that the two branches of the lambda are generated from the powers of the prime numbers 2 and 3.

In his discussion of this section of the *Timaeus*, Ernest G. McClain provides information that clarifies Plato's words.

We know from the earliest full commentary on the dialogue, written by Cranto in Plato's own century, that the Academy debated the relative merits of two different methods of "taking" Plato's proportions: a) "exponed in one row" as an arithmetic series, and b) arranged in form of the Greek letter Lambda _/_, separating the powers of 2 and 3.[253]

McClain goes on to explain the first method ("exponed in one row") and then turns to the lambda arrangement.

"The second solution . . . is far more elegant and instructive. It is the outline for Nichomachus's first table of proportions, developed from the prime numbers 2 and 3 (Introduction to Arithmetic, bk. II, ch. III). Nichomachus sets the powers of 2 along one side of a triangular table, the powers of 3 along the hypotenuse, and the resultant ratios of

1	2	4	8	16
	3	6	12	24
		9	18	36
			27	54
				81

the successive perfect fifths 2:3 in the vertical columns."[254] The numbers in Nichomachus's table of proportions can be extended indefinitely.

Rudolf Wittkower also addressed the notion of the lambda in relation to Plato's description of the creation of the universe.

> In the wake of the Pythagoreans, Plato in his *Timaeus* explained that cosmic order and harmony are contained in certain numbers. Plato found this harmony in the squares and cubes of the double and triple proportions, starting from unity, leading him to the two geometrical progressions, 1, 2, 4, 8 and 1, 3, 9, 27. Traditionally represented in the shape of the Greek letter lambda, the harmony of the world is expressed in the seven numbers 1, 2, 3, 4, 8, 9, 27, which embrace the secret rhythm in macrocosm and microcosm alike. For the ratios between these numbers contain not only all the musical consonances, but also the inaudible music of the heavens.[255]

These numbers were considered sacred by the Pythagoreans for several reasons. For example, the monad comes first and precedes all numbers; therefore, it denotes the point. In the progression from the prime number 2, 2 stood for a straight line, 4 for the rectilinear plane, and 8 for the rectilinear solid. In the sequence from the prime number 3, 3 was understood as a curved line, 9 as the curvilinear surfaces, and 27 as the curvilinear solid.[256]

Next, the series includes the first four integers whose sum, 10, was considered a perfect number. These four integers, 1, 2, 3 and 4, comprise the simple tetrad or the tetractys. The two quaternaries of the lambda (1, 2, 4, 8 and 1, 3, 9 and 27), called the double tetractys, were seen in the same way; that is, the last number of the sequence (27) is the sum of the preceding integers (1, 2, 3, 4, 8 and 9).

Most important, these numbers comprised the proportions of the parts of the compound of the world soul, the same mixture that was to be cut into the two lengths that were then curved around to form the circle of the same and the circle of the other. This has two consequences. First, these numbers denote the proportional distances between the planetary orbits of the circle of the other. Second, these proportions lead to the notion of the "harmony of the spheres"; for, after reciting the numbers to his companions, Timaeus recounts the deity's next act.

> After this he filled up the double intervals [i. e., between 1, 3, 5, 8] and the triple [i. e., 1, 3, 9, 27], cutting off yet other portions from the mixture and placing them in the intervals, so that in each interval there were two kinds of means.[257]

In other words, Pythagoras's spherical "harmony" was not audible. It consisted of mathematical relationships that created perfect or harmonious proportions among and between the heavenly bodies.

Ficino's World Spirit

The most complete discussion of Ficino's notion of the world spirit is in the third book of his treatise, *De vita triplici*, written between 1482 and 1489. The first part of this work is devoted to medicine and medical matters, reflecting Ficino's early education and a life-long interest. The second section is also medical, but it does contain a few references to astrology.

The third book, according to Wayne Shumaker, who has analyzed Ficino's "astrological magic," as he calls it, " is most pervasively magical Its substance is best suggested if we translate the title of this book, *De vita coelitus comparanda* . . . as 'On Obtaining Life from the Heavens.' "[258] The second of these two translations of the title of the third book, *De vita triplici*, is from D. P. Walker. His analysis of this same part concentrates on Ficino's "astrological music" and emphasizes his concept of world spirit.[259]

Walker introduces his own discussion of Ficino's astrology by stating, "[It deals] with methods of tempering the melancholic influence of Saturn by attracting the benign influences of Jupiter, Venus, Mercury, and, above all, the Sun." He then observes that Ficino's Roman Catholicism would not have permitted him to "accept an astrological determinism which included soul and mind. On this view, the highest part of man which could be directly influenced by the stars [would be] the spirit."[260]

Walker continues: "Ficino here accepts a theory of astrological influence . . . which postulates a cosmic spirit (spiritus mundi), flowing through the whole of the sensible universe . . ." This cosmic spirit, says Walker, is a mean between that which is above and that which is below.[261] In other words, the cosmic or world spirit is an intermediary between the world soul and its body, which includes the sublunar earth and human beings.

Evidently Ficino saw the world spirit as an intermediary that unites two extremes–the world soul and the world body–in his formulation of the universe. This emphasizes the importance of the principle of the mean in his system. In this instance, Ficino seems to have been conceptualizing a mean–the world spirit–that is not strictly Platonic. Although in the *Timaeus*, Plato did say that any two terms must be united by a third or mean term, his description of the creation of the world soul and body does not include a world spirit.[262] Although Plato's creation story has already been explained briefly herein, further clarification may be necessary, since Plato did refer to a third term in that account.

The intermediate term, which is referred to in this very difficult section of the *Timaeus*, seems to be like a "binder" that is made from undivided unity and divided matter. This binder results when the undivided is combined with the divided but at the same time also unites them. In a sense, then, a new unifying, essential being is created, and this in turn is combined with the same and the other to create a new compound. It is from this new mixture that the creator made the portions that were related to each other in the ratios of the numbers of the tetractys, which would finally yield the intervals of the Pythagorean musical scale. At this point, the creator divided the mixture of these portions and intervals into the two circles: the circle of the same and the circle of the other. The former became the sphere of the fixed stars or constellations; the latter was used for the seven planetary zones. Jowett observed that these two circles "represent respectively (amongst other things) the equator and the elliptic." He also noted the following:

> As the soul was interfused throughout the whole sphere of the universe, we must regard the two circles [as a simple framework], so to speak, denoting the directions of the two movements [of the soul]. These two circles are encompassed by a moving spherical envelope, being the circumference of the entire sphere of the soul . . .[263]

Plato's unwillingness to identify a world spirit did not deter Ficino, who interjected this concept into his commentary on the *Timaeus*.[264] However, since one cannot trace the notion directly to Plato, it must be concluded that Ficino's identification of this spirit was based on another source or sources wherein the notion of intermediaries was especially emphasized.

Walker wrote that the source of Ficino's world spirit was ultimately stoic.[265] That may be true, but it is probably more instructive to recognize that Iamblichus, the biographer of Pythagoras and Proclus, Iamblichus's follower, have been acknowledged as the thinkers who were most

enamored of the concept of the mean.[266] E.R. Dodds attributed a new "direction" of Neoplatonic thought to Iamblichus in the introduction to his translation of Proclus's *Elements of Theology*. According to Dodds, "the historical importance of Iamblichus has hardly been sufficiently recognized, no doubt because his metaphysical works have perished and the outlines of his doctrine have to be reconstructed mainly from Proclus's report of his teachings together with the fragments preserved by Strobeus and the semi-philosophical treatise *On the Mysteries of the Egyptians.*"[267]

Dodds goes on to say that many important doctrines can be traced to this man, doctrines that "have an important place in the later [Neoplatonic] system, [as well as] the dialectical principles which throughout control its architecture, [and] the law of mean terms. . . ." Further on, in his explanation of Proclus's contribution to this late (4th century C.E.) development of Neoplatonism, he states the following. "Again and again in the *Elements*, Proclus justifies his multiplication of entities, like Iamblichus in the same circumstances, but reference to the 'law of mean terms', viz. That two doubly disjunct terms AB and not-A not-B cannot be continuous, but must be linked by an intermediate term, either A not-B or B not-A, which forms a 'triad' with them."[268]

Appendix III: The Astrological Charts of May 13 and May 23, 1482

The chart of the disposition of the planets on May 13, 1482, at 2:00 p.m. shows that the sun, Mercury, and Venus were together in the ninth house; the sun had just entered the sign of Gemini, sharing that sign with Mercury. Venus, in the same *house*, was in her own *sign*, Taurus, a most excellent placement. The proximity of these planets to one another is close enough to say that they were "in conjunction."

The moon and the sun are particularly well placed in relation to each other. They are 35° apart, which is close enough to constitute what astrologers call a "bi-quintile" (36°) aspect. This aspect is granted the same characteristics as the "quintile," an angle of 72°, which is deemed especially propitious. According to tradition, an astrological aspect of 72° denotes a creative transformation of the individual who is affected by it. This is precisely what Ficino was advocating for the young Lorenzo.

Jupiter is in Leo, which means that he and the moon are in a trine aspect, an angle that is always beneficent.[269] Also, Jupiter is together with the "part of fortune," a relatively unknown relationship between the moon, the rising sign, and the sun that signifies "the type of personality that the individual will most likely develop and project . . . The part of fortune is a point of personal strength and happiness . . .[When it

is with a planet,] the planet's characteristics will also be externalized and made evident (if not dominant) within the personality."[270] So, the individual who might have been blessed with this horoscope would enjoy the bounty that Jupiter bestows and would partake of his expansive, generous, and just nature; the influence of Jupiter would pour down upon and condition the essential personality of the native.

Saturn is in Libra–the first house and rising sign–where he is exalted. Every planet has its own sign where its favorable qualities are enhanced. Libra's power over Saturn would tend to moderate that planet's more malefic traits and instead emphasize the perfection of relationships and the creation of harmony and beauty. Since Libra falls in the first house of selfhood and personality in this chart, Ficino might have seen Saturn's position there as an indication that Lorenzo would develop an awareness of the value of contemplation.

Some astrologers might believe that these favorable indications of Saturn's position on May 13 would be offset by the moon in Aries, which sign is directly across the chart from Libra. Because of their placements, Saturn and the moon are opposed to each other, an aspect that is often considered difficult. Ficino, however, did not consider an opposition absolutely detrimental. In the *Liber de Sole* he wrote, "the conjunction or opposition of the moon with the sun, if either occurs ahead of the rising sign, predicts both truth and fortune for the native."[271] This does not mean that he would have seen an opposition between the moon and Saturn in such a favorable light, but it does suggest that some circumstances might mitigate a baleful prognosis of that aspect.

In this case, Saturn in Libra is in a trine aspect to the three Graces, especially to Mercury at 13° Gemini. Moreover, since Mars is located in Aquarius, it also has a trine aspect to Saturn. This arrangement, called a "grand trine," divides the astrological map into three equal sections at 120° intervals and is considered particularly propitious, since it triples the favorable trine aspect. Its meaning relates to the notion that any triad consists of two opposites reconciled by a third part, which is the mean between the two. Thus, it implies harmony, and the individual

whose planets are arranged in this manner is granted a particularly harmonious disposition.

Since the grand trine of May 13, 1482, occurred in the three signs of the zodiac's twelve that are associated with the element air, which is reputed to be the spiritual medium, it would impart to the native a joyous and optimistic attitude, a willingness to help others, a desire to improve oneself, an intellectual ability, and the capacity to adapt.

Further, Mars in Aquarius was certainly not in "bad" aspect to the moon, although the angle between them probably would not be considered very powerful or beneficial either. Ficino was wary of Mars, seeing him as needing the calming influence of Venus.[272] In the fourth house of Aquarius, the aggressive and sometimes explosive Mars would have the benefit of Venus's soothing touch because of the trine aspect between them. Moreover, in this placement, he would be apt to assert his masculine strength in the cause of personal and family relationships.

Surely this is a horoscope that promises success and happiness, for it accentuates intelligence, sensitivity, and social interactions. It is even more impressive when seen in connection with the horoscope drawn up for May 23, 1482.

On May 23, 1482, ten days after the May 13, 1482 horoscope, the moon had traveled through the signs of Taurus, Gemini and Cancer and was positioned in Leo. Here she reached a conjunction with Jupiter, who had advanced one degree to enter the sign of Virgo. These two still enjoyed a favorable relationship. This circumstance was especially salutary in the eyes of Ficino, who wrote the following:

> So that you may proceed with the least danger and at the same time on the easiest path in all things, watch for the moon when she aspects the sun and is conjunct with Jupiter or at least aspects Jupiter at the same time as the sun, or certainly when, after an aspect to the sun, she quickly progresses to a conjunction with or an aspect to Jupiter.[273]

Indeed, the moon had aspected both Jupiter and the sun in favorable angles on May 13, and now she has progressed to be together with Jupiter at the same time that she has settled into another beneficial angle with the sun.

From her position in Leo, the moon looks back toward the planets in the ninth house from a 72° angle–the quintile aspect–to find that the sun had moved farther into Gemini. He now leads Mercury, who has fallen back and is hand in hand with Venus, who has advanced from Taurus into Gemini. Now all three Graces find themselves not only in the same house but also in the same sign, under the rulership of the planet Mercury and the deity Apollo.

In his position in Gemini, the sun has traversed 72° of the 360° circle of the zodiac. The moon, now in Leo, has covered 72° since May 13. Recalling that on May 13 she held a bi-quintile aspect to the sun, and observing that now she shares with him a full quintile angle, one must believe that the recurrence of 72° in these charts would have underscored the significance and meaning of that aspect with its symbolism of transformation.

Saturn holds his place in the first house of Libra, but Mars has advanced to Aquarius, which sign now is in the fifth house, bringing humanistic or social needs to the forefront. The grand trine among Saturn, Mars, and the Graces is maintained with little change in degrees, but the sun, as noted, is now the lead planet in Gemini in place of Mercury. Finally, on May 23, 1482, the moon is opposed to Mars rather than Saturn, and now she aspects the latter in a "loose" sextile. Thus, she has reversed the relationships held with those two bodies just ten days earlier.

Mercury's place in this chart is especially commanding because it seems to explain why Ficino called him "Mercurius Jovius" even more convincingly than any of the explanations heretofore offered. According to traditional astrological exegesis, each sign of the zodiac is divided into sections of 10°, which are called decans. Each decan has its own ruler, and, in chapter IX of *De vita coelitus comparanda*, Ficino relates that the

first decan of Gemini is governed by Jupiter.[274] Therefore, since Mercury, at 9°, comes under the power of Jupiter in Gemini's first decan, surely he would feel a particularly strong influence from that governor, which could account for the appellation, Mercurius Jovius.

Endnotes

Introduction

1 Tempera on poplar wood, consisting of seven panels and measuring 6'8½" x 10'4". The *Primavera* is in the Uffizi Gallery, Florence.

2 Giorgio Vasari, *Lives of Seventy of the most eminent Painters, Sculptors and Architects* II Trans., Mrs. Johnathon Foster; eds. Edwin Howland Blashfield, Evangeline Wilber Blashfield and Albert Allis Hopkins (New York: Charles Scribner's Sons, 1896), 210f.

3 Herbert P. Horne, *Allessandro Filipepi Commonly Called Sandro Botticelli, Painter of Florence* (London, 1908) .50.

4 John Shearman, "The Collections of the Younger Branch of the Medici," *Burlington Magazine* 117 (Jan., 1975), 12–27. See also Webster Smith, "On the Original Location of the 'Primavera," *The Art Bulletin*, LVII (1975), 31–39, for his interpretation of the *Primavera* based on the evidence of the Medici inventories regarding its location in 1498.

5 Leon Battista Alberti, *On Painting* [rev. ed.], trans. John R. Spencer. (New Haven: Yale University Press, 1966), 14.

6 Jacques Mesnil, *Botticelli* (Paris: Albin Michel, 1938), 50. *Ce tableau quelque chose de mysterieux: le sens même de la composition est demeure longtemps obscure. Que significent ces personnages, isoles ou reunis par petits groupes, dont chacun semble vivre, pour soi seul et suivre au loin un rêve qu'il ne révélera jamais? Que veut dire le geste vaque de cette femme à la tête inclinée comme alanquie?*

7 Ernst H. Gombrich, "Botticelli's Mythologies: A study of the Neoplatonic Symbolism of his Circle," *Journal of the Warburg and Courtauld Institutes,* VIII (1945) 11.

I. The Literature on the *Primavera*

8 Aby Moritz Warburg, *Gesammelt Schriiften*, Kraus Reprnt (Germany: Krause-Thomson Organization Ltd), 1969.

9 Leon Battista Alberti*, On Painting and On Sculpture*, trans. and ed. Cecil Grayson (London: Phaidon Press Limited, 1972), 97.

10 Ovid, *Fasti*, trans. and ed. Sir James George Frazer (Cambridge, MA.: Harvard University Press, 1959), 261f.

11 These two figures in the painting are now generally accepted as Zephyr and Chloris with this passage as Botticelli's source. On the other hand, Herbert Horne preferred Lucretius's words in *De Rerum Natura* V, 738–741 as the source for all three figures:

> Spring and Venus come; before them strides Zephyr, Venus's forerunner, and Mother Flora, closely following in his steps, he strews and fills their path with wondrous flowers and perfumes. Titus Lucretius Carus, *On Nature*, trans. Russel M. Geer (New York: The Bobbs-Merrill Co., Inc., 1965).

According to Horne, "These passages not only explain . . . the conception of Venus, which forms the central idea of this picture, but, also, the three obscurer figures of the composition, namely, Spring, Flora, and Zephyr." Herbert P. Horne, *Alessandro Filipepi commonly called Sandro Botticelli, painter of Florence* (London, 1908), 55.

12 Wilhelm Bode, *Sandro Botticelli*, trans. F. Renfield and F.L. Rudston Brown (London: Methuem & Co. Ltd, 1925), 55.

13 Mesnil, 50

14 Horne, 58

15 Lionello Venturi, *Sandro Botticelli,* trans. Dr. Horovitz (Vienna: Phaidon-Verlag, 1937), 19.

16 Erwin Panofsky, *Renaissance and Renascences in Western Art* (Stockholm: Almqvist & Wiksell, 1960), 192.

17 Gombrich, 1945, 7-60.

18 Brown, Alison, "Pierfrancesco de' Medici, 1430-1476: A Radical Alternative to Elder Medicean Supremacy?" *Journal of the Warburg and Courtauld Institutes*, 42 (1979), 81-103; 90.

19 Gombrich, 1945, 16. See Marsilio Ficino, *Opera Omnia* (facsimile of 1576 Basle edition, Turin: Bottega D'Erasmo, 1959), 805f. Subsequent citations to this work will be given as *Op. Om.*

20 Ibid. 17.

21 Ibid. 22.

22 Apuleius's novel was published in Rome in 1469 and found a receptive audience and much popularity.

23 After presenting some arguments to support his choice of this section of *The Golden Ass* as the source of the painting's program, as well as some explanations for Botticelli's obvious deviations from Apuleius's text, Gombrich acknowledged: "That there are serious difficulties in the way of linking Apuleius' text with the hypothetical programme for Botticelli's picture cannot be denied." (Gombrich, 1945, 28.)

 Approximately twenty-five years later, Gombrich republished his essay, preceding it with "A Postscript as a Preface." ("Botticelli's Mythologies: A Study in the Neo-Platonic Symbolism of hisCircle," *Symbolic Images: Studies in the Art of the Renaissance.* (London: Phaidon Press, Ltd, 1972), 31-81) Responding to other scholars who had offered interpretations of the *Primavera* that, in effect, took issue with the conclusions of his 1945 essay, Gombrich was led to question iconological methodology. First, he emphasized that his original essay presented a hypothesis and not a proof. (31) Further on, he wrote the following: ". . . . [T]he literature on the Primavera . . . has amply proved that there are innumerable references in ancient and Renaissance literature to the Goddess of Love I feel that their very wealth tends to obscure rather than to illuminate the problem of [such] paintings." (32).

24 Gombrich, 1945, 30.

25 Ibid. 54. Gombrich cites pages 1217 and 1902 of Ficino's *Op. Om.* to support this contention. The first of these citations refers to a section of chapter XI of Ficino's commentary on Plato's *Philebus*, entitled "About Venus and the gods; about the names of the gods and the reverence around them." The second citation is to his commentary on Iamblichus, "Concerning divine names."

26 Charles Dempsey, *The Portrayal of Love: Botticelli's Primavera and Humanist Culture at the time of Lorenzo the Magnificent.* (Princeton: Princeton University Press, 1992), 5ff.

27 Ibid. 6

28 Ibid. 6 f.

29 Ibid. 9

30 Ibid. 10

31 Charles Dempsey, "*Mercurius Ver*: The Sources of Botticelli's *Primavera*," *Journal of the Warburg and Courtauld Institutes* XXXI (1968), 251-273

32 Warburg demonstrated that Manilius's assignment of guardian deities to the signs of the zodiac determined the imagery of Cossa's frescoes in the Palazzo Schifanoia. See "Italienische Kunst und Internationale Astrologie in Palazzo Schifanoja zu Ferrara," Gesammelte Schriften (Germany: Kraus-Thompson Organization Ltd; rpt. 1969), 459-481

33 Manilius, *Astronomicon*, II, 439-447

34 Manilius assigned the remaining signs to the following guardians: Leo to Jupiter; Virgo to Ceres; Libra to Vulcan; Scorpio to Mars; Sagittarius to Diana; Capricorn to Vesta; Aquarius to Juno; and Pisces to Neptune.

35 *Op. Om.*, 1341. In chapter XIII of the fifth speech of Ficino's commentary on Plato's *Symposium*, Ficino has his speaker cite Manilius's guardians. The ruling planets are given on page 542.

36 It was for this reason that the ancients, as Ovid tells us, made the Ides of May sacred to Mercury. (Ovid, 663.)

37 Dempsey, *Mercurius Ver, 254.*

38 Ovid, 599-602.

39 Ronald A. Lightbown, *Sandro Botticelli* II (Berkeley: University of California Press, 1978), 72-81.

40 Mirella Levi-D'Ancona, *Botticelli's Primavera: A Botanical Interpretation, Including Astrology, Alchemy and the Medici*. Firenze: Leo S. Olschki Editore, 1983.

41 *Op.Om.* 845ff. See chapter VIII of this book for my interpretation of this letter.

42 Levi-D'Ancona, 47f

43 Ibid. 11; 14. In note 9, 11. Levi-D'Ancona cites her source for this date: Florence, *Biblioteca Nazionale, Magliabechiana Classe* 37, Codex 299, Folio 292. She gives the pertinent passage in Latin as follows:

 G 20 die 19 Julii 1482 fuit notificatum qualiter Laurentius Petri Francisci de Medicis consumavit matrimonium cum Ma Semiramide eius uxore et filia quondam illi Domni Jacobi Terii Dni de Appiano et pro ejus dote debet recipere F 2000 de sigillo et tantum ultra quantum declaratum fuerit per Magnificum Laurentium Petri Cosme de Medicis c. 109

44 Barbara Gallati, "An Alchemical Interpretation of the Marriage between Mercury and Venus" (Levi-D'Ancona), 99-121.

45 Levi-D'Ancona, 46; 65f. See also 50, n. 79 for her explanation of the relationship between the Mercury and central Grace figure.

Levi-D'Ancona observes, "Venus is shown clothed because she is usually clothed in astrological representations of Venus" (37). This statement is based on Gallati's essay in which she states, "The instances in which Venus is depicted clothed can, for the most part, be limited to when she is associated with the astrological function of her nature" (106). This, in turn, is based on J. Ferrante and George Economou, eds., *In Pursuit of Perfection* (Port Washington, New York: Kennikat Press, 1975), 23.

While the notion of a clothed Venus tends to support the occult readings of the paintings, the costume of the central figure bears little resemblance to those shown by Gallanti as examples of the astrological Venus. It is not probable that Botticelli clothed his leading lady in her distinctive robes out of whim or fancy; therefore, one must consider the possibility that the costume of the central figure in the *Primavera* was intended to denote something or, more precisely, someone other than the astrological Venus.

II. Compositional Analysis

46 Bode, 60.

47 Mesnil, *C'est la vision d'un monde superieur que Botticelli a essayé de traduir, d'un monde où la Beaute serait reine. C'est un rêve où les souvenirs des plus belles impressions de la view se mêlent aux images discontinues d'un passe merveilleux, une evocation de splendours révolues faite par une âme emplie due désir de creations nouvelles.* (52)

48 Vasari, 210, note 14.

49 Horne, 55.

50 Roberto Salvini, *All the Paintings of Botticelli, Part 2 (1445-1484.).* trans. John Grillenzoni *(*New York: Hawthorn Books, 1965) 24.

51 Venturi, 7.

52 Frederick Hartt, *History of Italian Renaissance Art: Painting, Sculpture, Architecture* (New York: Harry N. Abrams, Inc., 1969), 282.

53 Lightbown, I. 77.

54 Ibid., 16.

55 Ibid., 36.

56 Alberti explained this phenomenon in Book I of his treatise on painting. Grayson's translation of the passage in chapter 20 reads, "This is why men depicted standing in the parallel further away are a great deal smaller than those in the nearer ones–a phenomenon which is clearly demonstrated by nature herself, for in churches we see the heads of men walking about, moving at more or less the same height, while the feet of those further away may correspond to the knee-level of those in front." (Grayson, 57.)

Samuel Y. Edgerton, Jr. calls this "horizon line isocephaly." His definition may clarify the experience. "[I]f we see other persons standing on the same plane as ourselves, the apparent diminution in the size of more distant figures begins with the feet; the heads of all figures standing on the same level as the viewer are always seen aligned with his own head on the common horizon." *The Renaissance Rediscovery of Linear Perspective.* (New York: Harper & Row, Publishers, 1975), 26.

III. The Central Figure

57 Wilhelm Bode observed that the central figure is Venus because she is "identified as the Goddess of Love by her companion Cupid; for her fully clothed figure, her almost shy bearing and her melancholy glance would not otherwise suggest this goddess…" *Sandro Botticelli*, trans. F. Renfield and L. Rudston Brown (London: Methuen & Co. Ltd, 1925), 58f.

58 Vasari, 210. The complete passage is quoted above, 4, note 2.

59 Gombrich, 54.

60 Apuleius of Madauros, The Isis Book (*Metamorphoses*, Book XI), Trans. and ed. John Gwyn Griffiths (Leiden: E.J. Brill, 1975), 73f.

61 Ibid., 75.

62 Apuleius's descriptions of Lucius's initiations into the cult of Isis, first as a follower and then, later, as a priest, contain enough specificity of detail to have convinced scholars that the writer was himself a priest in Isis's cult, at "one of the oldest and most important temples of Isis in Rome." Martin Rist, *Two Isiac Mystics: Plutarch and Apuleius the Priest*. (Chicago: University of Chicago Libraries, 1936), 4.

63 As Apuleius has indicated, one of Isis's traditional attributes was the serpent. Ordinarily it was supposed to be concealed in a situla, a pail carried by Isis. The serpent was also associated with the god of healing, Asclepius, with whom Isis was linked, and by extension, with Hermes Trismegistus, her legendary ancient priest. The Greek Hermes and the Latin Mercury inherited this symbol from Asclepius, for they are shown with twin snakes wrapped around a healing wand, the Caduceus, and it is this attribute that identifies the male figure on the left side of the *Primavera*.

64 According to Plutarch, the Egyptian myth of Isis says she wore an amulet that means "the voice is true." Plutarch's *De Iside and Osiride*, trans. and ed. John Gwyn Griffiths (Cardiff: University of Wales Press, 1970), 205.

65 R. E. Witt, *Isis in the Graeco-Roman World* (Ithaca, New York: Cornell University, 1971). 133.

66 Plutarch states that the "elder" Horus was called Apollo. (Griffiths, *De Iside*, 205). See Macrobius, *Saturnalia*, trans. Percival Vaughn Davies (New York:

Columbia University Press, 1969), 143. "Among the Egyptians Apollo (and he is the sun) is called Horus–whence the name "hours" (horae) has been given to the twenty-four divisions which make up a day and a night and to the four seasons which together complete the cycle of the year." Macrobius equates Isis with the earth or world of nature, and therefore she is mother of the gods. Her consort, Osiris, he says, "is none other than the sun" (142).

67 Written in the first quarter of the second century C.E., about 25–30 years before the novel by Apuleius, Plutarch's essay tried to demonstrate that the Egyptian gods were originally Greek gods that migrated to Egypt. See Rist, 1.

68 Ficino's translation of the *Corpus Hermeticum* is included in the *Opera Omnia*, 1836–1857.

69 Frances A. Yates, "The Hermetic Tradition and Renaissance Science," *Art, Science and History in the Renaissance,* Charles S. Singleton, ed. (Baltimore: The John Hopkins Press, 1967), 255.

70 Ibid., 256.

71 Asclepius was the Greek god of healing and was held to be the son of Apollo. He was taught the art of healing by the centaur, Chiron. His main sanctuary was at Epidaurus, but his cult spread during the Hellenistic period, reaching Rome in the early third century B.C.E. Sacred to him was the serpent, with which he reached Rome and which is shown coiled around his staff or wand of healing (supra, note 53). However, the work known to Ficino as the Asclepius consists of dialogues on divine teachings of man, the One, and the Cosmos. See *Op. Om.* 1858–1877.

72 See Erik Iversen, *The Myth of Egypt and its Heiroglyphics in European Tradition* (Copenhagen: Gec God Publishers, 1961), 62f. for an account of how the Dominican abbot Giovanni Nanni (1432–1502) a.k.a. Annius, invented a history that was intended to establish that "the Borgia family descended directly from the Egyptian Hercules, who was the son of Osiris" This revisionism was the source for Pintoricchio's frescoes.

73 See also Ioan P. Couliano, *Eros and Magic in the Renaissance* (Chicago: The University of Chicago Press, 1987), 139. In his discussion of Ficino's magic, Couliano briefly explains the Florentine's "astromagic," tracing this concept of the affinities of the human body with the physical cosmos, particularly the seven planets, to the doctrine attributed to Hermes Trismegistus, put forth in the *iatromathematica.* Couliano's citation is given herein. "*Hermetis*

*Trismegisti Iatromathematica (Hoc est, medicinae cum Mathematica coniuncto)
ad Ammonem Aegyptum Conscripta, interprete Ioanne Shadio Leonnouthesio,"*
in *Johannes of Hasfrut, De cognoscendis et medentis morbis,* f. 113r.

IV. The Goddess of Many Names

74 *Op. Om.,* 548. This section is the third part of a treatise, *De vita triplici* and
is famous for Ficino's astrological references.

75 Ibid., 1858.

76 Ibid., 1870

77 Griffiths, *De Iside,* 131.

78 Although Minerva is identified with the Egyptian deity Neith by Plato, Neith
and Isis were often understood to be one and the same.

79 *Memineris praeterea Neptunum quidem providentiam naturaralem, Palladem
vero providentiam intellectualem significare, atque hanc ipsam Palladem a
Platonicis describi, divinitatem sapienter simul atque potenter tum coelestia
exornantem, tum quae sub coelo fuerent aedificantem; inter astra Arieti praecipue
praesidentem; & aequinoctialis circuli ducem; ubi potissimum vigere putant
motricem universi virtutem. Mandabis memoriae aureum epigramma; quod
proculus fit Aegyptiorum historiis legit Minervae templis inscriptum: Ego sum
quae sunt, quae erunt, & quae fuerunt. Velum meum revelavit nemo. Quem ego
fructum peperi sol est natus. (Op. Om,. 1439)*

80 "The fruit which I brought forth was the sun." Thomas Taylor, trans., *The
Commentaries of Proclus: On the Timaeus of Plato* (London, 1820), I, 82.

Ficino's commentary on the *Timaeus* seems to borrow more from Proclus'
earlier work than just this additional sentence in the inscription. Although
his debt to Proclus has not been investigated to any great extent, at least
not to my knowledge, the syncretism of the Florentine recalls the syncretic
Neoplatonism of the fifth century philosopher, which in itself suggests a
stronger influence on Ficino than hitherto has been noted.

Proclus's entire gloss on the remark by Critias in Plato's dialogue is really
an extended panegyric on Minerva, whom Proclus venerated as the patron
goddess of his native city, Byzantium, and whom he accepted as his own

protector. See Marinus' "Life of Proclus" in *The Philosophy of Proclus.* Laurence J. Rosan (New York: *Cosmos*, 1949), 11–35; esp.16.

81 *Op. Om.*, 965–975.

82 Ibid., 968.

83 Sears Reynold Jayne, trans and ed., *Ficino's Commentary on Plato's Symposium*, (Columbia, Missouri: The University of Missouri Studies, 1944), 156. See also *Op. Om.*,1331.

84 *The Letters of Marsilio Ficino* II trans. Language Department of the School of Economic Science, London (London: Shepheard-Walwyn Ltd, 1975), 145f. See also *Op. Om.*, 652f.

85 *Op. Om.*, 556.

86 Franze Boll, *Sphaera* (Leipsig: Druck und Verlag von B.G. Teubner, 1903), 513. (Cited by Witt, 326, n. 60.) Boll also cites a twelfth century Florentine copy of a Latin translation that would have been available to Ficino.

87 Griffiths, *De Iside*, 217.

88 Ibid., 121.

89 Ibid., 187.

90 Ibid., 159. In his commentary on this passage (392f), Griffiths wrote, "Isis is normally equated with Demeter, e. g. Herodotus, 2.59. Persephassa or Persephone . . . is identified with Isis by Archemachus, probably because she was said to have married Pluto, who was interpreted as Sarapis or Osiris. Like Persephone, Isis had a funerary role which connected her with the underworld."

91 Witt, 127.

92 Ibid., 128.

93 Rudolf Wittkower, "Transformations of Minerva in Renaissance Imagery," *Journal of the Warburg Institute*, II (1935–1939), 194–205. In support of this, Wittkower cited the following apocryphal poem ascribed to Politian *(Le Stanze, L'Orfeo e le Rime*, ed., Carducci, 1863, I, 381):

 Dalla piu alta stella
 Discende a celebrar la tua letizia,

Gloriosa Fiorenza,
La dea Minerva agl' ingegni propizia:
Con lei ogni scienza
V'e, che di sua presenza
Vuole onorarti a cio che sia piu bella. . .(200.)

94 Letters, II, 15. See also *Op. Om.*, 726.

95 See above, 75f.

96 Witt describes Neith as an androgynous warrior divinity who was, as such, the link between Athena and Isis at Sais.

97 Jayne, 182. See also *Op. Om.*, 1341.

98 Letters, I, 190f. See also *Op. Om.*, 724.

99 See Lightbown's discussion of this and a similar drawing in the Ashmolean Museum Collection (Oxford) (II, 166f.) The two drawings are featured in Wittkower's essay on Renaissance transformations of Minerva.

100 Leonard Barkan, *The Gods Made Flesh: Metamorphosis and the Pursuit of Paganism* (New Haven: Yale University Press, 1986).

101 Ibid., 2.

102 Ibid., 173.

103 Ibid., 174.

104 Ibid., 231.

105 Ibid., 232.

V. Ficino's Astrology and the Hermetic Tradition

106 Frances A. Yates, *Giordano Bruno and the Hermetic Tradition* (London: Routledge & Kegan Paul, 1964), 22.

107 Jacob Burckhardt may have been responsible for establishing a tradition that has denigrated the practice of astrology during the Renaissance when he wrote in 1878 that it was "a miserable feature in the life of that time." In addition, he specifically referred to Ficino as one who "despised" astrology and claimed

that it was an "invention" to say that Ficino defended its practice and cast the horoscopes of the Medici family members. *The Civilization of the Renaissance in Italy* II, trans. Ludwig Geiger and Walther Gőtz (1929; rpt. New York: Harper & Row, 1958), 486, 491f.

108 A superficial reading of Ficino's treatise "against" astrology, *Diputatio contra judicium astrologorum*, (c.1477) might lead one to believe that he was opposed to the practice, but Ficino manages throughout to disclaim his disclaimers. For example, he writes, "Constellations do not determine men's actions." Then, he goes on to say that the human soul governs the limbs through the human spirit (one of Ficino's essential tenets) and that the soul is ruled by the stars, or by "an inclination that is born in the body by the stars." Much of the treatise is devoted to discrepant opinions that Ficino found in the writings of ancient and antique authorities on astrology and to promoting the notion that free will can and must be exercized.

Sidera non faciunt actus hominum.

Si celestia efficient actus humanos, certe cum non sint cause materiales vel formales vel finales, essent efficientes et naturales. . . . Item sicut anima gubernat membra per spiritus, non e converso, sic Deus corpora per spiritus, non e converso. Igiter anima dominatur astris, idest inclinationi que ab astris innascitur corpori. See *Supplementum Ficinianum*, ed. Paul Oskar Kristeller. (Firenze: Leon S. Olschki, 1937), II, 11-74, esp. 28f.

109 *Letters*, II, 33f. See also *Op. Om.*, 697. Ficino's natal chart is given in this letter. "Saturn seems to have impressed the seal of melancholy on me from the beginning; set, as it is, almost in the middle of my ascendant Aquarius, it is influenced by Mars, also in Aquarius, and the Moon in Capricorn. It is in square aspect to the Sun and Mercury in Scorpio, which occupy the ninth house. But Venus in Libra and Jupiter in Cancer, have, perhaps, offered some resistance to this melancholy nature." Arnoldo della Torre established that Ficino was born at 9:00 a.m., October 19, 1433, at Figline (485).

110 Jayne, 18. See also Della Torre, 603. Jayne took most of his biographical information on Ficino from Della Torre, who related the depression of 1467–1474. This period of depression evidently was lifted when Ficino undertook the second version of his commentary on the *Symposium*, which was written at the suggestion of Lorenzo de' Medici. Lorenzo wanted this version to be, at least in part, an account of the re-enactment of Plato's original symposium

on love by the members of the Quattrocento Academy, which was held on November 7, 1474 (the alleged anniversary of Plato's birth) at Careggio.

111 "The ancients thought that one's own daemon descends to him from any cardinal point of the heavens. . . or from either side of the mid-heaven. . . . The ninth [house] is addressed as 'deus'. . . ."

Ficino adds that the eleventh house, on the other side of the mid-heaven or tenth house, is "synonymous with a good daemon." (*Op. Om.* 567)

Della Torre showed that Ficino included Plato's horoscope in the first (1467) version of his commentary on the *Symposium.* (*Storia dell'Accademia Platonica di Firenze.* Florence, 1902, 603.) Ficino also included Plato's natal chart in a letter written to Francesco Bandino on the life of Plato. See *Op. Om.*, 763.

112 Si quaras qualis Socratis daemon fuerit, respondebitur igneus, quoniam ad contemplationem sublimium eigebat. Item Saturnius, quoniam intentionem mentis quotidie mirum in modum abstrahebat a corpore. Attributus quoque ab initio, non acquisitus. Nam sibi a puero aicit aspiravisse. Non provocabit unquam, quia non Martius; sed saepe ab actionibus revocabat quia Saturnius (*Op. Om.*, 1387).

113 Virginia Conant, trans. *The Philosophy of Marsilio Ficino*, (New York: Columbia University Press, 1948), 25f. See also *Op. Om.*, 659.

114 Extant accounts of Pythagoras's life are by Porphyry (232–302 C.E.) and Iamblichus (c.250–c.325 C.E.). Iamblichus testifies to the fact that Pythagoras' followers accepted his divinity. "What was Pythagoras? For they say that he was the Hyperborean Apollo; of which this was an indication, that rising up in the Olympic games, he showed his golden thigh" Thomas Taylor, trans. *On the Life of Pythagoras*, (London, 1821), 102.

115 Taylor, *Iamblichus*, 10ff.

116 Certain fragments attributed to Philolaus are, nevertheless, extant. Their authenticity has been controversial, since it does not seem likely that they can be genuine. Edward Lippman's thorough scholarship on Pythagorean music includes bibliographical references to this subject. Lippman notes that J. Burnet "regards the fragments as suspicious" (*Early Greek Philosophy*, 4th ed., London, 1930, 279–284). G.S. Kirk and J.E. Raven in *The Presocratic Philosophers* (Cambridge, 1957) "conclude . . . that they are a skillful forgery based on Aristotle" (308–313). See Paul Oskar Kristeller, *Musical Thought in Ancient Greece* (New York: Columbia University Press, 1964), 167.

117 It has even been said, "With the exception of the master himself, Plato is the greatest of Pythagoreans. . . . In him the Pythagorean numerology was perfected." (Eric Temple Bell, *The Magic of Numbers*, New York: McGraw Book Co., Inc., 1946, 229.) What is not known is how much or to what extent Plato did perfect or refine the ideas of his predecessors Philolaus and/or Archytas of Tarentum.

VI. Ficino's Cosmology

118 The *Meno* and the *Phaedo* were also known in Latin translations. Parts of the Parmenides were included in Proclus' commentary on that dialogue.

119 Archytas of Tarentum, Plato's friend and presumably the student of Philolaus, has been credited with clarifying and promoting the connections among the four disciplines of the quadrivium: that is, geometry, arithmetic, astronomy, and music. Whether he actually wrote on their interrelationships cannot be verified, but Lippman has concluded that he probably did so. "That Archytas wrote on all of these sciences himself is more than likely; what we know of his work points in this direction, and the disciplines were so intimately associated with the Pythagorean outlook that they probably were always studied together. Indeed Vitruvius mentions Philolaus and Archytas of Tarentum among the men 'on whom nature has bestowed so much skill, acumen, retentiveness that they can be thoroughly familiar with geometry, astronomy, music and other studies.' " Lippman here quotes from *De Architectura* I.i.16. (16).

120 Paul Lawrence Rose, *The Italian Renaissance of Mathematics* (Geneve: Librairie Droz, 1976), 110.

121 Paul Oskar Kristeller. "Humanism and Scholasticism in the Renaissance." *Byzantion* XVII:(1944-5): 373. Kristeller addressed this same topic in a later paper. "… The main impact of Platonism . . . was felt in the mathematical sciences, which had been most cultivated and respected by Plato and his followers. Mathematicians who were concerned with the theoretical and philosophical status of their science, and philosophers who wanted to emphasize the certainty and importance of mathematical knowledge, would be inclined to recur either to the number symbolism of the Pythagoreans that had been associated with Platonism since late antiquity, or to the belief in the nonempirical a priori validity and certainty of mathematical concepts and propositions that goes back to Plato himself . . . "

122 Jowett. *The Dialogues of Plato*, 4th ed. (Oxford: At the Clarendon Press, 1953), III, 631.

123 Among the philosophers and theologians cited by Ficino are Crantor, Amelius, Origen, Porphyry, Proclus, Plutarch, Plotinus, Chalcidius, Severus, Atticus, Syrianus, Iamblichus, and Moses.

124 *Op. Om.*, 1438.

125 Jowett, 715f.

126 Ibid., 718.

127 Ibid., 718f.

128 Ibid., 719.

129 Ibid., 722.

130 Ibid., 723f.

131 According to William H. Huffman,in his book *Robert Fludd and the end of the Renaissance,* (Routledge, Chapman and Hall, Inc., 1988), "The basis of Fludd's metaphysical theories . . . is a Neoplatonic interpretation of the Old Testament, including the Apocrapha, bolstered by Ficino's translations of Plato, the Neoplatonists and Hermes Trismegistus." 21.

132 This is the order that Ficino, like Fludd, accepted. Plato placed the sun immediately above the moon, followed by Venus, Mercury, Mars, Jupiter, and Saturn.

133 Jowett, 728.

134 Ibid., 729-733.

135 Ibid., 735.

136 Ibid., 739-743.

137 Ibid., 745. Although Pythagoras is generally credited with the discovery and assignment of the four simple polyhedrons to the elements, fire, air, water and earth, scholars have not determined whether he, a disciple, or Plato himself was responsible for the assignment of the dodecahedron to the zodiacal heavens. Iamblichus tells a story that implies that he did not

question that Pythagoras was responsible for this. The story relates that a man called Hippassus, a member of the Brotherhood, "divulged and described the method of forming a sphere from twelve pentagons," therefore, "he perished in the sea, as an impious person, but obtained the renown of having made the discovery. In reality, this as well as everything else pertaining to geometry, was the discovery of that man; for thus without mentioning his name, they denominate Pythagoras." (Taylor, *Iamblichus*, 64f.)

138 It is to be expected that Ficino would remark on the dodecahedron in his commentary on the *Timaeus*. He claims that Plato believed that this solid is congruent with the universe because the twelve faces coincide with the twelve signs of the zodiac. He makes a point of the fact that each of the faces (pentagonal in shape) can be constructed from isosceles, scalene, or equilateral triangles and concludes, "each great dodecahedron construction reveals 360 triangles, because these portions also exist in the zodiac." (*Op. Om.*, 1464.)

Ficino makes an oblique reference to the dodecahedron in his commentary on the *Philebus*, where he writes the following. "The fifth life is so called since it imitates the fifth element, and since the first life is the concupiscible life, the second the irascible, the third the active, the fourth the contemplative (which is the life appropriate to the soul.) The fifth life is the contemplative life appropriate to the intelligence. Given the opportunity, it's the life Socrates will follow gladly." See Michael J. B. Allen, " *Marsilio Ficino: The Philebus Commentary: A Critical Edition and Translation.* (Berkeley: The University of California Press, 1975), 422.

139 In his commentary on the *Apologia*, Ficino described and defended Socrates's acceptance of daemons.

Also, why does [Socrates] call some beings daemons and others gods? Because a daemon inspired Socrates to sublime things as if it were a mediator and messenger of God. But, can we identify any of Socrates's perceptions of a daemon? Of course we can. For Timaeus says that God assigns to us the highest part of the soul just as if it were a daemon. Again, in the *Symposium*, the kind of love in the mind that enables us to contemplate divine beauty is called a daemon. In truth, in addition to this, it is inevitable that the superior substance of a daemon presides over us, because, as was proved in the *Symposium* and Laws, the human species is so greatly distant from divine beings that it needs a certain middle substance, such as that which is daemonic, to unite the two opposites.

Cur item alias daemonem, alias Deum vocat. Quia sublimis daemon Socratem quasi Dei interpres nunciusque afflabat. Sed numquid ipsum Socratis intellectum possumus daemonem nuncupare? Possumus certe. Nam Timaeus inquit, Deum nobis supremam animi partem tanquam daemonem tribuisse. Rursus in Symposio ipse mentis amor ad divinam pulchritudinem contemplandam, daemon cognominatur. Verum praeter haec necesse est superiorem nobis substantiam daemonis praesidere, propterea quod ut in Symposio Legibusque probatur, humanum genus utpote a divinus maxime distans, media quadam natura indiget, qualis est daemonica, quasi conciliatric (Op. Om., 138f).

140 See the *Apologia*, 1386. Here Ficino says that there are just as many daemons in the sphere of the constellations as there are in the zones of Saturn, Jupiter, or the rest of the planets. In addition, there are daemons in the zones of the four elements.

141 *Sunt enim ibide sub duce planeta, ferme eiusdem generis animalia multa, quomodo cunque vocentur Ego nunc communiter appello daemonia; . . . quae officio circuitumque planetam dominum imitantur (Op. Om., 1451).*

Ficino reiterates this concept in his commentary on the *Phaedrus* (Ibid. 1381).

142 This seems to summarize Ficino's understanding of the sources of daemons, although he is not completely clear about the number of daemons within each sphere. Indeed, his daemonology deserves much more study and explication, especially when one takes into consideration the amount of space that he devoted to it in his writings. There are innumerable references to daemons throughout the *Opera Omnia*, especially in *De vita coelitus comparanda* (531-572; esp. 566f) and in his commentary on the *Apologia* (1381-1389). In addition, Ficino commented on the views of Proclus on daemons (1908-1929) and those of Psellus (1934-1945), and on Iamblichus' "On the Mysteries," which takes daemonology for granted esp. 1905). His commentaries on Plato's *Timaeus (*esp. 1450f. and 1461-1463*), Phaedrus* (see 1381), and *Symposium* (1342f.) contain references to daemons that are valuable contributions to the topic. In his *"Diputatio contra judicium astrologorum,"* Ficino invoked the authority of St. Augustine to defend the existence of daemons.

Augustine says in his book about the nature of daemons that daemons foretell many things because of the acuity of their perception, their long experience, and the speed of their movement, at which men are astonished because of their own earth-bound, slow pace. Moreover, by means of these efficacies, which

are attributable to the airy nature of their bodies, they not only foretell many future events,r they also make them come true.

Augustinus libro de natura demonum dicit, quod daemones acumine sensus, experientia longa, celeritate motus multa prenuntiant, que homines terrena tarditate mirentur. Per has autem efficacias, quas aerei corporis natura sortita est, non solum multa futura predicunt, verum etiam faciunt (Supplementum II, 26).

143 Ficino even explained the inclinations and/or powers of the daemons of these three elements.

Plato says that from the very beginning, [watery daemons] have incited sensual desire to commit the greatest of evils. But, he says, the aerial daemons favor a more rational power, and in some way they separate rationality from the earthy and sensual natures. Then, he says, the fiery daemons convert the unhindered motion of reason to a more sublime kind of contemplation. Accordingly, the watery daemons rule the voluptuous life, the aerial daemons rule the active life, and the fiery daemons rule the contemplative life.

Quos Plato inquit, statim ab initio maiorum plurimis voluptatem immiscuisse. Aeros autem daemones rationali potius favere potentiae, eamque a vegetali sensualique nature quodammodo segregare. Igneos tandem discursum rationis ad sublimior contemplanda convertere. Atque hos pacto voluptuosae vitae daemones aqueos, activiae aereos, contemplativae igneos dominari (Op. Om., 1387).

144 In Ficino's other writings on daemons—e.g., the *De vita coelitus comparanda*—the names of Proclus and Iamblichus are recurrent as sources for his ideas on these beings.

145 *Omnes daemones sunt animae quaedam prodeuntes ex tota anima, id est, ex ipsa animarum idea, habent & spiritum, id est, tenue corpus, sed daemones, qui maxime suo corpori dominantur boni sunt atque, benefici, qui ante corpori minime dominanture mali sunt, atque malefici.*

. . . Hae quidem animae quoque sunt daemones, sed rite malefici nominantur, sunt autem tum hi omnes, tum quos diximus ab his diversi invisibiles, nec prorsus humanis sensibus manifesti, non enim solido corpore vestiuntur, praeterea nec unam omnes formam habent, sed figuris plurimis insignitas & form [as], quem illorum spiritum obsignant alias quidem apparent, alias vero nequa quam. Aliquando vero & formas mutant, illi scilicet, qui deteriores sunt, spiritus aiunt earum, qua quidem ratione corporum quiddam est, passioni obnoxium est atque dissolubile, sed qua ab animabus ita devinctum est, species eius diu

perseverare potest, neque, tamen est aeternum. Consentaneum enim est aliquid ab eo semper affluere atque nutriri. In harmonia quidem corpus bonorum consistit, quemadmodum & corpora nobis manifestorum, sed maleficorum daemonum corpora inconcinnasunt ac affectione passiva locum incolunt terrae vivinum.

In this same letter, Ficino explains why some daemons are bad and some are good. Some are harmful "to the human race if they have been angered, feel neglected or have not received proper respect, but there are those that are beneficial to men who offer them prayers, supplications, sacrifices and other such things that are consecrated to them."

Ficino continues:

Thus, although this opinion about daemons may be mixed and may show some misgivings about them, it is necessary to carefully distinguish between their natures with a rational approach; and, since uncertainty is going to reveal [the truth] about these daemons to men, one must use this method to make those distinctions.

Rata vero apud omnes fides est eiusmodi, eos certe laesuros genus humanum si irascantur propterea quod negligantur, neque cultum legitimum nanciscantur, rursus que benefacturos hominibus, qui eos votis supplicationibus que & sacrificiis, & aliis quae consequuntur sibi conciliaverint. Cum igitur opinio haec de daemonibus consusa fit, multumque habeat in eos calumniae, necessarium est eorum naturam ratione distinguere forte namque necessarium aiunt, unde circa illos error hominibus incidit declarare, distinguendum igitur hunc in modum (Op. Om., 875ff).

146 . . . Quid agentes haec peragunt? Utrum dominantes nobis, & quocunque placet, velut mancipia circumferentes? Non dominantur ait, sed nobis clam commemorant, spiritui namque, qui nobis inest, phantastico propinquant, utpote, qui & ipse spiritus sint. . . . (Ibid., 1941).

147 *At si minus tibi placet & familiarem hominis ducem daemonem appellare, saltem, ut placet nostris, bonum angelum appellato. (Ibid., 1388)*

148 *Semper vero memento sicut animae nostrae virtus per spiritum adhibetur membris, sic virtute animae mundi per quintam essentiam, quae ubique viget tanquam spiritus intra corpus mandamum, sub anima mundi dilatari per omnia . . . (Op. Om., 535).*

149 *Sed ad mundi spiritum redeamus, per quem mundus generat onmia quandoquidem & per spiritum proprium omnia generant, quem, tum coelum, tum quintum essentiam possumus appellare. . . .* (Ibid., 535).

150 R. Kippax, trans. "Of the Word *EI* engraven Over The Gate Of Apollo's Temple at Delphi." in *Plutarch's Lives and Writings*, IV, edited by A.H. Clough and William W. Goodwin (Boston: Little, Brown & Co., 1909) ,489. Plutarch continues in this section of his essay with an association between each of the five perfect bodies and one of the five senses: earth and touch, water and taste, air and hearing, fire and smell, and, finally, "heaven" and sight. Making sight the "highest" or most "celestial" of the senses compares with Ficino's assessment of that sense, for he, too, called sight the "highest" sense on occasion. Additionally, we are reminded of Leonardo, whose regard for sight is almost legendary.

151 Robert Midgley, trans. ""Why The Oracles Cease To Give Answers." *Plutarch's Lives and Writings*, IV, 30.

VII. Astrological Interpretations of Ficino's Letters and the *Primavera*

152 This letter was translated in its entirety by Gombrich. All excerpts included here in English are from his translation, cited above, 14.

153 *Op. Om.*, 763.

154 The northern signs of the natural zodiac are found on the lower half of the astrological map and, from left to right, are Aries, Taurus, Gemini, Cancer, Leo, and Virgo The southern signs, which appear on the upper half of the map, are, from right to left, Libra, Scorpio, Sagittarius, Capricorn, Aquarius, and Pisces.

155 For example, a favorable or "good" aspect might measure 120° (in which case the planets are said to be "in trine") or 60° ("in sextile") or 30° ("in semi-sextile"). Angles measuring 90° (a "square" aspect) or 180° (an "opposition") are considered "difficult" because the planets face each other from opposing positions and cannot easily transmit their benefits to one another.

156 Ficino's doctrines of the human soul, spirit, and body are just as complicated as his construction of the heavenly components of soul, spirit, and body.

Kristeller codified Ficino's hierarchy of the human entities in his *Philosophy of Marsilio Ficino*, wherein he observed that the Florentine provided the soul (itself composed of three parts: the mens, ratio, and idolum) with two intermediaries, "which reconcile the contrast between body and soul and are therefore supposed to explain their union." (371.) The first of these is called the "ethereal body"; the second is the "spirit." "The Spirit is a thin, air-like body generated in the heart out of blood and spread from there throughout the whole body" (372). The earthly body, composed of the four elements, is also thought of as a vehicle; but it is the air-like spirit that seems to be the means whereby the soul causes movement in the earthly body. (383).

157 In addition to the letters cited on pages 805 and 845ff. of the *Opera Omnia*, other letters appear on 812, 834, 905 and 908.

158 Gombrich, 57. This is the only part of a very long letter that Gombrich translated. Other translations of this letter are by this author.

159 *Quambrem, Marsili, in superos imo in te ipsum peccare iam desine. Agnosce quandoque tuam medicique genesim, cognosces statim Iovium Mercurium, Phoebumque & Venerem nascentibus vobis ab eadem prorsus coeli parte, scilicet Nona, quam fidei, religionis, ingenii, sapientiae domum & Phoebi gaudium Astronomi nominant, utrumque vestrum similiter aspexisse. Quo efficitur, ut non modo similis, sed etiam unus idemque ambobus inde genius sit tributus, Apollineus scilicet daemon, nono siquidem aetheris domicilio gaudens Apollo, Apollineus ad homines genios inde demittit. Ex horum numero daemonum unum vobis annuente Venere Mercurioque Phoebus ipse praefecit. Hinc una mens in vobis secuta est. Huc etiam una voluntas untrinque se contulit. Si ubi singula haec unam sunt, homo quoque semper est unus, ne forte quos coelum rationemque te ipsa coniunxit tu verbis ulterius separes, memento quotiens ad Medicem tuum scribis oportere ita praescribere (Marsilius Marsilio, S.). Atque ita demum superis aspirantibus inventionis tibi vena largissime profluet (Op. Om., 846).*

160 Gombrich, 58.

161 Lightbown identified the sword as a Renaissance falchion and the helmet as a Fifteenth Century military hat (I, 78). Conventional images of Mercury show him to be fair and mature.

162 Hartt, 190. See also Hartt, 4th ed./rev. by David G. Wilkins, 1994, 335.

163 Gombrich, 58. See *Op. Om.*, 536f. for Ficino's discussion of the three Graces in *De vita coelitus comparanda*. The letter about Pico was sent to Roberto Salutati and Hieronymus Venivenio, c.1488. (Ibid., 890.)

164 *Op. Om.*, 1385.

165 Michael R. Meyer, *A Handbook for the Humanistic Astrologer* (New York: Anchor Press/Doubleday, 1974), 749.

VIII. Lorenzo's Horoscopes

166 Bryant Tuckerman, *Planetary, Lunar, and Solar Positions* II, (Philadelphia: The American Philosophical Society, 1964), 749.

167 *Ver Quidem est temporum optimum, quoniam ab Ariete regno Solis incipit. . . . quod quatenus Sol ad medium ascendit coelum, vitalem, & animalem spiritum in nobis mirifice fovet.* (Ibid., 968.)

168 Dempsey, 1992, 39.

169 An election chart is a map of a future date that is chosen for a particular event because the planetary arrangement is especially favorable for the event at that time. Such charts were popular during the Renaissance and are still used today.

170 Gombrich, 43 (See *Op. Om.*, 805).

171 Meyer, 73.

172 Lightbown argued in favor of Lorenzo's marriage as the motive behind the *Primavera* on the basis of references to the wedding in a contemporary listing of letters from Lorenzo il Magnifico to relatives, friends, and acquaintances. The references in question represent the contents of letters written to Jacopo IV of Piombino, who represented Semiramide. One of these, dated March 28, 1482, says that il Magnifico's letter concerned Lorenzo di Pierfrancesco's wedding in May.

173 This is not meant to minimize the importance of astrological conditions in the selection of a wedding date during the Renaissance; indeed, the blessings of well-placed planets would have been sought for such an event. One can test

this by examining the stars on July 18, 1482, the date of the wedding between Lorenzo and Semiramide, according to Levi-Ancona's finding.

It would appear that that date was not chosen arbitrarily, since the same three Graces–the sun, Venus, and Mercury–were together again. The sun had just entered the sign of Leo, which is ruled by the stationary sun and (according to Manilius) the divine Jupiter. Ahead of Sol were Venus and Mercury; the latter planet was in the lead, about to leave Leo and enter Virgo. Awaiting him in that sign was Jupiter, which means that Mercury would have felt a two-fold influence from Jupiter. He would have been conditioned by Jupiter as the ruler of Leo and would have felt the power of the planet Jupiter as well.

Up ahead in the balance sign of Libra–claimed by Venus as her day sign and recognized as the sign of relationships–was Luna, in an almost perfect sextile aspect to the sun and in a semi-sextile aspect to Jupiter. Saturn was on the Libra-Scorpio cusp or borderline, in square aspect to the sun. Generally this is not considered propitious; but since Ficino saw the sun's aspecting influence as tempering if not transforming, one may believe that he could have seen Saturn's power (along with that of Mars, who opposed Leo's planets from his location in Aquarius) as subordinate to that of the Graces. Of greater importance is the fact that Ficino showed much more concern in his c.1477–1478 letter for Luna's relationships with Saturn and Mars than he did with the sun's aspects to those bodies. With that in mind, one should not be surprised to find that, on July 19, 1482, the moon was certainly not in bad aspect to Saturn, whom she semi-sextiled, and she was especially well situated to Mars (especially for a wedding). For, from her place in the balance sign, she trined him, who was in the sign of social concerns and responsibility.

That chart would have conformed to Ficino's description of a salutary horoscope, and it implies a conferral of benefits upon a marriage, suggesting that the date of July 18, 1482, was chosen intentionally and for these reasons.

IX. The Astrological Charts and the *Primavera*

174 This exclusion of the triad Zephyr, Chloris, and Flora brings to mind the observation of the editors of Mrs. Foster's translation of *Vasari*'s *Lives*, in which they noted that this triad seems to be "enveloped" by the tonality on that side of the painting. Their comment regarding the dominance of the carmine-colored drapery on the central and Mercury figures is even more significant when one sees these two images in terms of the astrological chart; the drapery seems to enclose the Graces and isolate these figures from the triad on the right.

175 Barkan, 173.

176 The images of Venus and five other planetary rulers included in this manuscript are reproduced in Stanislas Klossowski de Rola, *Alchemy: The Secret Art* (London: Thames and Hudson Ltd; New York: Avon, 1973), 8-11. De Rola cites Nicola d'Antonio degli Agli, 1480. *Biblioteca Apostolica Vaticana*, Cod. Urb. Lat. 899, fol. 14.

177 *Venerem quondam in Pythiis Apollinis hortis, flores ac fructus legentem varios, Mercurius amore saucius sequebatur. His illam denique & indice, & duce Phoebo sub lauro quadam seliciter assequutus, summa cum utriusque voluptate cognovit. Horum congressi scitus admodum formosusque natur est puer. In quo statim & perspicacem Mercurii sensum & gratam Veneris venvitatem Phoebique splendorem facile quivis agnoverit. Hunc igitur a Mercurii patris cognomini quem superi Logum cognominant, suus Apollo patronus Apologum nominavit. Iussitque ipsum passim discurrentem tantum humano generi salubri quadam delectatione prodesse, quantum frater eius Cupido noxiae voluptatis homo noceret. Igitur locorum ignarus Apologus dum extra Pythios hortos in proximis silvis oberrat, forte indicit in pastores, qui divina pueri forma & indole mirifice delectati, cum penes se diu detinverunt, atque cibis agrestibus, id est, glandicus & casteneis caeterisque id genus urbanum Apologum alverunt. Quapropter tandem tutata forma ex urbano subrusticus evasisset, nisi eius patronus Apollo propitia nuper porrecta manu e silvis ad hortos Pythios, quos hodie Pinthios Florentini nominant, feliciter reduxisset. Docet Apologus, divinum genus divini solum alimonia coalescere.* (*Op. Om.*, 847)

178 *Minerva quam prisci Sophiam nominant, cum animadvertisset solo se Iovis capite genitam, opus hoc divinum rata solo videlicet capite gignere patrem aemula, semel saltem capite pareret, ut ipse quoque tanquam parentis aemula, semel saltem capite pareret. Peperit ergo filiam tum avo suo Iovi, tum matri Minervae persimilem, ea sane statim natura avitam quandam tum animo aequitatem, tum vultu totoque corpore dignitatem prae se ferebat. Praeterea matris tam virilitatem, quam puticitiam & mentem, & questibus referebat. Hanc avus a Sophia matre Philosophiam volvis nominari, edixitque Philosophiae, ut quemadmodum ex Sophia, quae summi rerum omnium capitis filia exortum habet, ita semper plantis mundi posthabitis summa rerum capita pateret, neque ullum inferior Venere unquam veneficoque filio eius Cupidine haberet commertium. Alioquim pro aeterna Philosophia statim temporaneam Philocaliam tam re ipsa, quam nomine evasuram. Adiecit, ut multo magis omnis Plutonis infimi eiusque cultorum consuetudinem devitatet. Alioquin ambrosia nectareque amissis stygiae paludis aquas & herbas, quibus solis infeliciter deinde vescatur reportaturum. Monuit*

denique ne ambitiosam Iunonem aliquando sequeretur crassiori aere pervolantem, ne forte cum caligine serenitatem, procellis tranquillitatem, nubibus sydera, commutaret. (Ibid., 847)

179 *Orpheus Delphicos aliquando lucos ingressus, oraculum consulturus obvium statim quasi iam expiatus Apollinem habuit. Cum vero ad Apollinis dexteram numen musas tresque Gratias comitante cominus conspexisset, ad sinistram autem quamvis enimus sequentes picas & furias, admirabundus altius exclamavit. O quam diversi, o quam adversi duce hunc sequuntur exercitus? Se nolte vates mirari, Phoebus ait. Nempe quotidie mihi multi sacrificant, quo musarum a me Gratiarumque munera impetrent. Ergo quicunque puris sacra manibus operantur, musas a nobis gratiasque accipiunt. Quicumque vero pollutis attrectare sacra manubus audent, picas & furies invit reportant.* (Ibid., 847f.)

180 *Prometheus cum ascendisset in coelum ibique multa ab ipso Jove rerum omnium authore mysteria didicisset, hac una de re curiosius supplex interrogavit, quam videlicet ob causam Solem Mercuiumque prae caeteris Planetis tam propinquos assidue in coelesti circuitu comites invice esse ab ipso rerum initio statuisset. Respondit Iuppiter, ut quicunque Solem syderun dominum viderint absque sapiente Mercurio, in coelo nusquam incedere plane intelligant, & in terris potentiam nunquam absque sapienta, vel concedi debere, vel concessam diu posse regnare.* (Ibid., 848)

181 Cythera, Paphos, and Idalium were sites in Greece associated with Venus.

182 *Cum Alamannus inter Lauros nuper, (ut solet) saepe deambularet, in cupidinem Lauros circumvolantem saepius involans, denique comprehendit. Tenerum deinde puerum adolescens pius levibus suaviter tractans; manibus componebat, sertisque & floribus Deum iam plane agnitum exornabat, atque ita inter ornandum percunctabatur. Quae nam nova huc aura formose Cupido direxit alas? Est Paphos Idaliumque tibi sub alta Cythera? Tum ille suspirans, heu matrem, inquit, iam diu meam anxius passim quaerito, matrem mihi meam neque Paphos Idaliumque teddit, nec alta Cythera. Solus tamen Apollo quandoque longos miseratur errores, his me verbis admonuit. Mater, o Cupido, tua solebat quondam cantilenis choreisque solum levibus olectari, sed facta deinde ambitiosior coepit aliquando & Anchilli Homerum & Aeneo Vergilium invidere, ipsaque sibi vatem per similem exoptare, qui artes laudesque suas grandior iam Cythera personaret. Talem denique vatem mula post secula Laurentem nomine inter Lauros canentem nacta Venus apud Tuscos in Ipso gratiarum agro Charegio ibi iam suarum laudum Canus suavissimo delinitur, caeterorumque oblita omnium iucundissime conquiescit, ibi solum post hac musas inter pudicas requiescit Venus*

Cupido tua, illuc igitur & ipse te conferes una cum matre semper habitaturus. Ita quandoque mihi Phoebus Alamanne consulit. Hoc ergo Charegium relicta Cypro has denique Lauros haedera myrtoque neglectis, sollicitus iam diu quaero. Quod si illuc ad matrem ipse me duXEris, ego tibi prae caeteris afflabo propitius, ego tibi perpetua quadam nexu meam matrem conciliabo. Tunc Alamannus, per opportune, inquit, manus inter volasti divi cupido meas. Nempe trita meis pedibus, quae ducit Charegium, via est. O me felicem cuius inter manus hodie puer felicissimus pervolavit. Ergo huc age divine puer leves iam tende alas. Per Faventina Pomeria Apollineis auspiciis petamus ambo Charegium, ego quidem gressu, sed ipse volatu. (Ibid., 848.)

183 See Angelo Lipari, *The Dolce Stil Novo According to Lorenzo de' Medici* (New Haven: Yale University Press, 1936) for an analysis of il Magnifico's commentary on Dante, especially his view of Dante's "lady," whom, Lipari says, Lorenzo interpreted to be a personification of "beauty and human gentilesse." Lipari continues with the following:

She is an abstraction, or the author's concept of an ideal embodying those qualities in their full, true essence and highest degree. . . . Finally, in her death is exemplified the mystic death. The abstraction of these qualities from her physical self representing a concrete personality, is what is meant by her mystical death. It is the act of extracting the pure form from the concrete material object incarnating it, or the return to heaven (as it were) of the platonic idea after its temporal and material existence on earth. It is a process of purification and elevation to the state of absolute perfection. (108f.)

184 Lightbown gives the botanical names of the trees, plants, and flowers as revised by Dr. W. T. Stearn of the Natural History Museum, London. Although some of the plants in the *Primavera* are what Lightbown calls "conventionalized," the flowers that are identifiable bloom in the spring of the year. Some appear as early as February, and all but two or three bloom in May; the few that blossom later do so in June. The trees are *Citrus aurantium* (Seville orange), *Abies excelsa* (spruce), *Myrtus communis* (myrtle), and *Laurus nobilis* (bay-laurel). II,. 53.)

185 Gombrich, 61. See also *Op. Om.,.*848f.

186 An even simpler explanation for the name Lucilia may be that Ficino did not want his nymph to be confused with Juno Lucina who had been worshipped during the Roman period, assuming he was familiar with her. According to Fowler, "this Juno had a special power in childbirth. . . . [She] had no doubt

always been especially the matron's deity." Obviously, Juno Lucina would be inappropriate in the context of the *Primavera*. Additionally, the dies natalis of her temple (1) would have conflicted with the temporal function of the painting's triad. See W. Warde Fowler, *The Roman Festivals of the Period of the Republic* (London: Macmillan & Co., Ltd, 1899), 8.

187 *Op. Om.*, 969.

188 Ibid., 973f.

189 Ibid., 971.

190 Ibid., 1313.

X. The Alchemical Process and the *Primavera*

191 Titus Burckhardt, *Alchemy*, William Stoddart, trans. (Baltimore: Penguin Books, Inc., 1967), 76.

192 Kurt Seligmann, *Magic, Superstition and Religion* (New York: Pantheon Books, 1948), 84.

193 Frank Sherwood Taylor, *The Alchemists: Founders of Modern Chem*istry, (New York: Henry Schuman, Inc., 1949), 25.

194 Seligmann, 85.

195 Ibid., 93.

196 De Rola, 10.

197 Ibid., 63.

198 Ibid., 12.

199 H. Stanley Redgrove, *Magic and Mysticism* (Secaucus, N.J.: The Citadel Press, 1971), 132f.

200 Burckhardt, 106.

201 De Rola, 10.

XI. The *Primavera's* Alchemical Symbols

202 De Rola, 47.

203 Carl G. Jung, *Psyche and Symbol*, ed. Violet S. de Laszo (New York: Doubleday Anchor Books, 1958), 181.

204 Taylor, 52.

205 De Rola, 14.

206 Seligmann, 90f.

207 Burckhardt, 65.

208 Monstropedia, "Ouroboros," http://www.monstropedia.org/index.php?

209 Gombrich, 157.

210 Other sources testify to the importance of the hieroglyphic tradition of Renaissance humanists. In an article based on her doctoral dissertation (Bryn Mawr College, 1977), Diana Galis cited several examples of such sources in order to establish the use of hieroglyphs by Lorenzo Lotto, the subject of her dissertation. See "Renaissance Hieroglyphic and Lorenzo Lotto's Bergamo Intarsie," *The Art Bulletin*, LXII (1980), 363-375.

211 George Boas, trans and ed., *The Hieroglyphics of Horopollo*, (New York: Pantheon Books, 1950). Boas discusses sources and attributions in his introduction, 17-43.

212 Iversen observed that the manuscript was found on the island of Andros by Christopher Buondelmonti, who brought it to his native Florence about 1422. He adds:

As soon as it arrived in Florence, the manuscript of the Hieroglyphica was immediately copied and circulated, and in spite of the poor manner in which the text had been transmitted, and its late and obscure Greek, it was eagerly read and commented upon. Its erroneous and misleading conception of the script was not only generally accepted with uncritical confidence, but the book remained for centuries the unchallenged authority on Hieroglyphic questions. 65.

213 Boas, 20f.

214 Ibid., 28. In a note on this same section, Gombrich observes that Giehlow was the first scholar to call attention to Ficino's gloss (232).

215 Gombrich, 159.

216 Couliano, xviii.

217 Ibid., 24.

218 Ibid., 34.

219 Ibid., 37.

220 Boas, 57.

221 *Op. Om.*, 1461.

222 Gombrich, 159.

223 Burckhardt, 131 ff.

224 Ibid., 135.

225 *Op. Om.*, 1403.

 Hic enim numerus & solidorum primus est, primusque omnium in numero aeque pariter pares divisio quoque ispa solvatur . . .

226 Ibid., 1414f.

227 See Plutarch, "Of the Word EI Engraven over the Gate of Apollo's Temple at Delphi" for his interpretation of the meaning of the letter EI as a reference to the number five. Because of Delphi, that number is mystically associated with the god Apollo and, by extension, to the sun and the element of fire, the human soul, the five senses and the practices of prophecy, geometry, and music. Plutarch borrows from Plato (The Republic) the notion that five is the "marriage" number, combining as it does the odd number three (male) with the even number two (female). "Therefore have the Pythagoreans, through a certain resemblance, said that five is the marriage of the first male and the first female number." (Lives and Writings, IV, 485) Plutarch clearly assumed that Plato was reflecting a Pythagorean view of the number five.

228 De Rola, 12.

229 Seligmann, 96.

XII. Conclusion

230 This is recounted in Jayne, 18.

231 Witt, 274.

232 Wittkower, 199.

233 Smith, 31-39.

234 Gombrich, 71.

235 Ibid., 71.

236 Lightbown, I, 82ff.

237 Cited above, note 73, 136.

238 The story of Chiron's death was told by Apollodorus and Lucian. See Graves, *The Greek Myths,* II, (Middlesex, England: Penguin Books, 1960) 113-115.

239 Gombrich, 72.

240 Yates has argued that Ficino would have made a comparison between the creation story of the Hermeticum and that of Genesis and would have considered the immortal Man who descended to earth a prefiguration of the Christ. Thus, he would have accepted the divine wisdom of the ancient Egyptians as supportive of the Judaeo-Christian tradition and as a prophecy of what was to come. Further, he would have taken all the teachings, contained or implicit in what he believed were authentically ancient documents, as divine revelations. (Yates, *Giordano Bruno*, 20-43.)

241 Couliano, 32.

242 Ibid., 32f. The citations given here by Couliano are to Frances Amelia Yates, *The Art of Memory* (Chicago: The University of Chicago Press, 1966) and to Paolo Rossi, *Clavis universals* (Milan and Naples: R. Ricciardi, 1962).

243 Ibid., 33.

244 Brown, 101f.

Appendix I: Additional Analysis of the Literature

245 Arnolfo B. Ferruolo, "Botticelli's Mythologies, Ficino's *De Amore*, Poliziano's Stanze per la Giostra: Their Circle of Love," *The Art Bulletin* XXXVII (1955), 17-25.

246 Wind, 113-127.

247 Ronald A. Lightbown observed that Wind mistranslated Ovid "in an effort to sustain his strange interpretation of Flora, Chloris and Zephyr as a metamorphosis" *Sandro Botticelli* II, 52.

248 Ibid., II, 72-81

249 Ibid., II, 75

250 Ibid., II, 80f.

Appendix II: Ficino's World Soul and World Spirit

251 Jowett, *Dialogues*, III, 721.

252 *Op Om.*, 1451

253 Ernest G. McClain, *The Pythagorean Plato: Prelude to the Song Itself,* (Stony Brook, New York: Nicolas-Hays, Ltd, 1978), 60-63. In his commentary, Ficino evidently arranged the number of the double tetractys in the form of the lambda without question. See *Op. Om.*, 1459.

254 Ibid.

255 Rudolf Wittkower, *Architectural Principles in the Age of Humanism* (London: Alec Tiranti, Ltd, 1952), 91f.

256 Benjamin Jowett, *The Timaeus of Plato*, trans. and ed. R.D. Archer-Hind (London: Macmillan and Co., 1888), 107.

257 Jowett, *Dialogues*, 721.

258 Wayne Shumaker, *The Occult Sciences of the Renaissance* (Berkeley: University of California Press, 1972), 121.

259 D. P. Walker, *Spiritual and Demonic Magic from Ficino to Campanella* (London: The Warburg Institute, 1958), 3.

260 Ibid. Walker does not indicate the role of Ficino's daemons in this discussion; but that should not be construed as his denial of their role in Ficino's astrology. In fact, Walker's observation is consistent with Ficino's belief that the daemon's spirit secretly communicates with the human spirit.

261 Ibid., 12.

262 Jowett, *Dialogues*, 718

263 Jowett, *Timaeus*, 112

264 *Op. Om.*, 1449f.

265 Walker, 3.

266 As already noted, Ficino translated the Mysteries as well as Iamblichus' *Life of Pythagoras*. *Op. Om.*, 1878-1908.

267 E. R. Dodds, *Proclus: The Elements of Theology*, 2nd ed. Rev. Oxford: At the Clarendon Press, 1963, xix.

268 Ibid. xxii.

Appendix III: The Astrological Charts of May 13 and May 23, 1482

269 One of the two passages regarding the moon in relation to the sun and Jupiter in *De vita coelitus comparanda* demonstrates Ficino's concern for her aspects to those bodies. After stating that Jupiter is like the sun in excellence and that all astrologers ascribe universal beneficence to the sun and Jupiter, he goes on to say that one can bring the solar spirit together with the Jovial or combine solar and Jovial things if one would do so "when Jupiter aspects the sun in trine or sextile, or at least when the moon proceeds from an aspect to one to an aspect with the other, but most of all when she progresses from an aspect to Sol to a conjunction with Jupiter.

Jovem ver Soli similimum in plurimus excellentibusque muneribus quamvis occultioribus, & amicissimum esse scimus . . . omnesque Astrologi universalem beneficientiam Soli tribuunt similiter atque Jovi. … Quum igitur adeo consonant, facile poteris spiritum Solarem efficere pariter atque Jovium, ad res Solares &

Joviales rite poteris invicem commiscere, praesertim si & has invicem componas, & spiritui adhibeas, quando Jupiter Solem trino aspicit vel sextile, vel salterm quando Luna ab aspectu alterius ad alterum procedit aspiciendum. Masime quando ab aspectu Solis ad coitum cum Jove progrediture. (*Op. Om.*, 536)

270 Meyer, 245. Ficino referred to the part of fortune at least twice. See *Op. Om.*, 567 and 967.

271 *Op. Om.*, 967. *Et Lunae cum Sole coniunctio vel oppositio, ante hominis orium facta, veritatem nativitatis aperit, & fortunam.*

272 In his commentary on the *Symposium*, Ficino characterized Mars as "outstanding in strength" and capable of making men stronger, but when Venus is in a favorable aspect to him she "often checks his malignance. . . ." (Trans. S.R. Jayne, 176f. See *Op. Om.*, 1339.)

273 *Op. Om.*, 538. *Ut tutissimum omnium & commodissima simul incedas via, Lunam observa, quando Solem aspicit, coitque cum Jove, vel saltem Jovem simul aspicit atque Solem, aut certe quando post aspectum Solis mox ad Jovis coitum progreditur vel aspectum.*

274 Ibid. 542.

Bibliography

Alberti, Leon Battista. *On Painting* [rev. ed.]. Translated by John R. Spencer. New Haven: Yale University Press, 1966.

Alberti, Leon Battista. *On Painting and Sculpture.* Translated and edited by Cecil Grayson. London: Phaidon Press, 1972.

Allen, Michael J.B. *Marsilio Ficino: The Philebus Commentary: A Critical Edition and Translation.* Berkeley: The University of California Press, 1975.

Apuleius of Madauros. "The Isis Book." In *Metamorphoses,* Book XI. Translated and edited by John Gwyn Griffiths. Leiden: E.J. Brill, 1975.

Barkan, Leonard. *The Gods Made Flesh: Metamorphosis and the Pursuit of Paganism.* New Haven: Yale University Press, 1986.

Bell, Eric Temple, *The Magic of Numbers.* New York: McGraw Book Co., Inc., 1946.

Boas. George, Trans. and Ed., *The Hieroglyphics of Horapollo.* New York: Pantheon Books, 1950.

Bode, Wilhelm. *Sandro Botticelli.* Translated by F. Renfield and F.L. Rudston Brown. London: Methuem & Co. Ltd., 1925.

Boll, Franze. *Saphaera*. Leipsig: Druck und Verlag von B.G. Teubner, 1903.

Brown, Alison. "Pierfrancesco de' Medici, 1430-1476: A Radical Alternative to Elder Medicean Supremacy?" *The Journal of the Warburg and Courtauld Institutes* 42 ((1979): 81-103.

Burckhardt, Titus. *Alchemy*. Translated by William Soddart. Baltimore: Penguin Books, Inc., 1967.

Carus, Titus Lucretius. Translated by. Russel M. Geer. *On Nature*. New York: The Bobbs-Merrill Co., Inc., 1965.

Conant, Virginia, trans. *The Philosophy of Marsilio Ficino*. New York: Columbia University Press, 1948.

Couliano, Ioan P. *Eros and Magic in the Renaissance*. Chicago: The University of Chicago Press, 1987.

De Rola, Stanislas Klossowski. *Alchemy The Secret Art*. New York: Avon Books, 1973.

Dempsey, Charles. "Mercurius Ver: The Sources of Botticelli's *Primavera*. *Journal of the Warburg and Courtauld Institutes* XXXI (1968): 251-273.

Dempsey, Charles. *The Portrayal of Love: Botticelli's Primavera and Humanist Culture at the time of Lorenzo the Magnificent*. Princeton: Princeton University Press, 1992.

Dodds, E.R. *Proclus: The Elements of Theology*, 2nd ed. Rev. Oxford: Oxford at the Clarendon Press, 1963.

Edgerton, Samuel Y., Jr. *The Renaissance Rediscovery of Linear Perspective*. New York: Harper & Row, 1975.

Ferruolo, Arnolfo B. "Botticelli's Mythologies, Ficino's *De Amore*, Poliziano's *Stanze per la Giostra*: The Circle of Love." *The Art Bulletin* XXXVVII (1955): 17-25.

Ferrante, J. and George Economou, eds. *In Pursuit of Perfection*. Port Washing, NY: Kennikat Press, 1975.

Ficino, Marsilio. *Opera Omnia*. Facsimile of Basle: 1576, Turin: Bottega D'Erasmo, 1959.

Fowler, W. Warde, *The Roman Festivals of the Period of the Republic* London: Macmillan & Co., Ltd, 1899.

Galis, Diana. "Renaissance Hieroglyphic and Lorenzo Lotto's *Bergamo Intarsie*." *The Art Bulletin* LXII (1980): 363-375.

Gallati, Barbara. "An Alchemical Interpretation of the Marriage between Mercury and Venus." In *Botticelli's Primavera: A Botanical Interpretation, Including Astrology, Alchemy and the Medici,* edited by Mirella Levi-D'Ancona, Firenze: Leo S. Olschki Editore, (1983): 99-121.

Geiger, Ludwig and Walther Götz, *The Civilization of the Renaissance in Italy.* New York: Harper & Row, 1958.

Gombrich, Ernst H., "Botticelli's Mythologies, A Study of the Neoplatonic Symbolism of His Circle," *Journal of the Warburg and Courtauld Institutes,* VIII (1945): 7-60.

Gombrich, Ernst H., *SymbolicImages: Studies in the Art of theRenaissance.* London: Phaidon Press Ltd, 1972: 31-81.

Graves, Robert. *The Greek Myths,* II, Middlesex, England: Penguin Books, 1960.

Hartt, Frederick. *History of Italian Renaissance Art: Painting, Sculpture, Architecture.* New York: Harry N. Abrams, Inc., 1969.

Hartt, Frederick. *History of Italian Renaissance Art: Painting, Sculpture, Architecture.* 4th Edition. Revised by David G. Wilkins. New York: Harry N. Abrams, Inc., 1994.

Horne, Herbert P. *Allessandro Filipepi Commonly Called Sandro Botticelli, Painter of Florence.* London, 1908.

Huffman, William H. *Robert Fludd and the end of the Renaissance.* New York: Routledge, Chapman and Hall, Inc., 1988.

Iversen, Erik. *The Myth of Egypt and its Heiroglyphics in European Tradition.* Copenhagen: Gec God Publishers, 1961.

Jayne, Sears Reynold, trans. and ed. *Ficino's Commentary on Plato's Symposium.* Columbia, MO: The University of Missouri Studies, 1944.

Jowett, Benjamin, *The Dialogues of Plato,* 4th ed. Oxford: Oxford at the Clarendon Press, 1953.

Jowett, Benjamin. *The Timaeus of Plato.* Translated and edited by R.D. Archer-Hind. London: Macmillan and Co., 1888.

Jung, Carl G. *Psyche and Symbol.* Edited by Violet S. de Laszo. New York: Doubleday Anchor Books, 1958.

R. Kippax, trans. "Of the Word *EI* Engraven Over The Gate Of Apollo's Temple at Delphi." in *Plutarch's Lives and Writings*, IV, edited by A.H. Clough and William W. Goodwin. Boston: Little, Brown & Co., 1909

Kirk G.S.and J.E. Raven. *The Presocratic Philosophers.* Cambridge: Cambridge University, 1957.

Kristeller, Paul Oskar. "Humanism and Scholasticism in the Renaissance." *Byzantion* XVII:(1944-5): 373-?

Kristeller, Paul Oskar. *Musical Thought in Ancient Greece* .New York: Columbia University Press, 1964.

Kristeller, Paul Oskar, ed. *Supplementum Ficiniamnum.* Firenze: Leon S. Olschki, 1937.

Kristeller, Paul Oskar. *The Philosophy of Marsilio Ficino.* New York: Columbia University Press, 1943.

Language Department of the School of Economic Science, trans. *The Letters of Marsilio Ficino* II. London: Shepheard-Waywyn Ltd, 1975.

Levi-D'Ancona, Mirella. *Botticelli's Primavera: A Botanical Interpretation, Including Astrology, Alchemy and the Medici.* Firenze: Leo S. Olschki Editore, 1983.

Lightbown, Ronald A. *Sandro Botticelli* II. Berkeley: University of California Press, 1978.

Lippman, Edward. *Early Greek Philosophers*, 4th ed., London, 1930.

Lipari, Angelo. *The Dolce Stil Novo According to Lorenzo de' Medici.* New Haven: Yale University Press, 1936.

Macrobius. *Saturnalia.* Translated by Percival Vaughn Davies. New York: Columbia University Press, 1969.

Manilius. *Astronomicon,* II: 439-447.

Marinus. *The Philosophy of Proclus.* Translated by Laurence J. Rosàn. New York: "Cosmos," 1949.

McClain, Ernest G. *The Pythagorean Plato: Prelude to the Song Itself.* Stony Brook, NY: Nicolas-Hays, Ltd, 1978.

Mesnil, Jacques. *Botticelli.* Paris: Albin Michel, 1938.

Meyer, Michael R. *A Handbook for the Humanistic Astrologer*. New York: Anchor Press/Doubleday. 1974.

Monstropedia. "Ouroboros," http://www.monstropedia.org/index.php? (accessed July 25, 2009).

Robert Midgley, trans. ""Why The Oracles Cease To Give Answers." *Plutarch's Lives and Writings* in *Plutarch's Lives and Writings*, IV, edited by A.H. Clough and William W. Goodwin. Boston: Little, Brown & Co., 1909

Ovid. *Fasti*. Translated and edited by Sir James George Frazer. Cambridge, MA: Harvard University Press, 1959.

Panofsky, Erwin. *Renaissance and Renascences in Western Art*. Stockholm: Almqvist & Wiksell, 1960.

Plutarch. *De Iside and Isiride*. Translated and edited by John Gwyn Griffiths. Cardiff: University of Wales Press, 1970.

Redgrove, H. Stanley. *Magic and Mysticism*. Secaucus, NJ: The Citadel Press, 1971.

Rist, Martin. *Two Isiac Mystics: Plutarch and Apuleius the Priest*. Chicago: University of Chicago Libraries, 1936.

Rose, Paul Lawrence. *The Italian Renaissance of Mathematics*. Geneve: Librairie Droz, 1976.

Rossi, Paolo. *Clavis universals*. Milan and Naples: R. Ricciardi, 1962.

Salvini, Roberto. Translated by John Grillenzoni. *All the Paintings of Botticelli, Part 2 (1445-1484)*. New York: Hawthorn Books, 1965.

Seligmann, Kurt. *Magic, Superstition and Religion*. New York: Pantheon Books, 1948.

Shearman, John. "The Collections of the Younger Branch of the Medici." *Burlington Magazine* 117 (January, 1975): 12-27.

Shumaker, Wayne. *The Occult Sciences of the Renaissance.* Berkeley: University of California Press, 1972.

Smith, Webster. "On the Original Location of the *'Primavera'."* *The Art Bulletin* LVII (1975): 31-39.

Taylor, Frank Sherwood. *The Alchemists: Founders of Modern Chemistry.* New York: Henry Schuman, Inc., 1949.

Taylor, Thomas, trans. *The Commentaries of Proclus: On the Timaeus of Plato.* London, 1820.

Taylor, Thomas, trans. *Iamblichus on the Mysteries of the Egyptians, Chaldeans, and Assyrians.* Chiswick: C. Whittingham, 1821.

Tuckerman, Bryant. *Planetary, Lunar, and Solar Positions,* Vol. 2. Philadelphia: The American Philosophical Society, 1964.

Yates, Frances A. *The Art of Memory.* Chicago: The University of Chicago Press, 1966.

Yates, Frances A. *Giordano Bruno and the Hermetic Tradition.* London: Routedge & Kegan Paul, 1964.

Yates, Frances A.. "The Hermetic Tradition and Renaissance Science." *Art, Science and History in the Renaissance,* edited by Charles S. Singleton. Baltimore: The Johns Hopkins Press, 1967.

Vasari, Giorgio. *Lives of the most eminent Painters, Sculptors and Architects.* Translated by Mrs. Johnathon Forster; Edited by Edwin Howland Blashfield, Evangeline Wilber Blashfield, and Albert Allis Hopkins. New York: Charles Scribner's Sons, 1986.

Venturi, Lionello. *Sandro Botticell.* Translated by Dr. Horovitz. Vienna: Phaidon-Verlag, 1937.

Walker, D.P. *Spiritual and Demonic Magic from Ficino to Campanella.* London: The Warburg Institute, 1958.

Warburg, Aby Moritz. *Gesanmelt Schriiften.* Germany: Krause-Thomson Organization, 1969.

Wind, Edgar. *Pagan Mysteries of the Renaissance.* London: Faber & Faber, Ltd, 1958.

Witt, R.E. *Isis in the Graeco-Roman World.* Ithaca, NY: Cornell University, 1971.

Wittkower, Rudolf. *Architectural Principles in the Age of Humanism.* London: Alec Tiranti, Ltd, 1952.

Wittkower, Rudolf. "Transformations of Minerva in Renaissance Imagery." *Journal of the Warburg Institute* II (1935-1939): II, 194-205.

Index